The UNDERWATER PHOTOGRAPHY
HANDBOOK

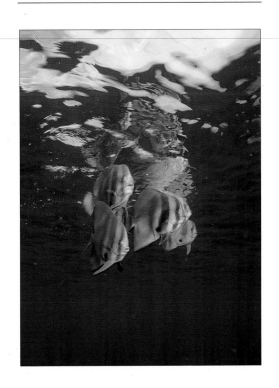

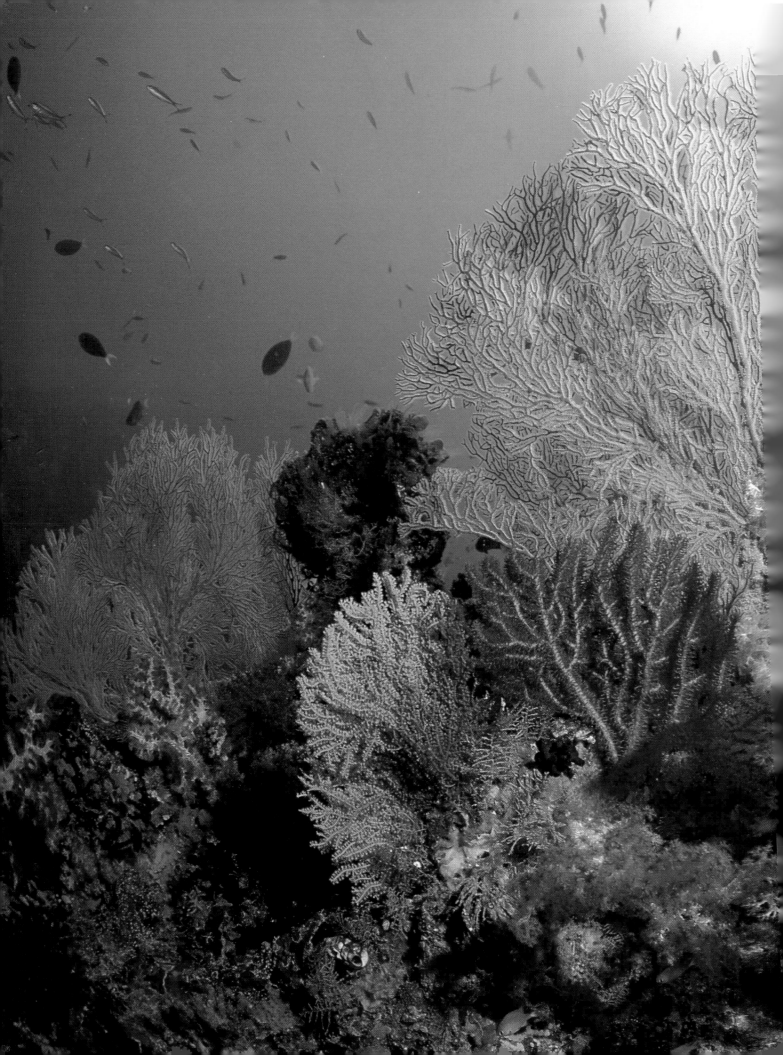

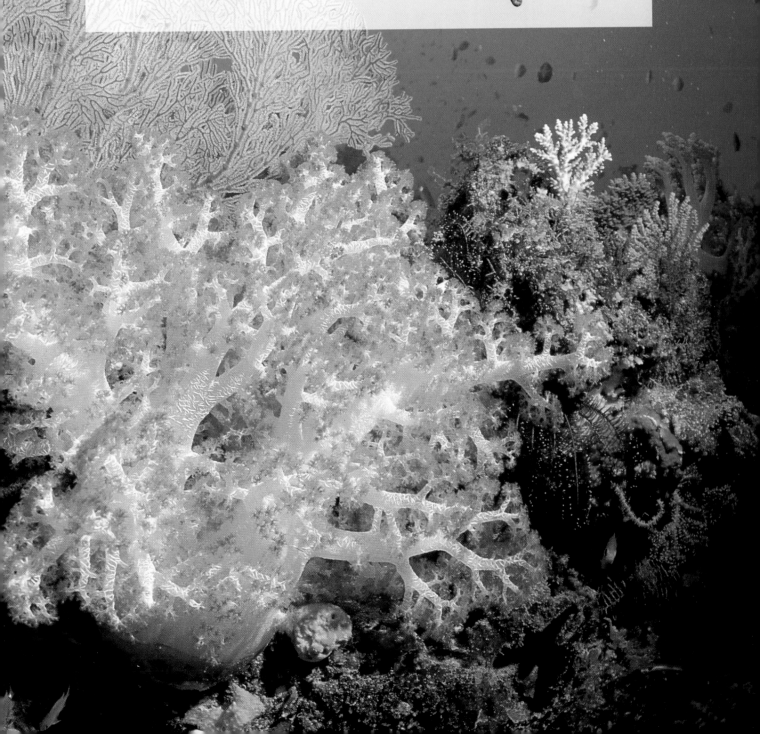

The
UNDERWATER
PHOTOGRAPHY
HANDBOOK

First published in 1998 by
New Holland Publishers (UK) Ltd
London • Cape Town • Sydney • Auckland

10 9 8 7 6 5 4 3 2 1

First edition

Library of Congress Cataloging-in-Publication Data
Köhler, Annemarie.
 The underwater photography handbook/Anne-
 marie and Danja Köhler.–1st ed.
 p. cm.
 Includes index.
 ISBN 0-8117-2966-4
 1. Underwater photography–Handbooks,
 manuals, etc. I. Köhler, Danja. II. Title.
 TR800.K64 1999 98-38835
 778.7'3–dc21 CIP

Reproduction by Unifoto (Pty) Ltd
Printed and bound in Singapore by
Tien Wah Press (Pte) Ltd

AUTHOR'S ACKNOWLEDGEMENTS
There are many people involved in the creation of a
book. To them all, a heartfelt thank you! There are
however always a few who, for their unbelievable
generosity, deserve an extra measure of appreciation:
 Our editing team, Anouska Good and in parti-
cular Simon Pooley for his skill in simplifying our
thoughts, yet still retaining the heart of the matter.
 Our designer Mandy McKay, who came to love
the sea while doing an admirable job.
 Navot and Tova Bornovsky of MV *Ocean Hunter*,
Palau and skipper Dave Miller of MV *Tiata* in
Kavieng, Papua New Guinea, who put us in place

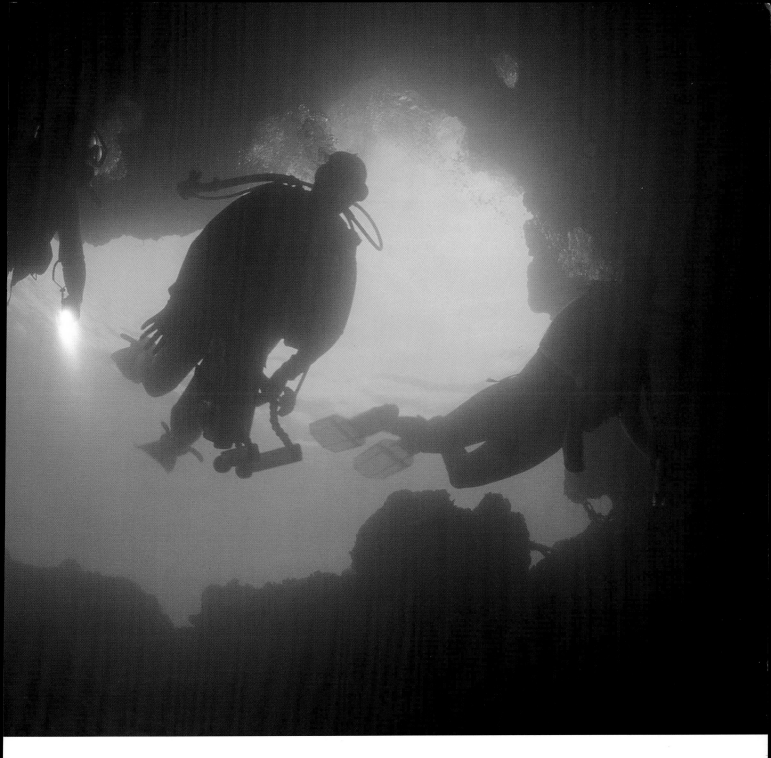

perfectly, every time, and generously shared the secrets of their worlds with us.

Rob van der Loos of MV *Chertan*, a true friend who through his love for the ocean and Milne Bay, Papua New Guinea, taught us so much! Also to his crew: Peo, Cheri and Stanley in particular, you guys are the very best of them all!

Photo Staa, Cape Town, and in particular Tony Staa, for their super service and care in developing our thousands of eagerly awaited transparencies.

John Colclough who walked ten extra miles to provide current information and photo-equipment, and helped set it up for product photography.

Nikon, Sea & Sea, Ikelite and Amphibico for supplying product photography.

Margaret Seet in Singapore, for going beyond the call of duty in solving our camera problems, including delivery of back-up systems to remote dive areas.

Sandy Ashwell of Worldwide Travel for arranging each perfectly meshed international trip. Bob Lowe and Singapore Airlines for great service and generously accommodating our photographic luggage.

Megan Brookman and Jamee Nowlin for their patience and elegant underwater modelling.

Amori Strüwig, the daughter who holds the fort while I live my dreams.

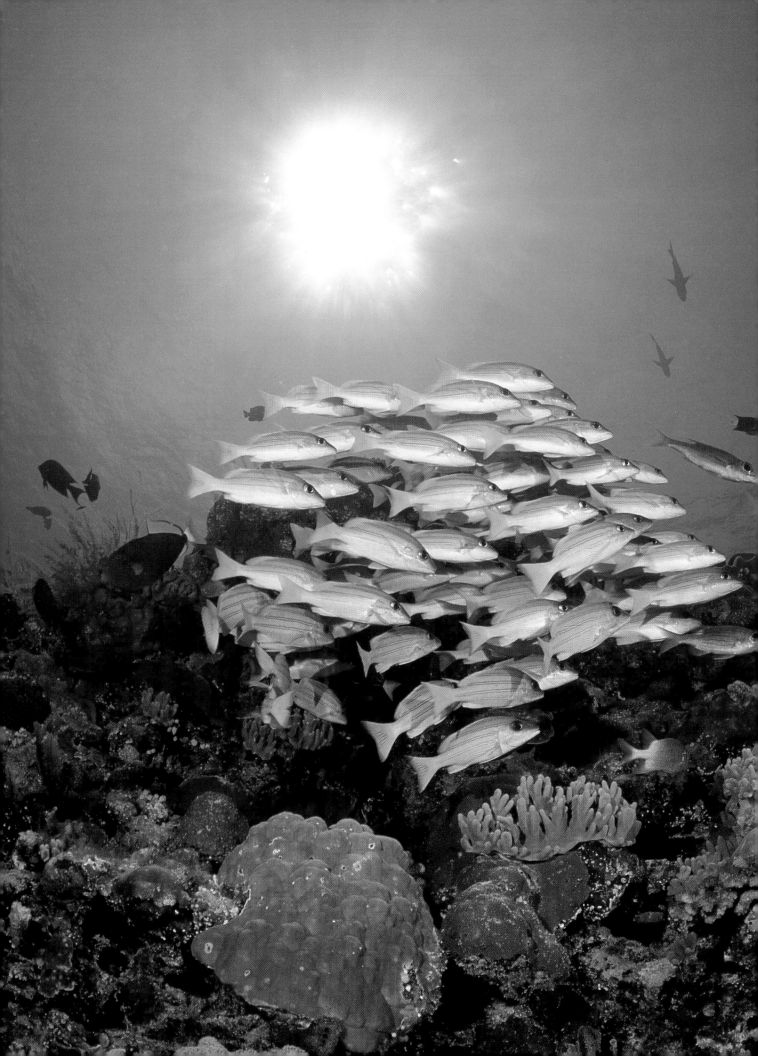

CONTENTS

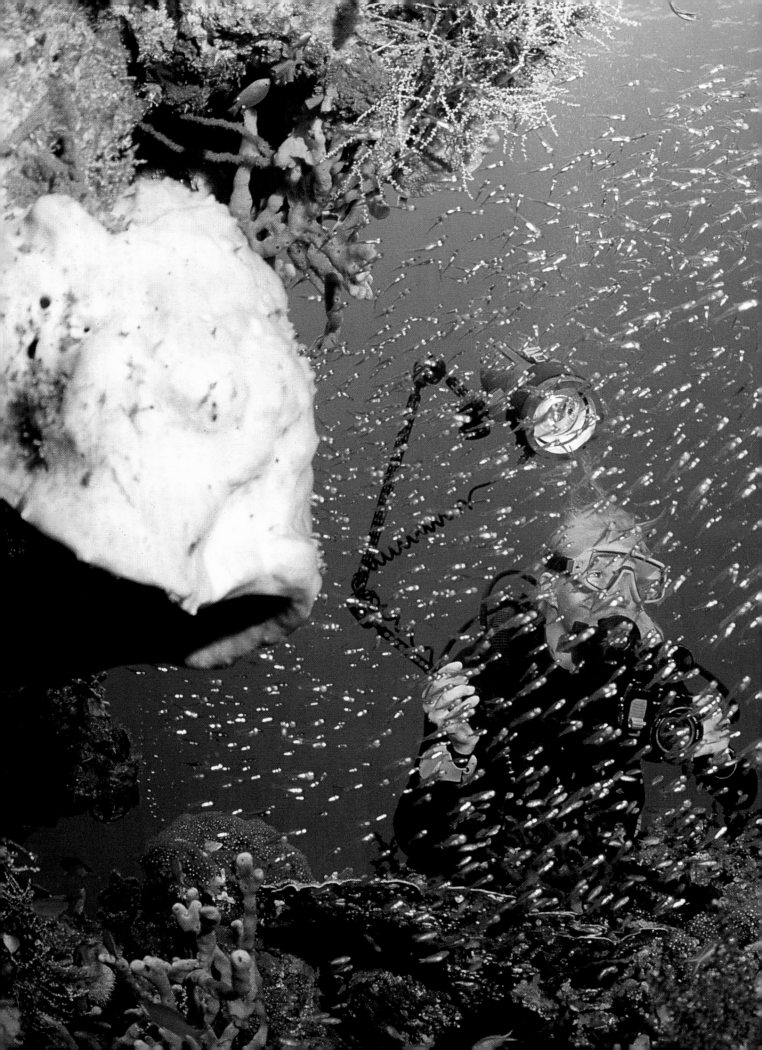

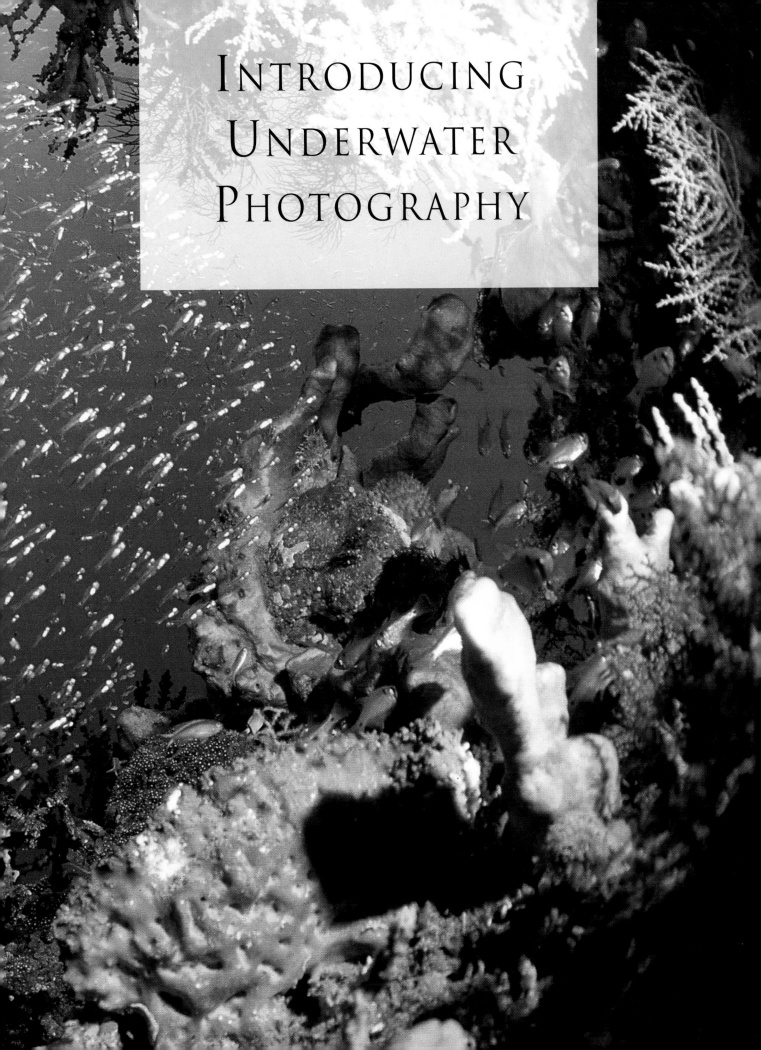

INTRODUCING
UNDERWATER
PHOTOGRAPHY

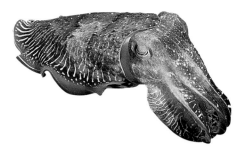

AN IDEAL
ART FORM

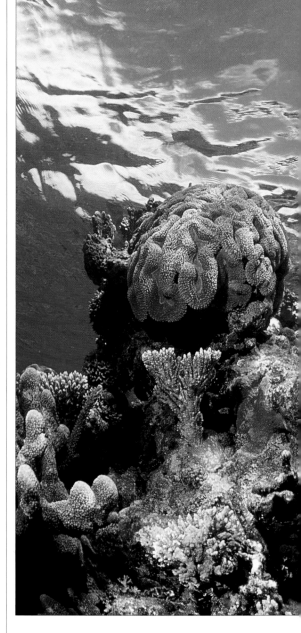

Have you ever attempted to explain diving to a non-diving friend? However eloquent you are, it is virtually impossible to communicate the spirit of tranquillity, the liquid skies and the bustling, vibrantly coloured coral reefs without some visual aid. But there is a lot more to underwater photography than entertaining our friends: it permits us to savour and relive our underwater experiences, while allowing us to study the incredible diversity and detail of, for instance, life on a tropical reef.

An ideal art form and an easily learnt science, photography rapidly increases our awareness and understanding of this exquisite wilderness. Once the skills are acquired, photography is compelling and addictive, a lifetime affliction for which there is, quite simply, no cure – the quest for the 'ultimate' image never ends.

The purpose of this book is to get you in the water and taking photographs, fast! It will not teach you to construct a camera, nor will it bewilder you with technicalities. What it will do is explain which factors will influence you when photographing underwater and what to do about them.

Most common errors, whether made by beginners or by experienced photographers, almost always have something to do with the simple, basic principles of photography – yet you need not be a rocket scientist to learn and understand these.

Coral reefs are living mosaics of symmetry and pattern.

In addition, underwater photography is in many respects a lot easier than photography practised on dry land: the ambient light is always blue, and once 'on location' you can glide, weightlessly, toward your chosen subject – which in most instances will stay remarkably close.

Underwater photography is a skill that provides fulfilment, endless pleasure and inner gratification dive after dive. So, what are you waiting for?

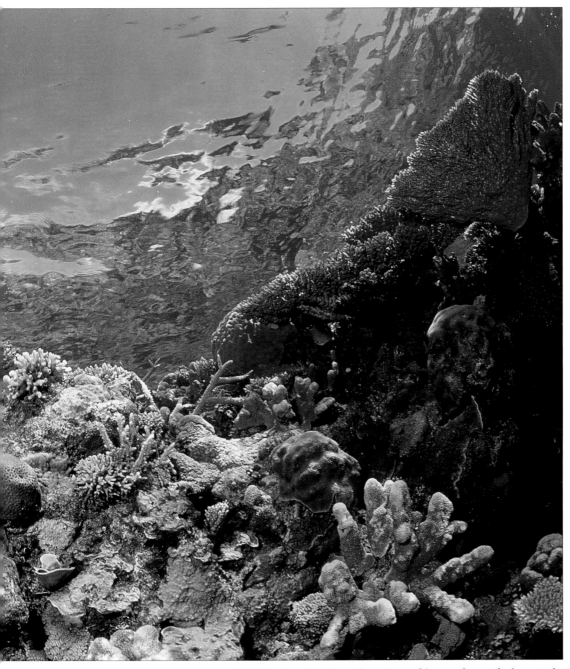

A picture describes the underwater world more eloquently than words.

GETTING STARTED

Your decision to become involved in underwater photography depends both on the amount of time you will devote to diving and how regularly you dive. Will every dive be a photographic occasion for you? Let us consider your personal inclinations and then analyze your needs.

Perhaps simple holiday snapshots or video for family and club entertainment is all you are after.

But beware! Your first successful shots may almost immediately create the desire to become a more serious photographer. Getting 'serious' about photography means that you aim to make the activity an important part of your life – possibly to the point where it may contribute to your income or even become your livelihood.

Although an understanding of basic photographic principles is essential, the quality of your images

does depend on the quality and capability of your equipment. Really good results require an investment of time and money, thus it is sensible to start with equipment that sets you few limitations. If you are going to photograph regularly, commit yourself to the best reliable system you can afford.

MAKING THE BIG DECISION – STILL PHOTOGRAPHY OR VIDEO

Underwater photography, irrespective of the format, requires an eye for detail, composition and colour, and the ability to note unusual factors that may seem insignificant to others. However, if you want to capture detail, colour and form, or freeze one breathtaking moment in time, still photography should be your choice. If, on the other hand you are enamoured of the dynamics of movement, action and behaviour, then video is your medium.

The price of equipment is of little help in deciding between still photography or video. A simple holiday snapshot camera is on a par with a soft plastic-bag-type housing for an existing domestic video camera, while at the other end of the scale, housings for sophisticated single lens reflex (SLR) cameras with high quality optical lenses and a variety of strobes cost much the same as three-chip digital video cameras in fully controllable electronic housings with monitors and underwater lamps. As price determines quality, it is the level of photography you wish to achieve that will decide what equipment you choose.

Still photography

Still photography presents a format in which a big story must be told with a few, very well-chosen words. Each image *is* in fact your story. The love of this format is a calling; usually, you will somehow know that 'this challenge is for me', and it is unlikely that you will even consider video.

But still photography requires some extra effort. Because the still camera is more exacting and not as forgiving as video, an understanding of your camera and basic photographic principles is paramount to achieving good results. The still photographer retains a great deal of individual control over results

Right The voluptuous form and striking colour of a closed sea anemone make it a fascinating choice of subject for still photography.

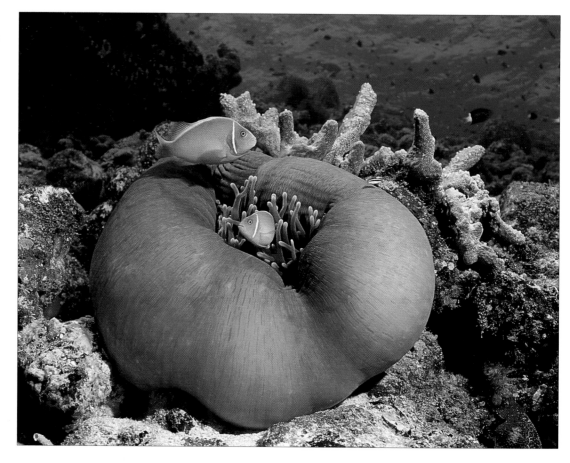

Opposite Videography is able to capture the essence of a coral reef – with its vibrant soft coral gardens moving gracefully in the current.

in terms of exposure and focus, and must therefore master the necessary techniques.

In still photography different lenses or extensions are necessary to achieve picture variety; this is a major factor for consideration in the choice of a camera system. If this sounds overwhelming, relax, as learning underwater photography is a matter of mastering one lens at a time. Initially you may not instantly be successful – but even experts rarely get 36 perfect exposures! While success depends mainly on coming to grips with basic rules, a measure of perseverance and determination is important. By analysing and correcting visible problems, you quickly progress and photograph more confidently. Soon both the 'keeper' rate and your personal satisfaction will grow in leaps and bounds.

Videography

If you are uncertain which path to follow, choose video! Whether you are an amateur or aspiring broadcast photographer, video is simple and requires little effort to learn. You set the camera on automatic, load it in the housing, get in the water, point towards your subject and press record. No matter how inexperienced you are, you will almost certainly have some footage decent enough to please yourself and impress your friends.

Video cameras work well in natural light and their wide-angle capacity offers depth of field almost to infinity, so that almost every important living thing in the ocean appears sharp. What's more, you will capture them acting, reacting and interacting. The ultimate pleasure of video should also not be forgotten: get out of the water, rewind, plug the camera into the television and, 'hey presto', you have instant gratification, watching your footage!

Obviously, the better the videographer, the better the video. The learning curve for videography is short – as soon as you see results, it is immediately evident where you went wrong or, for that matter 'right'. As there is no waiting for film to be developed, errors can be corrected as soon as the next dive and good techniques repeated or broadened.

Finally, an extra dimension of fun is added by postproduction editing. This allows countless stories to be told with different combinations of the very same footage. But, there is one more plus: video cameras can also be used on land and tape can always be re-used.

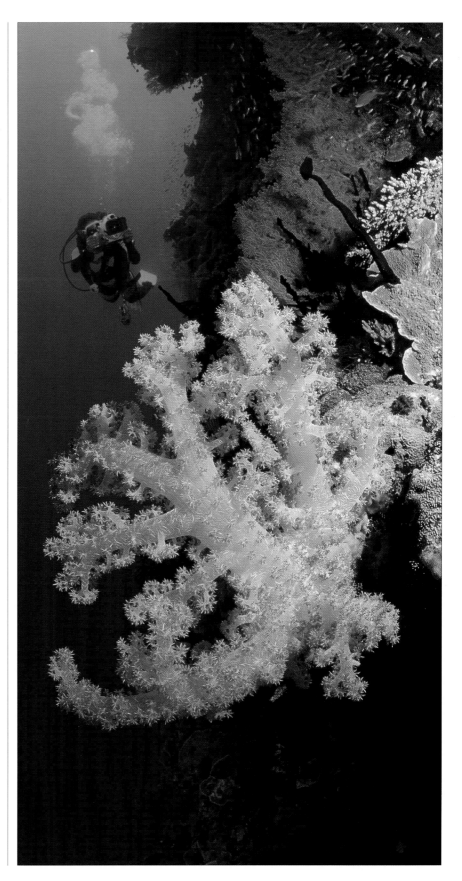

EQUIPMENT FOR STILL PHOTOGRAPHY

Taking a camera underwater presents us with considerations entirely different from those valid on land. The limitations of what is essentially an unnatural environment for humans, the different photographic methods and the bewildering range of equipment calls for a step-by-step approach to help you determine your final choice and balance it with your budget, opportunities and aspirations. To provide a starting point and comparative information, we will discuss how cameras, lenses, housings and underwater strobes, or flashguns, work. Then follow suggestions for an ideal equipment scenario and a concise table listing all the options.

However, the wide variety of underwater camera equipment available makes it impossible to discuss specific models in depth. It is thus imperative that you research and compare features, and read the manufacturer's instructions, both before and after purchase. We all hate doing this, but it is important for choosing and safeguarding your investment.

Note also that brand and model names used here are not intended as advertisements for manufacturers. Most are popular current choices, intended only to place equipment in a specific bracket of quality and ability. Also, be aware that new systems with improved features appear continuously to replace others. Consider a variety of models in the same league, both for the best features and price.

Each photograph captures one magic moment.

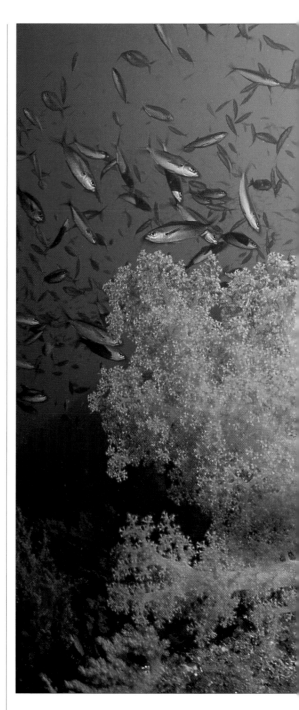

UNDERSTANDING CAMERAS

To take a conventional photograph at its most basic involves a combination of three elements: a camera body, a lens and a film. Since any one of the three elements are useless without the others, we usually refer to the combination as 'the camera'. This phrase changes to 'camera system' once we add a variety of lenses and flash guns and accessories.

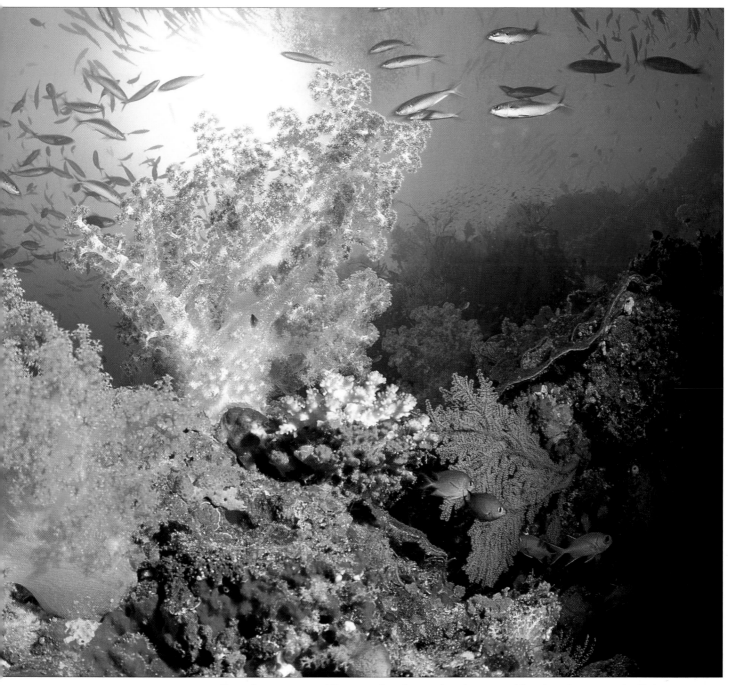

Different lenses capture different angles of view of a subject. Focal length is chosen specifically for this reason.

Any camera essentially does only two things: it gathers and focuses light through a lens, and it controls and projects it onto a light-sensitive film. Photographers call this process exposure. These exposures are developed, giving us permanent images.

The sophistication of these images, however, depends on two factors. The first is the optical quality of lenses and the additional camera features with which the nature and intensity of light can be controlled and manipulated. The second is how much freedom the camera offers the photographer to manipulate exposures according to personal taste and artistic aspirations. Foolproof instant cameras exclude much of this freedom.

The most essential camera control features are: a **film speed dial**, which is used to set a camera for a

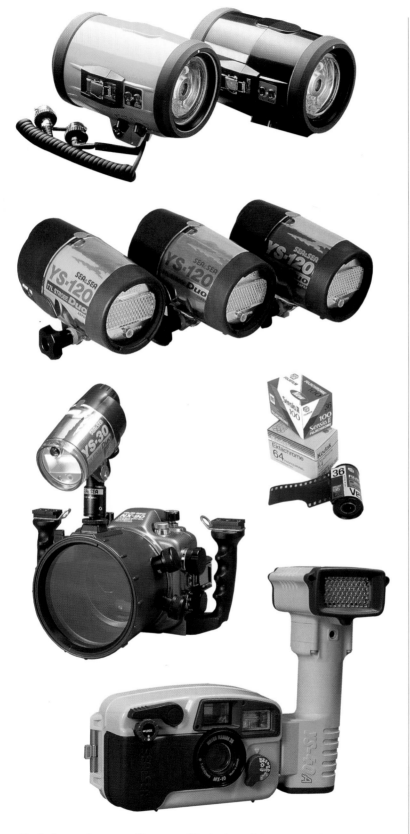

Each element has a specific range of limitations. Select your equipment to match your photographic aspirations.

wide variety of films with different sensitivities; an **aperture control** which allows you to open and close a diaphragm in calibrated degrees, known as f-stops, to determine how much light is allowed in; a **shutter speed dial**, which allows you to set one of several calibrated shutter speeds, to determine the duration of light for exposing the film. When the shutter release is depressed all three functions combine simultaneously to influence exposure.

Sophisticated cameras have many more features, such as programme and focusing modes which let you set specific automatic parameters for specific situations. **Motor drives** advance film automatically to the next frame, either singly or continuously in quick succession, and automatically rewind the film when it is fully exposed. **DX coding** reads and automatically sets the film speed encoded on film cassettes. **Exposure compensation buttons** allow aperture settings to be over-ridden in fractions of f-stops.

Most modern cameras used underwater are **35mm format** – a format that refers to the width of film exposed in one shot. Medium format specialist cameras produce much larger images, but these are rarely seen underwater.

UNDERSTANDING LENSES

A camera lens is the eye with which a photographer sees and interprets his world. However, a single lens cannot take care of all situations – each lens is optimized for specific distances, and specific purposes. Macro lenses, for example, are used very close to subjects, and are designed to focus down to a small minimum distance. Wide-angle lenses can also focus close, but are optimized to capture a wide view with sharp focus from foreground to infinity.

Lenses also have different focal lengths, or angles of view (that part of the scene they are capable of including in the image frame). Focal length is expressed in measurements such as 15mm, 35mm, 50mm and 100mm. The 'longer' the focal length, the narrower or smaller is its angle of view and vice versa.

Lenses, both for amphibious and housed systems, are selected and mounted before entering the water and usually cannot be changed underwater. The photographer must predetermine which lens will capture anticipated subjects. This choice is normally based on criteria such as water conditions, photographic opportunities, and personal interest. For example, in dirty water one would try to minimize

water between subject and lens and therefore photograph macro. If huge schools of fish, big animals or panoramas are expected, there is no point in taking medium-range lenses – you'll shoot in wide-angle.

Fortunately, almost the entire underwater picture range can be met with just a few select lenses. This is because the diffusing and filtering nature of water requires that the photographer works extremely close to the subject. The three main photographic interest areas underwater further helps restrict lens choices. They are:

• **Close-up and macro photography**, which forms a large part of most marine portfolios and is the only successful technique to use at night. This entails capturing reef features and creatures from thumbnail size to medium sized fish.
• **General medium range photography**, which entails close underwater scenes, diver portraits, divers with small creatures, large fish and small schools of fish.
• **Wide-angle photography**, which produces the

majority of most marine portfolios as it is ideal for and captures the most popular and impressive pictures: panoramas, full-length divers, people-animal interaction, large marine creatures, wrecks and silhouettes. This technique extends into breathtaking extreme close-focus wide-angle images, where smaller, even macro foreground subjects can be made dominant within an overall panorama. Wide-angle lenses are extremely versatile and, while expensive, should be an early acquisition.

THE PRICE FACTOR

While your choice depends on how much money you are prepared to spend on a camera system, it must also be influenced by your photographic needs and aspirations. Unfortunately, price always has a bearing on the capabilities and limitations of any system; sophisticated electronic features and superior optics deliver quality, but are more expensive.

If you are an **occasional holiday photographer** you probably want simplicity and ease of operation, coupled with an economical price. The instant type

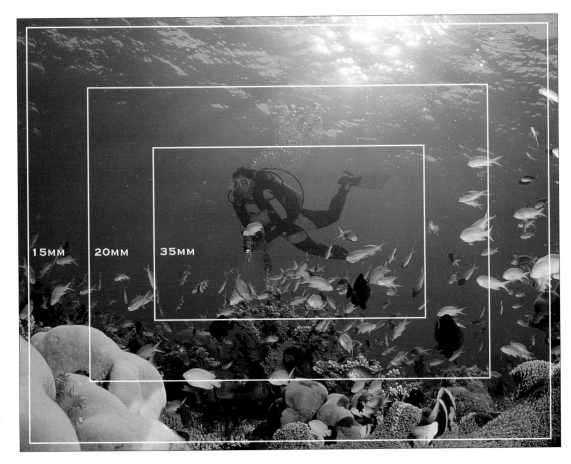

It is the focal length of a lens that determines how much of a scene can be captured if you photograph it from the same distance.

15MM 20MM 35MM

cameras, while they are a tempting economical option, have many limitations and are more suited to snapshots than creative photography. Their lenses do not focus close enough on small subjects, while the on-camera flash causes high back-scatter reflection, because it is mounted too close to the lens. Thus, irrespective of manufacturer, most are more

suited to snorkelling and few are waterproof and effective at average diving depths. The same limitations may apply even to slightly more sophisticated water- and weatherproof cameras. In truth, there is simply no really good underwater snapshot camera on the market yet.

The next step up brings you to a choice between two kinds of economical 35mm camera designs. These are good, complete underwater systems with TTL (through the lens) metering, sporting a variety of lenses and accessories.

While their price and capabilities make them very attractive for the casual hobbyist, their optics do not quite match the quality of the Nikonos or housed SLR (single lens reflex) cameras.

One of these models is a viewfinder camera. This means that a viewfinder that is positioned higher up and separate from the primary lens is used for focusing and framing. The difference between what the viewfinder and the camera lens sees causes a photographic anomaly called parallax error that must be understood to be mastered (*see* page 53). The alternative is a basic SLR camera, with the advantage that focusing and framing through the viewfinder accurately represents what the lens sees.

A **serious amateur photographer** pursues photography more regularly and expects excellent results. In this case it makes sense to buy the best system you can afford, gradually if necessary – and then to grow with your system. The choice here lies between cameras like the amphibious Nikonos V, or housing one of a range of sophisticated cameras like Nikon, Canon or Minolta. The sophistication and higher price of these systems makes it necessary to consider these points before committing yourself:

• Your initial investment should not be lost with future system upgrades or extensions.
• The basic system must allow immediate use, while the availability and compatibility of future additions must be guaranteed.
• Your basic system should be of high enough quality to serve as a back-up later, should you progress to an additional/different/more sophisticated system.
• Elements like strobes, connecting plugs, synchrocords and adapters to be compatible/exchangeable, both for present and possible future systems.
• Reliability and comprehensive after-sales service at reasonable prices is important.

Large features like sea whips can only be captured with wide-angle lenses.

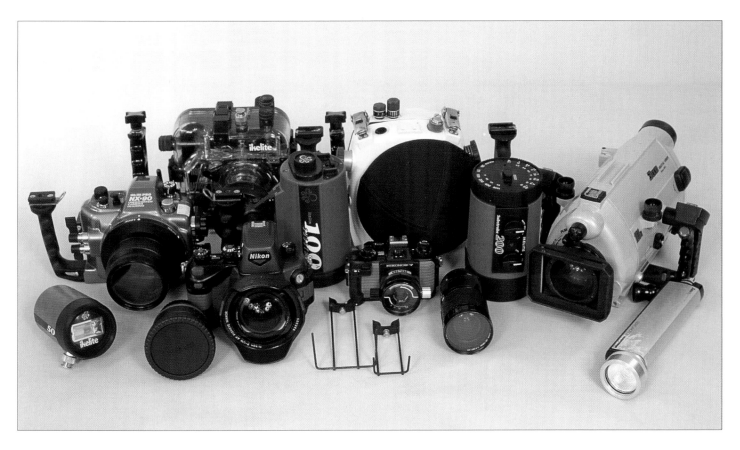

AMPHIBIOUS OR HOUSED?

In order to use a camera system underwater, we must either waterproof it with a custom built housing, or buy a system that is amphibious (designed to be waterproof in itself). Both options can deliver great underwater images, but you may prefer one over the other for its specific advantages. Here the way you prefer to operate will be as important as quality, while your choice of a system may also partially depend on the photographic environment.

For 90% of amateur photographers, the **Nikonos system** is probably the best choice. It was the first mass-produced underwater camera and to this day remains the industry standard. The camera is compact and simple to use.

Doing macro photography with the Nikonos V is point-and-shoot easy and it delivers excellent wide-angle images. Although capable of excellent results, the Nikonos V for the medium range is more limited, its success depending entirely on photographing large enough subjects at close distances. Failure to do so results in distant, monochromatic images.

Working photographers inevitably add the Nikonos V and its two wide-angle lenses to their equipment, both for the outstanding optics and for fast use in furious-action or big-creature photography, as encountered with dolphins, manta rays and whale sharks.

Housed systems are considered superior for their precision of composition and versatility in most underwater situations, as well as the variety and flexibility of the lenses that can be used. Thus, a serious underwater photographer should, without doubt, opt for this system.

With housed systems close-up photography is the easiest beginner's technique. The true macro lenses deliver stunning and varied magnifications, but require some experience. For housed systems the medium range is considerably larger, as close-up lenses extend admirably into this range, while added zoom lenses can provide greater subject variety.

A housed camera has greater flexibility in the majority of photographic situations than any of the presently produced amphibious cameras.

A note of warning: housed systems should not, but may, produce slightly inferior wide-angle images compared to the Nikonos V. This stems not from lens quality, but from incorrectly fitted dome ports.

Don't let the equipment jungle confuse you – define your needs before you set about choosing the equipment you will need to realize them.

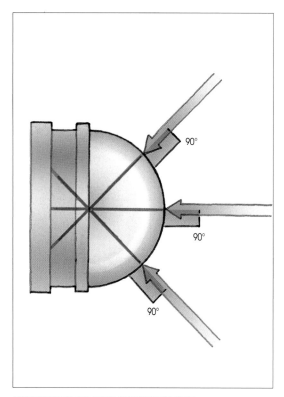

LIGHT MUST STRIKE THE DOME PORT CORRECTLY.

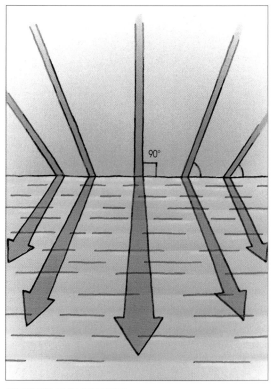

DISTORTION OF LIGHT IN WATER.

SLR DOME PORTS

Curved domes allow wide-angle lenses to focus light correctly underwater, even if the light arrives from extreme outer view edges. The amphibious Nikonos wide-angle lenses allow this without interference from air.

In housings, however, we not only use flat field land lenses, but light must travel through a layer of air inside the housing. The problem is that refraction occurs whenever light travels from one medium to another, except when it strikes at a 90 degree angle. For this reason, accurate dome port alignment is crucial.

The dome port creates a curved virtual subject image and situates it in front of the film plane, at a distance roughly twice the diameter of the port. This correctly directs the image to the lens. Thus, with an 20cm (8in) dome port, the virtual image forms 40cm (16in) in front of the port.

But for the virtual image to be sharp and in focus, the dome port must align correctly with the front and rear nodal points of the lens – these are mathematically calibrated light entry points. In this lies the problem of housed wide-angle optics. Surprisingly,

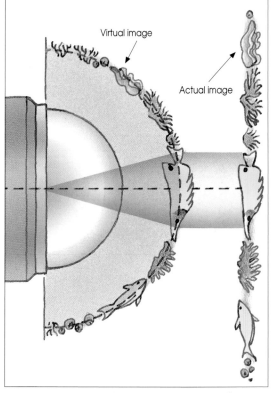

DOME PORT SHOWING VIRTUAL IMAGE.

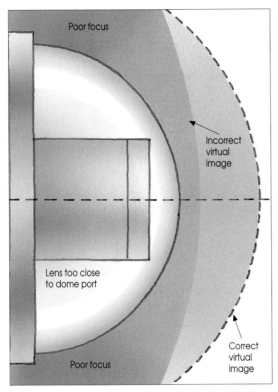

FOCUSING ERROR WITH FLAT FIELD LENSES.

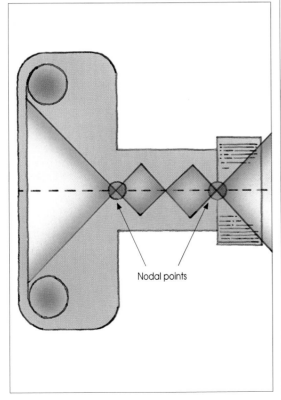

NODES OF FOCUS.

in almost 95% of manufactured housings the lens is too close to the dome! This causes light to partially radiate away from the lens, resulting in some loss of sharpness, further exaggerated by large apertures.

If the lens is correctly centred, aligned and equidistant from the dome port at all points, then focus sharpness will extend throughout the entire image, including the edges. The problem can be corrected by establishing both front and rear nodal points and then adding a corresponding space between lens and dome, via a spacer ring on the port.

STROBES

As they are simply indispensable for marine photography strobes, also known as flash units or speedlights, should be a priority purchase. They not only restore colour filtered out by water density, but transform underwater images from the ordinary into the magnificent.

In essence, strobes are all the same, with feature variations. To work in unison, strobes are connected to cameras with 'life-lines' called synchro-cords. The strobe draws electrical power from a pre-charged on-board battery pack and collects and stores it in a capacitor. When enough energy to power a flash has accumulated, a strobe-ready light turns on. The camera shutter release triggers the strobe when an image is taken and the stored power flows from the capacitor to the flash tube, which emits (in most cases) one brief flash of light.

Strobes can have variable power-settings. These are advantageous for greater control over output intensity, and therefore exposure. In addition a TTL setting is essential for most cameras, (some have accurate non-TTL auto sensors), as this synchronizes with the camera's through-the-lens metering sensor for automatic strobe exposures.

Most good strobes will come with power-setting combinations like these:

• Full, ¼ power, ¹⁄₁₆th power, ⅛th power and TTL.
• Full power, ½ power, ¼ power and TTL.

Strobes that have only a full power-setting, allow little exposure creativity. A slave setting is a handy extra feature. This allows the strobe to function as a normal strobe unit (setting off), or (setting on) to be set off only by the flash of another strobe. Dedicated slave strobes are only capable of the latter.

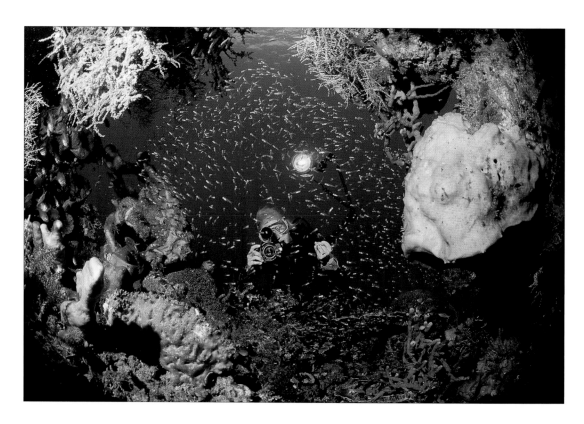

A strobe is essential to high-light rich, vibrant colour and detail underwater.

The period between flashes, during which the capacitor recharges power, is called the **recycle time**. Recycle times should be short – just a few seconds. This depends on the strobe, but also on the quality and strength of the strobe batteries. Nickel-cadmium batteries are best for short recycle times, as they keep on functioning consistently, even up to the point of cell exhaustion. Alkaline batteries produce progressively longer recycle times as they weaken.

After continued use, ready lights may turn on before the capacitor is completely charged. If fired immediately, subsequent charges are accepted at lower rates. It is thus advisable, whenever possible, to delay the next flash for a few seconds.

Strobe outputs and effects also depend on their beam angles. Wide beam angles and powerful output is essential for wide-angle photography. For close-up work, on the other hand, you will only require much smaller and cheaper strobes. Some models have adjustable beam angles.

The beam angle is based on the light value in the centre of the light beam; this may differ by as much as one f-stop from light at its edges. It is important that the beam angle should cover the entire picture area seen by the lens, otherwise it will appear bright in the centre and darker at the edges – creating an undesirable 'hot spot' effect. This can be partially remedied by detachable diffusers, which widen the angle and soften and spread light more evenly. The cost, however, is light reduction by one f-stop, which must be compensated for if this is not desired.

Slave strobes with cordless slave sensors are more expensive, but preferable for practical reasons. Slave strobes (multiples can be used) are triggered by the flash of the primary strobe, provided they are positioned to sense it. This is a creative addition, used in various lighting situations for interesting effects.

THE IDEAL SCENARIO

The two ideal equipment scenarios for housed SLR and amphibious systems concentrate on wide-angle and macro techniques, because almost 90% of an underwater photographer's portfolio is devoted to these. The remaining 10% concentrates on medium range photography.

This does not mean that your system should be identical to the ones illustrated. The illustrations merely demonstrate the minimum equipment that a working photographer would use in the field, both for excellence and the comfort of not having to change lenses or ports between dives.

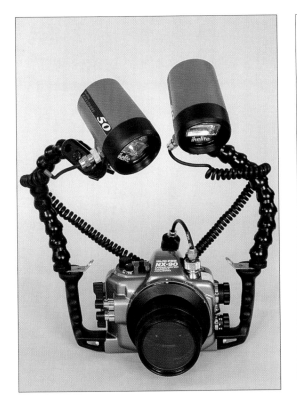

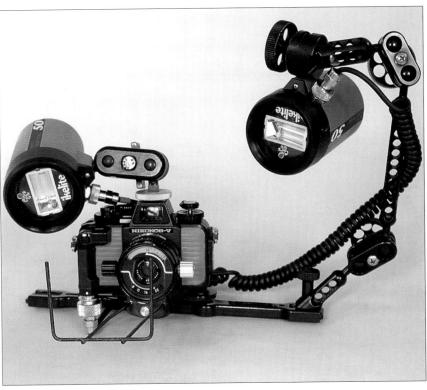

Above left and right The ideal macro setup entails extremely flexible arms and two small matching strobes that recycle rapidly.

Left The typical beginner's one-strobe setup presents limitations when lighting larger subjects or controlling backscatter.

Below The ideal wide-angle setup requires very long flexible arms and two matching strobes with wide beam angles.

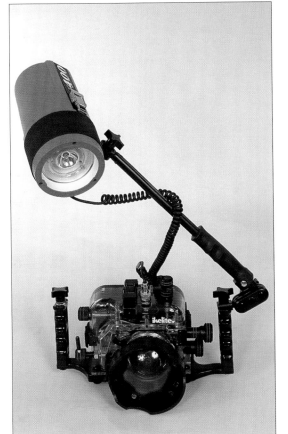

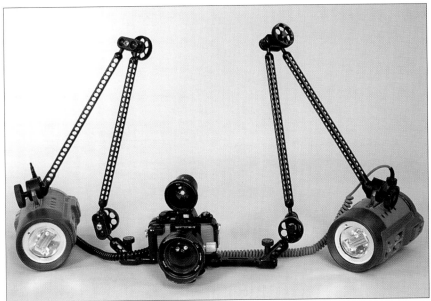

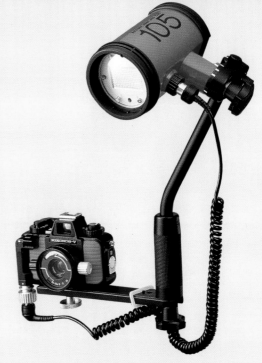

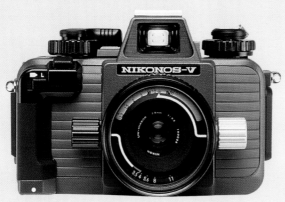

The Nikonos V is a dedicated amphibious 35mm system and, in combination with its 15mm lens, is perhaps the best choice for wide-angle photography. It is widely used both as a primary and back-up system, but professional photographers seldom rely solely on it.

ADVANTAGES	• Easy to learn, it is the perfect choice for beginners, hobby photographers and aspiring serious photographers • Delivers excellent, professional results • Reliable, compact, rugged, lightweight and portable • Easy to maintain and prepare between dives • Manual and automatic exposure control • Automatic TTL flash control • Advanced, accurate built-in light-meter • Offers a choice of five optically corrected lenses, the quality of which cannot be faulted • Well-supported by the manufacturer, and due to its market dominance, there is a proliferation of independent compatible equipment.
DISADVANTAGES	The Nikonos V lacks reflex viewing – the image seen in the viewfinder is not the one you will get. Problem areas: • it requires understanding and effort to estimate distances accurately for pre-setting a focus range • presents parallax error (*see* page 59), because both wide-angle lenses are used in combination with top-mounted auxiliary viewfinders. This must be understood to be corrected • while the camera can be used on land, the selection of lenses for this purpose is narrow.
OTHER CONSIDERATIONS	This is the camera most often used to teach underwater photography. It has been around for so long that almost foolproof exposure 'recipes' exist. Understanding this camera rapidly leads to consistent photographic excellence. Reasonably priced for entry level, it can be systematically developed to a sophisticated level, without the loss of the initial investment. *Note: Information on strobes is included on page 21.*
SERVICE	If well-maintained, the system virtually guarantees consistent trouble-free service for many years. The manufacturer recommends a service after 25 dives. In my opinion, provided the camera is meticulously maintained, it can handle as many as 150-200 dives without any professional attention. The camera can easily be serviced by the technically gifted, with the aid of excellent service guides.
RECOMMENDATIONS	For the budget-conscious, a good starter Nikonos system entails a camera, a small strobe, a 35mm and 28mm lens, and the close-up and macro converters. Later, add a larger strobe and the more expensive wide-angle lens. Also look at the more economical, easy to use Sea & Sea MX10 point-and-shoot system. The strongest contender to the Nikonos is Sea & Sea's Motor Marine II-EX.

MACRO	CLOSE-UP	MEDIUM RANGE	WIDE-ANGLE
35mm and 28mm lenses each have their own specific extension tubes and framers to provide magnification rates of 1:3, 1:2, 1:1 and 2:1. The macro set-up locks you into this mode for the duration of the dive.	35mm, 28mm and 80mm lenses are all converted with the same optical element, while each of these lenses has its own specific distance rods and framers. These allow magnification rates of 1:2.2, 1:4.5 and 1:6. The close-up element can, however, be removed underwater so that the prime lens can be used.	• The more economical 35mm and the slightly wider 28mm Nikkor lenses are the 'standard' lenses of the system and closely approximate the perspective of the human eye underwater. • The 35mm lens, at minimum focus, covers a picture area of slightly less than 60 x 90cm (2 x 3ft). It has an excellent and reliable depth-of-field scale and is easy to focus • The 28mm lens, with its closer minimum focus distance of 60cm (2ft) and increased depth of field, has the edge in reef-inhabitant photography.	• The 15mm with its 90° angle is the dearest lens of the system but also the best, and usually surpasses the image quality of equivalent housed lenses. • The cheaper 20mm lens has equally excellent optics, but a narrower 78° angle of view. Minimum focus distance is 40cm (1.3ft). It is good for beginners. • The 20mm is preferred for fast-action or big-animal photography, when close subject proximity is not possible. Its subject images appear much larger than those taken with the 15mm lens. Either lens is used with an auxiliary viewfinder. The 20mm viewfinder can be used with the 28mm lens, and has an additional mask for this purpose only.
• System is point-and-shoot easy while rendering excellent macro pictures • Once connected, the camera's viewfinder and focusing becomes obsolete • Calibrated distance rod determines lens-to-subject distance • Matching framers indicate subject size, the approximate picture area and the approximate sharp focus plane.	• System is point-and-shoot easy while rendering excellent close-up pictures • Once connected, the camera's viewfinder and focusing become obsolete • Calibrated distance rod determines lens-to-subject distance • Matching framers indicate subject size, the approximate picture area and the approximate sharp focus plane.	Lenses deliver excellent results, if subjects are large enough and close enough (± 1m; 3ft). At closer working distances, if you measure *actual* distance, reduce this by ⅓ to get an in- focus image, as the 35mm lens's distance scale is in air measurements and underwater measures *apparent* distance, like our eyes through a mask.	• The 15mm and 20mm wide-angle lenses are outstanding, compact and fast to use – both for action and close to the surface photography. • For fast action the lens can be set for a specific range and exposure and need not be adjusted again for the duration. This leaves the photographer free to concentrate on the subject.
• Framers are larger by a buffer zone of 0.6cm (0.25in), to exclude them from the image. Do not position important parts of the subject in the buffer zone • The framers do not fit in tight corners and are not suited to skittish subjects • This fixed configuration is less flexible in working distances and shooting angles • Precise framing and sharp-focus-point placement can be problematic.	• Framers are larger by a buffer zone of 0.6cm (0.25in), to exclude them from the image. Do not position important parts of the subject in the buffer zone • The framers do not fit in tight corners and are not suited to skittish subjects • This fixed configuration is less flexible in working distances and shooting angles • Precise framing and sharp-focus-point placement can be problematic.	The lenses are not suitable for working distances beyond ± 1m (3ft), panoramic scenes or small subjects.	The viewfinders cause parallax error – which the photographer must correct. Viewfinders show only 90% of the true picture area – thus to avoid unplanned image edges an additional 10% all-round edge must be added during composition.

• All Nikonos lenses must be preset for a focus distance, rather than focusing the standard SLR camera way, thus the photographer must be able to estimate camera-to-subject distances accurately. People with focusing problems frequently prefer this method.

• The new Aqualens attaches to the traditional Nikonos V body and is essentially a clever 'housing' with a choice of two dome ports that can accommodate various topside wide-angle lenses instead of the traditional lenses. This can broaden the scope to extreme wide and fish-eye lenses.

Note: Several independent producers, such as Sea & Sea, make Nikonos V compatible lenses and accessories. For macro this concentrates on extension tubes for the 35mm lens and includes frames with removable prongs or a frame-free penlight aiming system. Sea & Sea now produces a macro kit that can be removed underwater, to allow larger subjects to be shot. Compare price, quality and practicality.

HOUSED SYSTEM

	HOUSING	SLR CAMERA
ADVANTAGES	• Best choice for serious photography • Best choice for photo journalism • Ideal for behavioural photography • Increased power, versatility and flexibility in terms of perspective, angle and subject size – therefore increases creativity • Dual purpose (land photography). Note: Since some cameras are more suitable than others, both housing and camera must be considered at the same time	• Allows features like autofocus, motor drives, DX coding and exposure compensation • Can be used on automatic or manual, or both • Allows precise focusing, and virtually precise framing through a viewfinder • Solves problems and limitations of the Nikonos system • Offers a wider choice of lenses – including true macro • Ideal for fish and shy subjects.
DISADVANTAGES	• Added bulk, complexity and usually expensive • A little more cumbersome to maintain • Not as fast to use as the Nikonos However, inconveniences are mostly surface-bound and balanced by the image results.	• Needs better grasp of photographic fundamentals • Takes longer to set up, reload film or change lenses.
ESSENTIAL FEATURES	• Ease of focusing – large, clear comfortable viewfinder with illumination • Illumination of any top deck Liquid Crystal Displays (LCDs) • Easy access and precision for controls – particularly manual and autofocus controls • Place emphasis on a smooth shutter release that responds instantly to finger touch • Exposure mode control • Fast autofocus speeds • Ease of changing lenses and film between dives – without dismounting camera • Glass lens ports – more expensive than acrylic, but superior • Ensure that optical quality and seating of dome ports for wide-angle lenses is perfect • Must be possible to self-service housing O-rings otherwise do not buy the housing • Neutral buoyancy when loaded with camera.	• Must be selected specifically for underwater suitability – irrespective of price range, it is crucial that it can be modified with a comfortable viewfinder (High-eyepoint viewfinders in better housings do not require this.) • Must offer optical excellence and variety of lenses in terms of capability and focal length – look at both brand and compatible lenses with emphasis on quality • Camera should be compatible with wide range of popular, reliable TTL underwater strobes • Production reliability and future availability.
DESIRABLE FEATURES	A control for selecting light-meter options.	• Autofocus options like single shot, continuous and freeze-focus modes. • Choice between centre-weighted and matrix metering.
OTHER CONSIDERATIONS	Once mastered, a housed system indisputably becomes superior to the Nikonos. Note that in some housed lenses, focus and aperture are controlled via slip-on gears, secured to the lens with small screws. Each lens should have its own set for faster lens changes and proper fit. *Note: information on strobes is included on page 21.*	Important that an existing land camera is suitable for underwater viewfinding.
SERVICE	A good rugged housing will cope for long intervals without any special service.	Does not need servicing for several years.
RECOMMENDATIONS	Price difference has to do with control features and electronics. • Low budget: EWA Marine flexible plastic bag-like housings rated to 30m/100ft fit just about any compact or SLR land camera. These are useful for keeping out deck spray. • Middle range: Sea & Sea NX-90 PRO (Nikon N90S) and CX-600 in acrylic and metal. • Top of Range: Subal, Anthis Nexus, Tussey, Aquatica (now distributed by Nikon). • A good starter combination for the budget-conscious may be a camera, a housing, a 50mm or 60mm lens, and a strobe. While limited, this will allow quite a wide range of images in the medium to very close-up range, considered the easiest technique to learn with a housing. Later expand to macro and wide-angle lenses.	The Nikon F2, F3, F4 and F5, and the Canon F1 deliver enlarged viewfinder prisms called 'sportfinders', 'action-finders' or 'speedfinders'.

MACRO	CLOSE-UP	MEDIUM RANGE	WIDE-ANGLE
60mm 100mm 105mm 200mm	Close-focusing 50mm or 60mm macro	Close-focusing 50mm or 60mm & zoom lenses	14mm 15mm 16mm 18mm
• The 100, 105 and 200mm lenses are true macro lenses – the first two are general workhorses, the last is more specialized. • These lenses have incredible magnifying abilities – even for the tiniest creatures • Dramatically magnify image size on film. • Nonintrusive – thus do not violate boundaries of creature tolerance. • Superior to Nikonos in terms of image, creativity, freedom and flexibility of perspective, distance or subject size.	• Good beginner's lens, can handle from full-frame nudibranchs to large fish. • This lens is versatile and also covers the border-range between macro, close-up and medium range photography. They can render small subjects on a 1:1 scale. • Superior to Nikonos in terms of creativity, freedom and flexibility of perspective, distance or subject size. • Excellent for tight framing of large subjects • Available as autofocus.	• Huge scope of subject possibilities between big full-frame fish portraits, reef and diver (face/mask) portraits. • Working distances range between 7.5cm (3in) to 1m (3ft) away, particularly excelling at the latter. • Zoom lenses considerably extend the range both in distances and subjects. • Excellent beginner's lenses.	• Capable of all the creative wide-angle techniques such as close-focus wide-angle and steep-perspective trickery. • Due to the SLR viewfinder, parallax error does not occur. • Useful in turbid water as it can focus at short distances.
• Not a beginner's lens • More expensive than Nikonos set-up. • The 60mm is a popular starter lens but is not capable of high magnifications.	• Although suited to macro, is less effective for extreme magnification. Further, as they have to be placed extremely close to the subject, they are at least as intrusive as framers.	None	• Cannot match the compactness of the Nikonos system. • Cumbersome when diving close to the surface on snorkel.
• Short minimum focus distances.	• Short minimum focus distances.	• Short minimum focus distance.	• Choose rectilinear lenses with very close minimum focusing distances.
Autofocus (although this is not always effective).	Autofocus (although this is not always effective).	Autofocus (although this is not always effective).	Autofocus (although this is not always effective).
Note: macro lenses can extend considerably, and this must be taken into account when selecting a flat port.	Note: Close-up lenses capabilities extend into medium range photography – it is therefore a versatile lens.	Note: The usefulness of any zoom lens is determined by, and limited to, its minimum focusing distance and its close-range reproduction quality. Variables are for instance 20-35mm, 24-50mm and 28-85mm, the latter being the best choice.	Note: Housed wide-angle lenses can match Nikonos V 15mm lens image quality if the dome port is of high quality. Compare brand and compatible lenses but never sacrifice optical quality. Fisheye lenses have at least a 180° angle of view. Underwater the typical barrel distortion is less apparent.
n/a	n/a	n/a	n/a

• As the maximum working distance underwater is around 1.5m (5ft), lenses of short to medium focal lengths with maximum depth of field are best. This applies to wide-angle lenses too – their working distances can be as small as 15cm (6in)!
• The faster autofocus lenses are preferred for underwater photography.

EQUIPMENT FOR VIDEOGRAPHY

During the past few years video technology has brought about so many exciting changes so fast that it is impossible for any book to be completely up to date: video cameras progressed from 8mm and VHS formats to Hi-8 and SVHS. Then came image stabilizers, fancy effects, onboard titling, swing-out monitors, and three-chip processing. Today we finally have the acclaimed digital format. Thus, rather than concentrate on brand names, let us look at basic buying points that will help you to make an intelligent choice.

You must decide on format first, because this will influence your choice of both camera and housing; usually made by different manufacturers. Consider housings next as this will dictate whether favoured cameras are suitable.

FORMAT CHOICE

Camera format confuses a lot of people, but there are really only two factors that need be considered – quality and running time. **Compact VHS (VHS-C)** has been around for several years. It utilizes a compact cassette, which can be played on a standard domestic VCR (with an adapter). Its wide compatibility is the main reason for choosing the format. Its disadvantage is that it has less recording time than the 8mm formats.

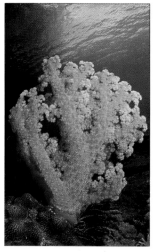

Soft tree corals make ideal beginners' subjects.

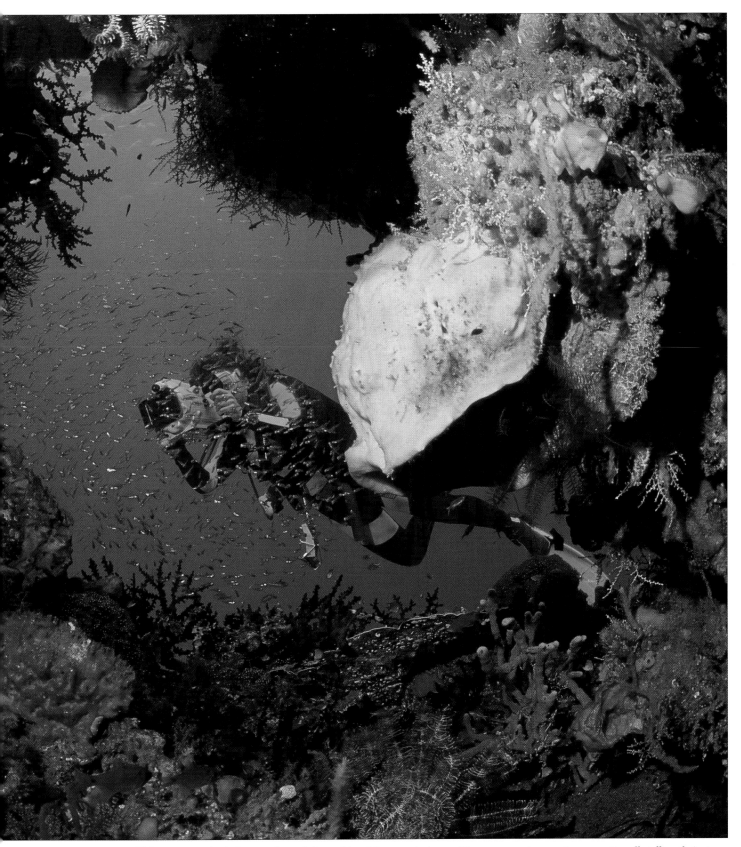

Video captures both the grandeur of the reef in all its complexity, and its many moving creatures, continually telling their story.

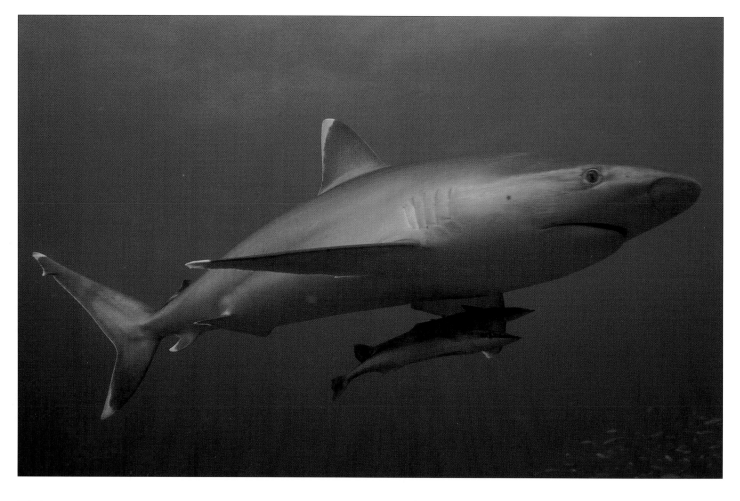

The impressive presence and dynamic movement of sharks make them coveted video subjects.

Super VHS-C is the upgrade. It retains the compactness of the cassette, but yields sharper pictures. Being a higher quality tape it has 400 lines of horizontal resolution in comparison to the 220 to 240 lines of the Compact VHS. While you can edit this tape to standard 8mm or VHS formats, you will lose the better resolution. To achieve the full benefit you must have a TV monitor that can play back 400 or more lines of resolution as well as S-video inputs and outputs for editing.

High Band 8mm (Hi-8) lifts the standard of 8mm in the same way. While the cassette size is retained, usually special metal tapes are used. The tape must display the 'Hi-8' designation, because Hi-8 cameras will automatically switch to and record in the lower 8mm format resolution for 8mm tapes. The higher resolution requires the same higher quality S-video in- and outputs and monitor, and Hi-8 compatible editing equipment to achieve maximum quality. However, even when used with standard equipment, the images off this tape will still be better than 8mm.

Three-chip processing is available for either of the latter two formats and improves colour by handling red, blue and green separately.

All these formats are analogue systems. When analogue signals are copied, they deteriorate with each generation, magnifying any shortcomings.

When **Designated Digital Format (DV)** was launched in 1995 the video world was changed forever. That it is supported by 50 manufacturers bodes well for the system. While it collects sound and pictures in the same way that other video cameras do, the processing method is vastly different.

Essentially, the digital camera splits the recorded information into millions of bits, allots each one a number value, either 0 or 1, and then compresses them. The system concentrates on the accurate or moving parts of the picture. Parts that remain the same (e.g. blue water) are condensed and unnecessary information is eliminated. Simultaneously the system splits the colour signal into red, green, blue and brightness and processes these separately – this

renders a cleaner colour signal, like that used for broadcast. So digital format in essence means:

- More subtlety and colour accuracy
- No colour bleed, even with reds
- A huge range of colour shades (up to 16.9 million)
- Much sharper pictures with finer detail
- Negligible jitter and drop-out
- A greater range of brightness
- A better sampling of sound
- 500 lines of horizontal resolution
- Smaller tapes.

The great advantage of this system is that, provided the video remains in the digital format, the information stays the same and can be copied over and over with virtually no loss of quality. While digital cameras are currently still expensive, their quality is so superior, that they are steadily gaining the video market – a trend that should soon put the format within reach of the 'man on the street'.

The **camera housing** market seems biased toward Hi-8, and I would not recommend going below this or Super VHS-C standard. If you already possess a video camera, check the required features before buying a housing. If you are serious about videography and can afford it – buy digital – it is superb!

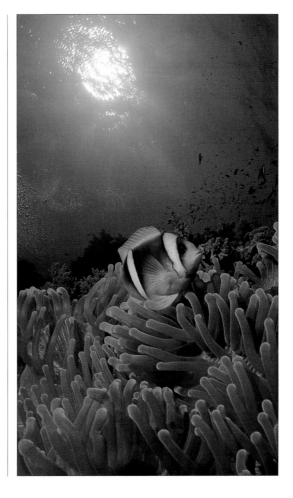

As the cheeky clownfish must remain in its anemone, it is a good subject for beginning videographers.

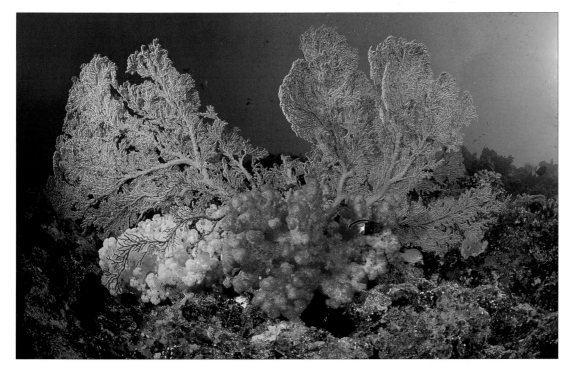

The camera must move around stationary subjects to retain the sense of motion necessary for the video format.

	VIDEO CAMERA HOUSINGS	VIDEO CAMERA
ESSENTIAL FEATURES	• Balance and buoyancy – loaded with the camera the housing should be almost neutrally buoyant, in a level shooting position. If it is not comfortable to hold, you won't be able to hold it steady. You should be able to hold the housing with one hand, keeping the other free for controls or support. • Size and weight – important for travelling. Bigger housings may adversely influence buoyancy, but tend to be steadier than small ones. • Ease of operation – accessible, easily operated basic controls. • Electronic controls should plug in via the remote control input, but these fail first when the housing is flooded, causing double repairs. • Mechanical controls which utilize push rods and gears are excellent on some housings, but in others may slip out of adjustment. Such housings are easily saved when flooded. • Viewfinder magnifiers are essential; don't buy top-mounted plastic framers or simple rear port windows. Check viewing a few centimetres in front of your face, while wearing a mask! • Wide-angle converters allow you to get close to, and still entirely capture, large subjects. Usually these are supplied with housings – the higher the quality, the better the resolution, the higher the price. • Exterior microphones pick up sound more clearly and avoid motor sound. To eliminate sound, plug camera microphone with a disenabled jack. • Connecting brackets for video lights must support the housing manufacturer's models – check mounting shoes or tap holes.	• A full-range autofocus macro lens allows automatic macro mode – preferable to standard lenses with macro mode that must be set and tied down, locking you in for the dive duration. • A minimum 8 x zoom lens capability. • Automatic exposure control; be sure to test exposure consistency. • Automatic white balance control with a choice of settings. • Variable shutter speeds – 1/60 to 1/125 suffices underwater, not topside. • TTL automatic focus is essential – don't settle for standard autofocus Sonic and infrared focus systems are defeated by housings and water. • Image stabilizer – not essential underwater, but super topside. • Electronic colour viewfinder strongly recommended for underwater as it considerably eases focusing and viewfinding of small subjects, while it rapidly indicates overly hot colour with correction filters and without video lights. • A large, easy-to-see, rear-positioned viewfinder, capable of being enhanced by a housing viewfinder magnifier. • Size and weight is important if you travel frequently. • Several batteries, as a fresh one is needed for each dive; consider charging times for multidive situations. Choose power and long running times (advertised running times are overoptimistic). • Back-light correction is essential for topside – even if housings do not support this.
DESIRABLE FEATURES	• Interchangeable flat ports for macro and dome ports for wide-angle for better resolution and versatility. Some housings are made only with dome ports. • A small LCD monitor is superb for viewing comfort, peripheral vision and especially for prescription lens wearers. They are not ideal in over bright conditions.	These features are supported only by sophisticated housings: • Iris override – allows manual exposure. • Gain control – boosts the video signal for low-light conditions, but adversely affects the image. • White balance hold – allows greater colour creativity. • Fade control and titling option – nice for topside, but usually not supported by housings. • Time-code generator – super for editing accuracy, but not all editing machines can read them!
RECOMMENDATIONS	**Economical range:** • Ikelite models and the Gates Guppy are excellent affordable choices. • Both Sony and Ikelite have easy to use and reliable models. The rugged Stingray system is excellent and extremely popular. **The sophisticates:** • Amphibico of Canada with electronically controlled housings for three-chip Hi-8 and digital cameras, plus a range of extreme wide-angle and macro lenses, monitors and lights. Due to electronics, these are sensitive and not ideal for faraway rugged conditions. • Sea & Sea's VX-1000 is specifically designed for Sony's DCR VX-1000, 3CCD digital video camera. • Gates Corporation makes a wide range of excellent and practical manual housings, also for digital cameras and the latest Sony VX3Pro, as well as accessories. The housings survive even the most rugged conditions without difficulty and are highly recommended. • Aquatica makes a housing of which the back is interchangeable for an SLR camera or a Sony video camera. There are, however, many more housing manufacturers and it is extremely important to research the market carefully before you buy.	

ESSENTIAL ACCESSORIES

VIDEO LIGHTS

- Compare lights made by the housing manufacturer with other popular models
- The lights should accommodate both close-up and wide-angle video
- Twin lights spread light more evenly than just one, irrespective of power
- Adjustable arms are essential
- Consider practical wiring connections, battery location and weight and ease of changing bulbs and batteries
- High output and long burn times are preferred but use up batteries rapidly or require larger, heavier batteries
- Compare burn and recharging times – you may need several chargers, plus voltage and plug adapters if you travel. Also ascertain whether output can be changed by different strength bulbs
- White light gives the best results

Other considerations
Compromises are usually necessary:
- The weight and complexity of some lamps may put you off
- Some models have wet plug battery connecters, but they are heavy and have long charge times

Recommendations
Light and Motion Industries manufacture several excellent models, both simple and sophisticated. Their flexible knuckle-and-joint arms are superb and are adaptable to almost every housing.

For easy, lightweight models, the Sunray cordless module that works off a popular quick-charging workshop-tool battery is hard to beat. It loads easily and can be removed and reattached under water. The 50-watt lamps, pushed brighter by reflectors, adequately illuminate all but the largest subjects. For long dives or large subjects two extras can be carried by a lighting assistant. They are problem-free even in rough conditions.

COLOUR CORRECTING FILTERS

Advantages
- Improve and maximize natural light and enhance the colour quality of underwater video significantly at certain depths.
- Rid the video of recording underwater colour-cast, but different filters are required for blue and green water.
- Function best between about 4m (13ft) and 20m (65ft) depth.

Problems
- Should not be used for close-up work with video light.
- Should not be used below 18m (60ft).
- Overcorrect in shallow water and bright light, causing a red cast if not removed. This also occurs when pointing the camera towards the sun. Accidental over-correction can to some degree be negated with modern computer editing techniques.

Other considerations
Colour filter models vary in practicality; the best one is a built-in swivel filter controlled by an external lever. The next best are external push-on or screw-on types, but they are not suitable for dome ports. The least desirable filter screws directly onto the camera lens. It cannot be removed when not required.

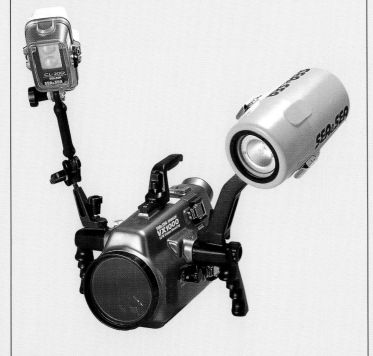

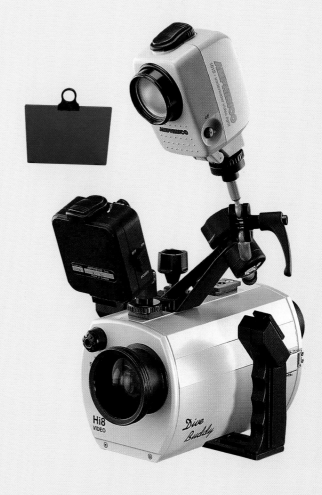

MAINTAINING YOUR EQUIPMENT

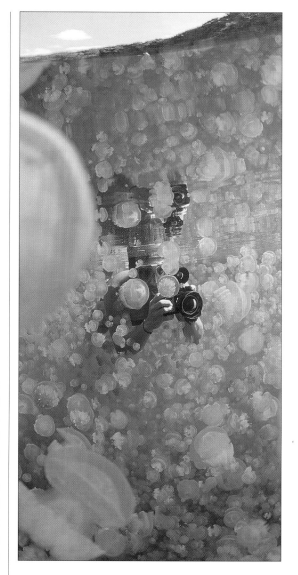

The marine environment is extremely hard on photographic gear and all photographers suffer from the consequences at one time or another. However, conscientious equipment maintenance adds years to the life span of a system and saves a considerable amount in servicing costs.

All metal parts inevitably corrode; we can only slow the process. **Corrosion** is exceptionally bad when connecting metals are mismatched. Disaster occurs whenever aluminium is combined with brass or zinc, while combinations that do work include aluminium with stainless steel or chromed brass.

• The greatest maintenance secret remains proper, careful soaking and washing in fresh water as soon as possible after every dive, preferably when everything is still wet and before salt crystals can form.
• After washing, dry all equipment thoroughly. Don't use high pressure air to do this – it may force water past O-rings into the camera. Don't fall into the trap of drying equipment without washing – not even if you are only changing film.
• Corrosion commonly causes seizing of threads and binding of parts. It is important to disassemble *all* nuts, bolts, controls, screw-in plugs and connecters, as well as any other attachments on cameras and housings after every day's diving. This includes trays, strobes, strobe extension arms and brackets.

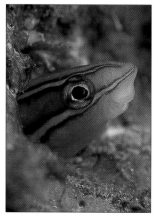

A Sabre-tooth blenny.

• Pay special attention to strobe socket plugs and battery compartment covers.
• Release all tension clips for storage.
• Always disconnect synchro-cords and dry and maintain them if you expect them to last. They are expensive and cannot be repaired. Unattended, they fuse faster and tighter than any other connection.
• Clean cord connecters with toothbrushes. Use one for greasy thread connections, another for cleaning the ends of the cords. Do not leave cords attached to the camera for any length of time. With too much flexing, synchro-cords eventually break down. Always carry a spare if you travel.
• Patiently remove fused screws with a repeated heating and cooling process, aided by a product such

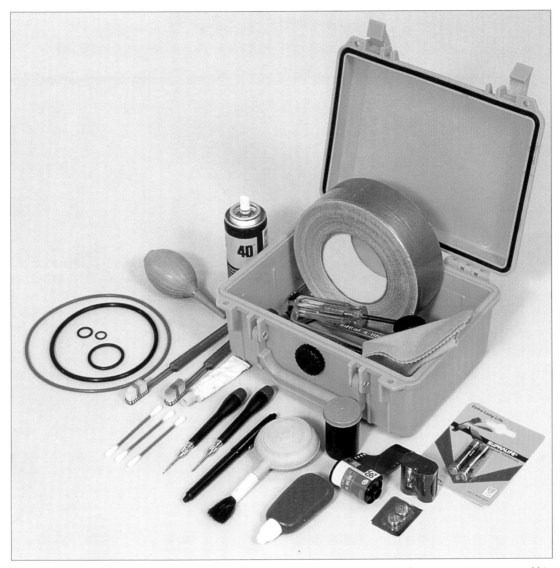

A typical camera maintenance tool kit.

as WD-40 and some gentle tapping of the screw head. Don't use excessive force, the screw may break and require expensive repairs. Drilling out screws from aluminium housings almost never works.

The secret of **O-rings** lies in understanding how they work with nature to provide a seal: as pressure increases and pushes against the O-ring or its seat, the O-ring flattens, creating a barrier. Since all O-rings need to be flexible to change from round to flat, keeping them pliable is the key to keeping water out of the camera system.

• Use the proper, prescribed lubricant; don't try to save money by using other jellies and unguents.

• Apply O-ring grease sparingly – it is a lubricant, not a sealant!

• Keep O-rings meticulously clean and free of lint or salt, and wash them from time to time.

• Do not poke out O-rings with sharp instruments: pinch them sideways between fingers to create a small loop by which they can then be lifted out.

• *Beware:* some housings have 'dry' O-ring seals that need never be lubricated at all!

• Remove O-rings during camera storage as they become flattened. Also remove O-rings for airplane flights, where it is preferable to use dedicated storage sets.

• Before use, check the main O-ring for hairs or lint before you close the camera back or housing door.

Right *Clean and maintain O-rings after each dive.*

Far right *A small amount of the recommended grease will keep O-rings sitting firmly in their grooves, and prevent them from twisting as the grooves slide into position.*

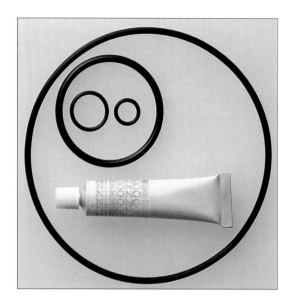

WHEN YOUR STROBE DOESN'T WORK

Electrical connections corrode much faster than any other parts exposed to humidity, making your strobe the least reliable piece of equipment of all. Such corrosion may cause unreliable firing or complete failure. The strobe may not recycle or batteries may drain despite recharging or replacement. Alternatively, wires inside the connecting cables may have broken.

Establish whether the fault lies with the strobe, camera or synchro-cord. Check strobe batteries with the recycle light, listen for whine when switched on, check battery charger and individual batteries, disconnect and test synchro-chord (multimeter), clean all connections, wiggle connected cables to test for broken wires. Once cables have flooded or broken, they must be replaced. Check camera for corrosion in synchro-cord plug.

• Keep O-ring grooves scrupulously clean. If they are really dirty, use a damp cotton swab. Add a drop of detergent to the water with which you dampen the swab. Then follow up with the folded corner edge of a paper towel to remove any potential fibres. Between dives a paper towel suffices.
• Do not grease O-ring grooves or surfaces around them. This merely traps sand and sediment.

How long do O-rings last? Nobody knows. Replace them at least once a year, sooner if you dive very often. If O-rings are not removed during storage, chances are they will need replacement much sooner.

Moisture of any kind is fatal to housings, cameras and strobes. You should be salt-free and dry before attending to your camera equipment. Amphibious camera users should learn to open (most) cameras with the lens up, to avoid stray droplets falling into the camera. I use an ample supply of well-washed, super-thin face cloths for drying and blotting up droplets and find them far more practical than unwieldy towels or tissues and toilet paper. They are easily rinsed, dry within the hour and off-duty serve as soft packing material for my lenses. On boats, camera tables are often situated on decks, exposed to salt spray. You may have to work out some sort of cover, or carry your camera inside, placing it preferably somewhere safe on a floor. This is also the safest place for a camera during rough crossings. Judge dive cruises carefully. If you feel frantic about your system's safety, you may have to share your cabin with it!

Flooding

Flooding is every underwater photographer's nightmare. Yet in 99% of cases, flooding is due to simple 'pilot error'. Common causes: hectic preparation, a dirty O-ring, an overly greasy O-ring, an overly dry O-ring, incorrect lubricating grease or incorrect closure. Concentrate during predive preparation and work on clean, dry, well-lit surfaces. The skiff to the dive-site is simply not the place to prepare a camera, although amazingly many photographers will try this – at least once. Test your housing without the camera before it goes on a dive (watch for a steady stream of tiny bubbles). If a camera or housing is going to leak, it will do so at low pressure, in the shallows, and then it will usually not fill in seconds. Watch your camera for leaks during the first 5 to 6m (16.5 to 20ft). Some housings have a leak-warning light. Leak detectors can be fitted to any housing.

If you see a leak:
• Don't panic – your life is more important than a camera.
• Switch camera and strobe off. Ascend safely and do not ignore the safety stop.
• Do not swing the camera about. If housed, tilt the camera backwards at 45° so the water collects in the bottom of the housing where it does least damage.
• If completely flooded, turn the camera on its back to save the lens.
• Once you are out of the water, remove all film, batteries/tape and leave the compartments open.
• Remove the camera lens, check for water damage.

• Inspect viewfinders (SLR). If undamaged keep the camera horizontally upright.
• If the camera is completely flooded, it is probably not salvageable. Rinse in fresh water and dry with a hairdryer or leave in natural air and get it to a service facility.

Sometimes one does not notice a flood. There are several bad signs you can encounter after a dive:

• The film does not advance smoothly (the film emulsion may be swollen with moisture).

• The flash won't fire or self-fires (the flash contacts are damp).
• You see water droplets in the viewfinder, lens port or counter window.

In such cases, turn off all the electronics. For Nikonos V set the dial to M, and switch off the strobe. **Strobes can produce fatal voltages and currents. When flooded, strobes should be switched off immediately and should not be opened unless you know what you are doing.** Capacitors may still be charged, even if batteries are disconnected.

MAINTENANCE MATERIALS

Maintenance materials are cheap, easy to find and simple to use. Most are small enough that an adequate supply can be kept, preferably in a dry plastic container with an airtight lid. A big bucket or tub is essential for soaking and washing away from home.

• A small bowl for soaking salt off O-rings
• Cotton-tipped swabs
• Scuba (or food) grade silicone spray which will not affect rubber or plastic (do not spray directly onto O-rings)
• A product like WD-40 for using sparingly on metal-to-metal fittings. (Must not come into contact with O-rings or the camera shutter!)
• Electrical contact cleaner. Be sure that it is a type that will not affect rubber or plastic (radio and electronics stores)
• A toothbrush
• A soft medium-sized synthetic paintbrush (art stores)
• Lens blower, lens cleaner and lens tissues – approved type only for coated lenses
• O-ring grease/lubricant
• Spare O-ring set for camera/housing.

In addition, travelling photographers should carry:
• A small set of high-quality, tempered steel screwdrivers that will fit the appropriate screws
• Philips head screwdrivers sizes 00, 0 and 1
• Pair of fine needle-nose pliers
• Pair of fine pliers for holding nuts and screws
• Watchmaker's tweezers
• Insulation tape
• Silica gel
• Pencil with eraser tip (for cleaning battery contacts)
• Spare strobe/underwater lamp bulbs
• Spare camera batteries
• An electrical multimeter
• Small soldering iron for releasing fused screws
• Duct tape (waterproof and has a multitude of uses).

Above left If you cannot remove an O-ring with your fingers, then use something like a credit card, rather than a sharp instrument.

DIVING WITH A CAMERA

The single biggest hurdle in the successful pursuit of marine animals, and indeed good photography, is the diver. If you are still flailing around in the water, you are not ready to take up underwater photography, for no matter what system you choose, you, the photographer, are the central accessory.

LIVE TO DIVE ANOTHER DAY

Unlike land photographers, divers are limited by factors like bottom time, safety rules and air and film capacity. In fact, not only do we leave our natural sphere for an alien and sometimes unpredictable one, we very often dive and photograph in conditions under which land photographers would simply pack up and go home!

Once engrossed by their subject matter through a camera lens, a photographing diver becomes a solo diver *par excellence*, and through his distraction, necessarily turns his buddy into one too. This is all the more reason to be extremely self-sufficient and comfortable in the aquatic realm.

First master the skills of diving – be sure of your abilities and adept with your diving equipment. With good dive training the foundation is laid, but experience is crucial and can be attained only by repeated diving in differing conditions. You must be in perfect control of your buoyancy, be familiar with your

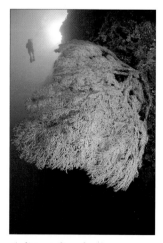

A distant diver lends a sense of scale to an image.

buoyancy compensator (BC), be correctly weighted and be able to fine-tune buoyancy with controlled breathing. You must know how to move around quietly, without stirring up sediment and you must be able to maintain an in-water hovering position for some time. Photography requires a great deal of concentration, making it imperative for safety procedures to become completely automatic. Only then can a camera enter the equation.

There is not a single photograph that is worth a diver's life!

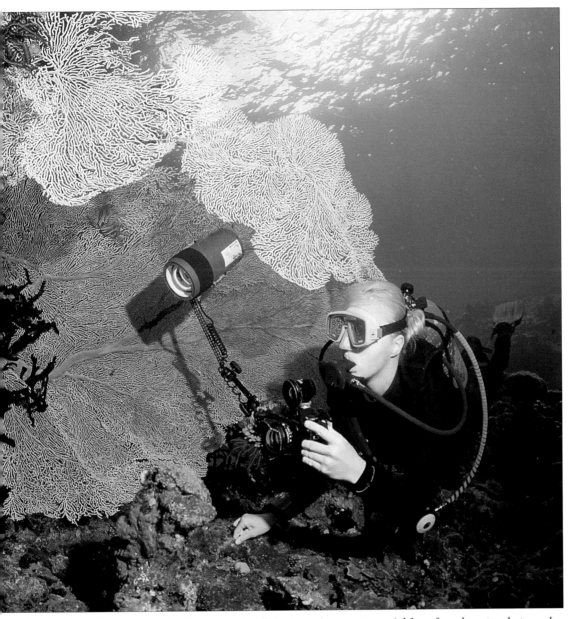

Good diving skills, streamlined diving gear and sufficient experience are essential for safe underwater photography.

THE DIVING ENVIRONMENT

The experienced diver should be able to accurately judge underwater conditions. A photographer must also be able to find almost invisible layers of life on a reef. An acute awareness of how reef life is interwoven and how different marine species habitually behave is essential for finding animal subjects and estimating their reactions in advance. Incredible opportunities often occur lightning fast. Your prior knowledge helps keep you prepared at all times.

On your dives you will come across a wide and complex range of connected environments: such as the shallows, depths, walls, reefs, reef floors, caves, grottoes, and tunnels. Each contains specialized creatures and organisms, adapted to place, background and circumstance. But each species is also inextricably linked with the entire reef, dependent upon factors such as sunshine, temperature, currents, winds, and available nourishment.

Do not disregard other great photo opportunities in tropical waters. Lesser known seagrass meadows, mangrove-lined bays and sandy flats are filled with treasures uniquely their own. When diving off boats, the big, open blue sea broadens your repertoire with

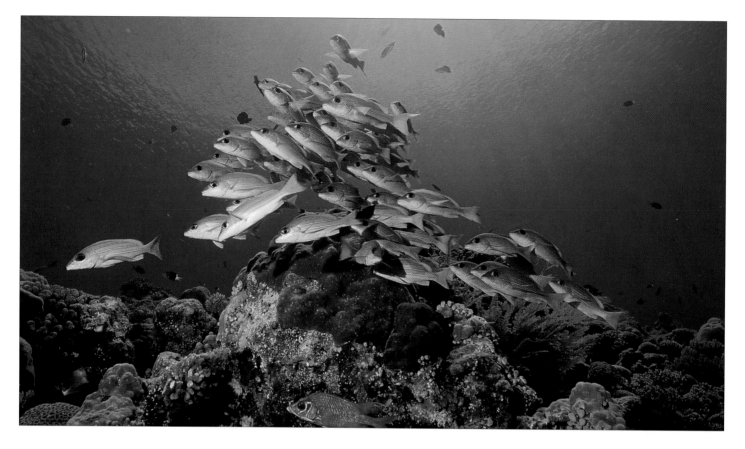

It is prudent to be comfortable in currents when diving at the edges of reefs.

its own mysterious, free-drifting life forms and, on occasion, behemoth nomadic inhabitants.

Large animals and pelagic schools always collect where currents strike reefs and create abundant feeding opportunities, making it prudent to learn current-diving techniques. Dawn and dusk dives reveal entirely new creatures tied up in the urgency of changing shifts. This is often the preferred time for courtships. Night dives add thousands of crustaceans and a range of other subjects that are never seen by day, while sleeping diurnal inhabitants can be very closely inspected and photographed.

You probably either love or hate wreck diving. See wrecks in a new light. Far from offering only a 'dead ship' survey, wrecks are frequently isolated isles of life in an otherwise barren ocean. When a wreck provides the only protective habitat around, strange partners, neighbours and associations may occur. As these self-contained 'artificial reefs' are much smaller and more compact than their natural counterparts, they may present much greater opportunity for diversity and close encounters. With some care, marine animal shots need not even show a hint of wreck at all!

Make sure that you know, investigate and research each environment for its unique marine life styles and photographic opportunities. Videographers have few problems with selecting their equipment, but still photographers must anticipate the potential and preselect the correct lenses, strobes and techniques for the shoot, before they enter the water.

Whether on land or in the ocean, both wildlife and wildlife photographers avoid the crowds. Groups, roaring bubbles, rapid movements and flailing arms are terrifying to marine life. Move completely away from other divers and ensure that your buddy knows to stay behind or above you at all times. Learn to breathe slowly and rhythmically, releasing only gentle bubble streams. Never skip-breathe – it is unsafe diving practice and results in noisy, uncontrolled bubble bursts. 'The more eyes, the more subjects' is a statement that can turn into a two-edged sword. While co-divers can be helpful in spotting subjects, they can become extremely irritating too. Make sure to inform them beforehand of your subject requirements, to avoid distracting 'finds' that you have no desire to photograph.

A PHOTOGRAPHER'S BUDDY

Diving as a photographer makes you different to all other divers. This has great bearing on your choice of a buddy. On the hunt, most photographers prefer to dive solo, especially when stalking shy subjects. Others become dependent on their buddies almost to the point of being unfair and rude.

Each photographer wants different traits in their buddy – but it is important for both parties to be aware of the raw facts: buddies have to be 'experts' in their own right, an attribute for which they are very rarely thanked or praised.

A photographer's diving buddy:
• must be patient while the photographer stalks their subject, often over long periods
• must have good 'spotting' abilities and should be knowledgeable about animal behaviour
• must know which subjects deserve immediate attention, and which ones can wait
• must develop well-understood signals to convey subject matter and urgency
• must be able to help herd and gently coax animal subjects for the camera
• must have the competence and gear necessary to function as an all-round model
• must be able to interact photogenically with marine life when modelling
• must be willing to be camera- or tripod-bearer and lighting assistant
• must have good diving skills, be self-sufficient and never stir up muck or scare marine life away
• must take charge of monitoring air consumption, bottom time and safety measures.

Provided that important issues have been sorted out in advance, diving photographers can team up to great mutual benefit. A permanent pair could, for example, decide to concentrate on two different techniques like macro or wide-angle photography.

A buddy can simultaneously carry an extra camera and be your model.

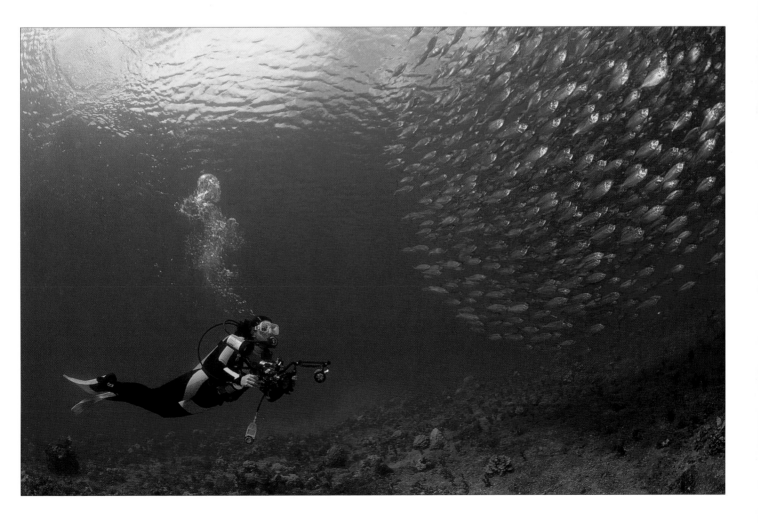

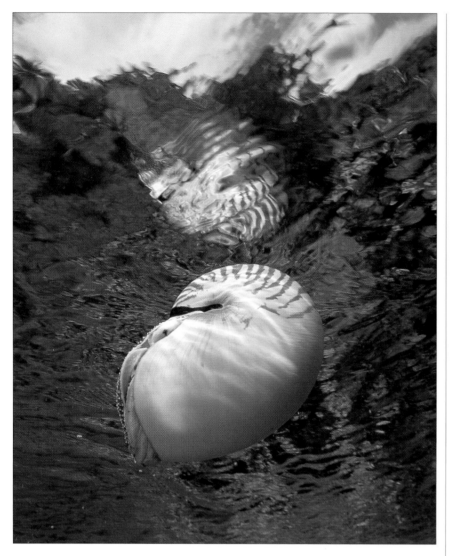

Above However serene it seems, the underwater realm remains alien, and calls for advanced diving skills before you begin to photograph it.

This helps avoid conflict and aids in building a wonderfully diverse combined portfolio. Buddies who have compatible equipment may have a wider lens variety to work with, if techniques are switched fairly. Each buddy can help 'herd' subjects toward their partner and simultaneously function as their partner's interacting model.

WATER – THE ALIEN ENVIRONMENT

Problems are not as easily solved underwater as they are on land. Water is an alien environment in which we are connected to transportable breathing air. We have to wear masks and can't see as acutely as we do on land, nor locate where sounds originate from. We must master controlled descent and ascent, as well

as comply with safety rules. It is only prudent to carefully consider and manage an additional burden like photography.

It would really be rather silly to enter the water without knowing where camera controls are or how your camera works. The only place to learn these skills is on dry land: you must be able to employ all camera controls by feel alone.

Never jump into the water with your camera – lenses can rip off and O-ring seals dislodge. A camera must either be handed down by somebody or placed where you can comfortably reach it after entry. When diving off platforms or inflated rubber boats, lower the camera into the water with one hand and only then roll gently off the edge.

As well as the occasional wave slam, fast skiffs and rubber boats cause strong **engine vibrations**, especially along the floor – yet this is the favourite space for cameras on the way to the dive site. If possible, lift at least the bulk of your camera off the floor once you are seated, perhaps resting it against a leg to help absorb vibrations and any unexpected shocks. While it has not been proved conclusively, there is some suspicion that engine vibrations are capable of dislodging O-ring seals.

Because they can be dangerous, **neck straps** and all but the smallest **lanyards** that keep filters and viewfinders safe, should be avoided at all costs. Somehow they always float and get in the way underwater. Cameras that are lugged about on straps easily bump into fragile corals, damaging both the reef and the camera.

Your camera should be held with your hands, ready for instant use. In emergencies camera neck straps, difficult to untangle and ditch, could cause you to drown. You must always be able to drop everything, at once!

Most of the time, the chances of finding and retrieving your camera intact later are good, unless you were diving over an abyssal drop-off. Never-the-less, be psychologically prepared for such a sacrifice – after all, **unlike your life, your camera can always be replaced**.

Also remember that your camera system does represent some of your weight – important for perfect **buoyancy**. On the other hand, you will become too buoyant should you drop your camera, and then you must immediately vent air from your BC to avoid embolism.

UNDERSTANDING LIGHT

Light is pivotal to photography. Indeed, photography is often described as 'painting with light'. This principle also applies underwater, but with some important differences as water is 600 times denser than air.

LIGHT ABSORPTION

Water absorbs much more light than air, both vertically and horizontally. This causes around 60% of all photographic errors. But water also reflects light and is influenced by surface conditions, the angle of the sun and the time of day. Midday light is often best. This is also when the sun is ideally positioned for inclusion as a compositional element.

LIGHT DIFFUSION

Water density diffuses light – a factor aggravated by the presence of tiny suspended particles, even in the clearest water. These not only absorb light, but create underwater photography's most bothersome problem – backscatter. The more suspended particles, the more apertures must be opened to capture light, or the closer we must move to our subject.

LIGHT REFRACTION

A further anomaly caused by water is refraction – the bending of light rays as they pass from air to water. Water's refractive index of 1.33 causes it to magnify by one third – subjects appear both larger and a third closer than they really are. In underwater photography this presents us with the illusion of **apparent distance**. Remembering this can probably eliminate another 20% of photographic errors.

SELECTIVE COLOUR REFRACTION

Sea water acts like a huge blue-green filter. As depth increases colour is lost – starting at the red end of the spectrum until indigo and blue are all that remain. This can only be remedied by artificial light and close distances. Carry a torch to reveal to you the colours your strobe will illuminate for your photographs.

Absorption, diffusion and refraction all decrease contrast underwater. For the camera this translates into flat images and a loss of sharpness – remedied only by moving closer to the subject, into shallower water, or by introducing artificial light. The cardinal rule for good underwater photography is therefore: get rid of the water! This simply means getting close to your subject. The distance meant by 'close' never fails to surprise beginners. To attain sharpness and rich, vibrant colour, a photographer should be closer than 1.8m (6ft) to the subject! Most images are taken with mere centimetres between subject and lens.

Below left At depth, artificial light is necessary to replace colour and enhance the detail.

Below In order to maximize colour, underwater photographers must work at surprisingly short distances from their subjects.

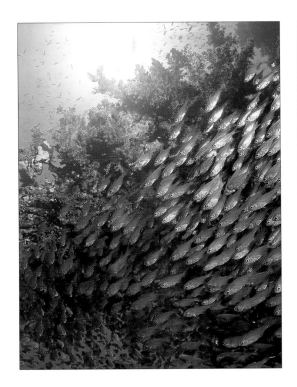

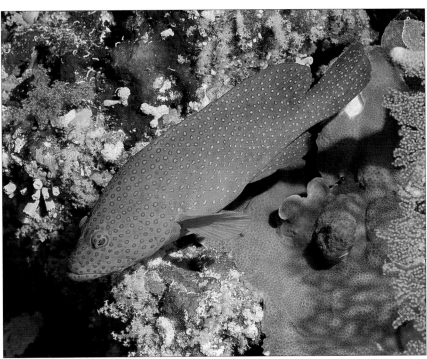

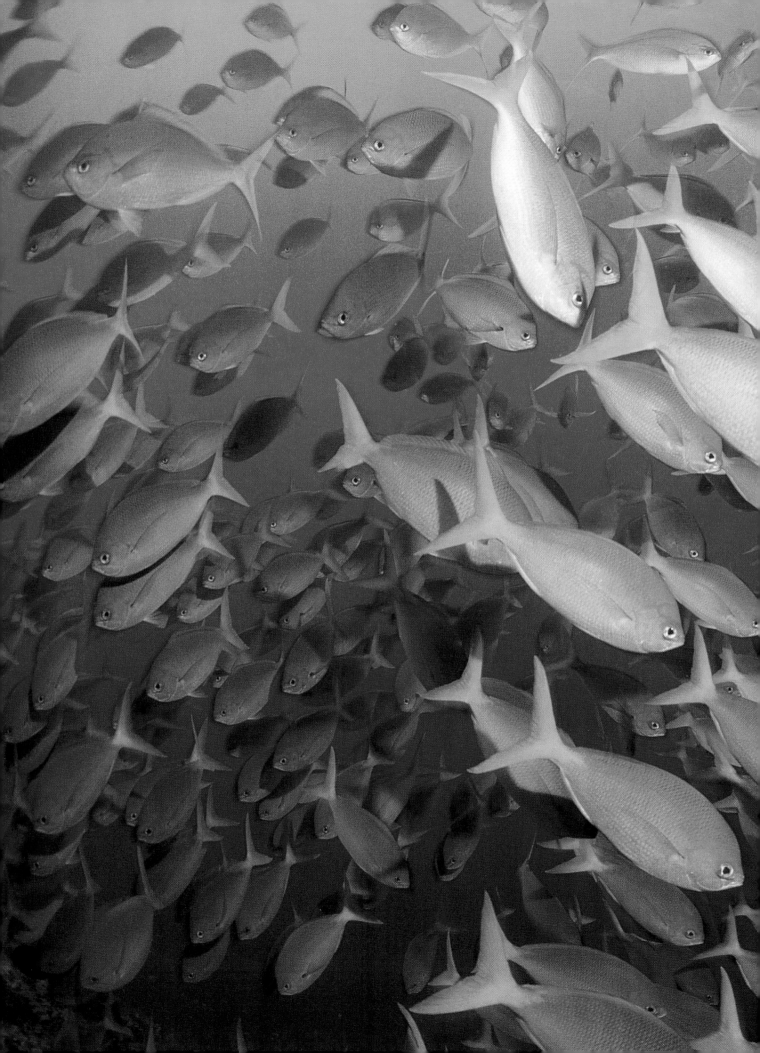

STILL PHOTOGRAPHY

CONTROLLING YOUR CAMERA

It is logical to expect that there is one photographic method that is better than all the others – a standard recipe or approach. Some simple formulas do exist, and on average they give reasonable and sometimes even excellent results.

But very soon taking *some* good photographs will not be enough. Also, formulas are based on average conditions that may not always apply. To consistently attain successful images, you must understand both your camera features and exposure. These basic photographic fundamentals enable *you* to control your results and ultimately will expand your photography into a creative, individual style.

The technical part of taking an underwater photograph is based on a combination of factors. Most can be controlled entirely by the photographer operating in the manual mode. These include: the lens aperture, shutter speed, film speed, focus and depth of field, together with the brightness or reflectivity of a subject and the brightness of your light source. Combined correctly they deliver what is known in photography as 'a correct exposure'.

What is more, once understood, these technical factors can be juggled to obtain results vastly superior to the norm of automatic 'correct' exposure. Even if consistent quality is not important to you and you prefer formulas, this chapter will still benefit you when evaluating results. It supplies all the information needed to correct errors and solve problems.

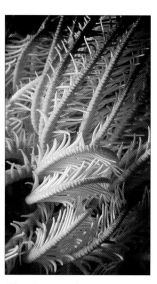

The photographer must become adept at picking out delicate, beautiful detail.

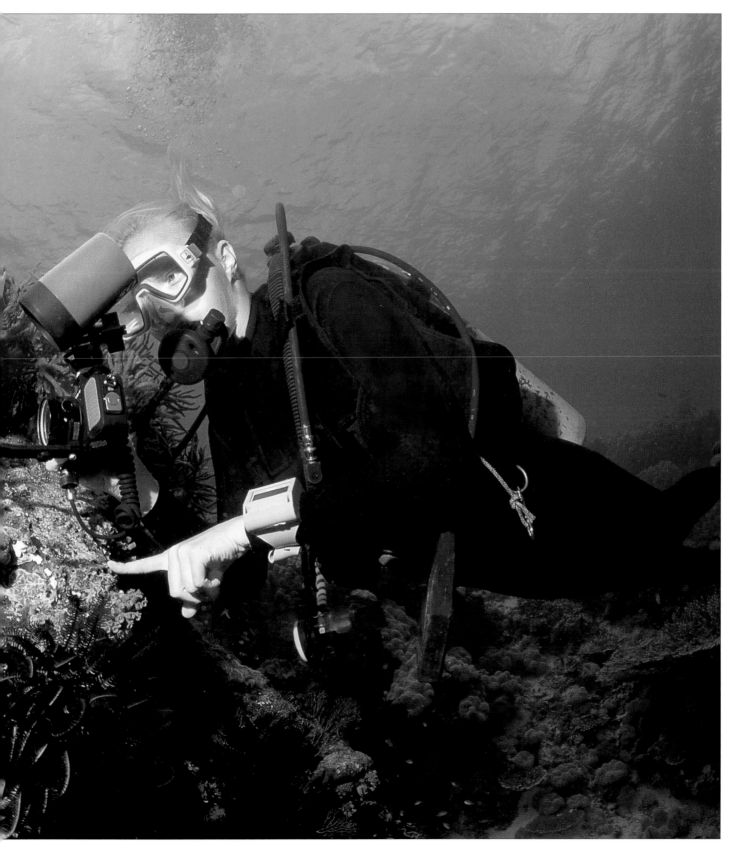

Even in among fragile corals, environmentally friendly photography is possible. Steady yourself with just one fingertip on a dead patch.

APERTURE

The word aperture simply means 'opening'. In photography, aperture refers to an adjustable iris-type **diaphragm** which can be set to control the size of the opening through which light passes to reach the film. The diaphragm thus determines the amount of light that will reach the film.

Camera apertures are made larger or smaller in precisely calibrated steps, to let in a precalculated amount of light. This allows calculable adjustments to be made for differing light situations underwater. Each adjustment is given a numerical value. These are called **f-stops** and they are marked on every lens, usually in a sequence like this:

f/2 f/2.8 f/4 f/5.6 f/8 f/11 f/16 f/22 f/32

Here the smallest number – f/2 – represents the largest opening. The largest number – f/32 – represents the smallest opening. This may sound illogical, but the numbers are obtained by dividing the focal length of the lens by the width of the aperture. (The numbers on your lens may differ from the example.)

Starting at the smallest number f/2 (or f/2.8) and while looking at the diaphragm in the lens, turn the aperture to f/4. The opening has become smaller.

With this one single click, you have *halved* the amount of light that can reach the film. This process repeats itself for every f-stop you advance, always *halving* the amount of light allowed in by the previous stop. This reduction in aperture size is called 'stopping down'. If you reverse the process, progressively turning from f/22 or your highest aperture number to each lower numbered f-stop, you are *opening* the aperture. Each stop opened will *double* the amount of light allowed by the previous f-stop. Enlarging the aperture is called 'opening up'.

Aperture sequences like that above are called consecutive **full stops**. But, in between full f-stops there are fractional, partial or half f-stops:

f/2 **f/2.4** f/2.8 **f/3.3** f/4 **f/4.8** f/5.6 and etc.

In some lenses the widest aperture may be a fractional or partial f-stop. The Nikonos 35mm lens for example, displays an extra aperture, f/2.5, while the 28mm lens has an f/3.5.

Many lenses do not indicate fractional stops with numbers: some merely show a little dot, others nothing at all. They are there nevertheless and can be used! In writing, a fractional f-stop between f/8 and f/11 may be expressed as f/8-11.

Exposure control can be manipulated to deliver a myriad vastly different results for the same subject.

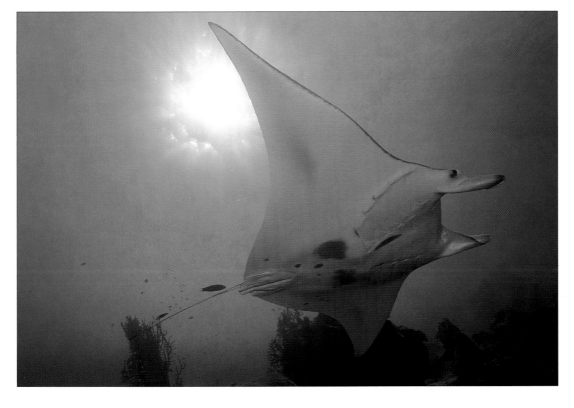

Both the underside of this manta ray and the correctly exposed brilliant sunburst have been captured here, through employing a correct aperture and shutter speed combination.

We set apertures to interpret light intensity for the camera, and change them for differing intensities or to attain different effects. Apertures can also be used to increase depth of field in photography, especially in close-up work. In general we make use of just a few aperture settings in 'normal' underwater conditions, and for this reason they become very easy to remember.

SHUTTER SPEED

While the aperture controls the *amount* of light that reaches the film, the shutter speed controls the *length of time* that light is allowed to fall on the film. The speed at which the shutter operates will also determine whether any movement of either the subject or the camera is 'frozen'. Shutter speeds are also indicated in numbers, but this time in fractions of a second. A typical sequence looks like this:

FAST						SLOW
1/500	1/250	1/125	1/60	1/30	1/15	1/8

At *slow* shutter speeds the shutter stays open for *longer*, lengthening the time for which light can fall on the film. Each new setting up the scale *doubles* the shutter speed, thereby *halving* the time for which light can fall on the film. What is important is that **the difference between each shutter speed is also equivalent to one f-stop of exposure**.

Slow shutter speeds allow more time for light to strike the film in low light situations, although the camera or your arms may have to be steadied. They also allow a longer time for things to go wrong: you could move because of a surge, or fish could move past your lens. Either will cause **blurring** on your picture. So, we normally photograph at at least 1/60th second (*see* page 64). We can, however, deliberately create artistic blur – to attain a feeling of motion or exclude a confusing background. Faster shutter speeds are used for fast moving subjects.

As a rule for hand-held pictures, **the shutter speed number should not be drastically slower than the focal length of the lens used**. For a 35mm lens, the recommended minimum shutter speed is 1/30 or faster; for a 55mm lens, it should be 1/60 or faster and so on. Slower shutter speeds in these situations always significantly increase the risk of blur and the camera must be kept very steady. Even tripods do not invalidate the rule, as the environment contains moving creatures that will register as a blur when they pass the lens while the shutter is open.

DEPTH OF FIELD

It is important to understand the concept of 'depth of field', for it relates directly to the sharpness of a photographic image.

However, depth of field sharpness is different from sharpness obtained by focus. As depth of field is a factor with which there is very little room for error, it is important not to confuse the two! You could have an 'in sharp focus' subject, but still have an image lacking sharpness because your subject fell outside the depth of field.

Depth of field and its relation to focus sharpness can be explained by demonstrating on a fish subject that, for teaching purposes, will sit obligingly still:

When you focus on the fish at a given distance, there is **one specific point** or plane at which the lens focuses in pin-sharp focus. For animal subjects photographers usually choose to position this point at the eyes. Were the fish simply a flat slice and evenly distributed across this plane of sharp focus, we would have no problems. But, of course, the fish has considerable body bulk – both sideways and, more importantly, from nose to tail.

Thus the face of the fish will partially stretch in front of, and the body partially beyond, our ideal sharp-focus plane (the eyes). Additionally, we usually include some foreground and background to our subject, unless it is a close-up portrait.

Theoretically this implies that we can only attain partial in-focus sharpness on any image, but fortunately this is not so. There is a significant area both in front of and behind the eyes of the fish, which is still perceived as in focus. The entire 'thickness' of that space or area is a **safe focus area**, known as depth of field.

Factors affecting depth of field:

• the aperture we use
• the size of the picture area
• the subject-to-camera distance.

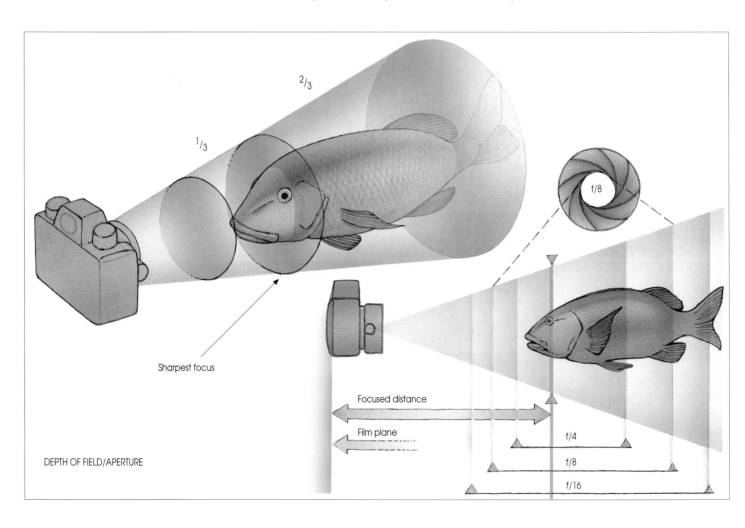

Sharpest focus

Focused distance

Film plane

DEPTH OF FIELD/APERTURE

f/8

f/4

f/8

f/16

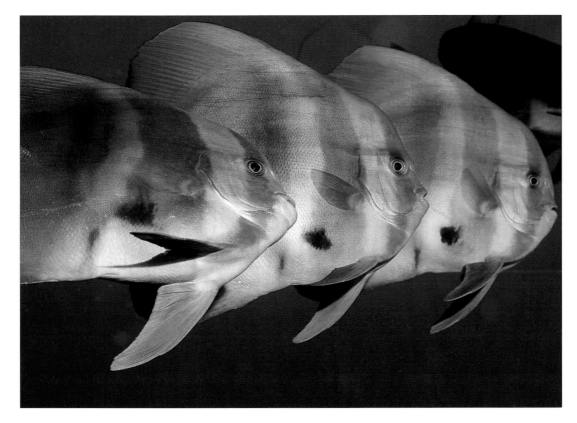

Place sharp focus on the middle batfish, and the parallel planes of all three batfish allow them all to be included within the lens's depth of field.

This is how depth of field can vary:

1. The higher the f-stop (smaller aperture), the greater the depth of field, and vice versa.
2. The larger the picture area, for instance in wide-angle photography, the greater the depth of field, and vice versa.
3. The further the focused distance, the larger the picture area and therefore the greater the depth of field, and vice versa.

Let us return to our imaginary depth of field 'slice'. Objects that fall outside this 'thickness' are not cut off suddenly. Loss of sharpness occurs quite gradually, increasing as parts of the subject or its surroundings gradually fall further outside both the **sharp focus plane** and the **safe focus 'thickness'**.

This happens because light reflecting from outside the focal range of the lens arrives at the focal film plane in blurry, unfocused circles instead of sharp focused points. Called **circles of confusion**, these can cause those soft, out-of-focus areas in images. If they also pass through the lens at its edges, they must be bent even further in an attempt to become focused. In the extreme, they show up as visible, disturbing circles. We avoid or reduce soft focus problems by excluding light rays from the margins of the lens – quite simply by *reducing the size of the aperture*.

Although smaller apertures provide more depth of field, a reduction in aperture size also reduces the amount of light that reaches the film. On land this can be corrected with longer exposure times, but underwater long exposure times are impractical and besides, when apertures become too small, they once again introduce new aberrations.

For practical purposes f-stops are thus limited to f/32 on most cameras and on some even to f/16. The trick is to compromise – you balance all other factors with aperture so that you get both a well-lit and in-focus picture.

However, when you add a **strobe** to light your picture, its light is not only closer to the subject than ambient natural light, but also brighter. This enables you to use a smaller aperture, which in turn means more depth of field!

Depth of field becomes crucial in **close-up** and **macro** photography as it drastically decreases the closer we get to a subject, even while shooting at f/22. The distance from lens to subject is, for this

reason, equally important. For Nikonos users these distances are precalculated and determined by the distance rods mounted with the macro and close-up kits, each matching a specific converter and thus attaining the optimum depth of field. The boundaries of the corresponding framer only *approximately* indicate the sharp focus plane and must be tested for accuracy. Keep in mind that different distances will dictate how much the depth of field extends in front of and behind the frame boundaries.

With a housed SLR camera these extremely small depths of field and varying lens-to-subject distances also apply, but are handled very differently. This is discussed (*opposite*) in the section on focus.

While the **depth-of-field to focus ratio** with lenses is usually divided into one-third in front of the sharp focus plane and two-thirds behind it, this drastically changes in extreme close-up, because of the very small distance involved. For example, a lens focused for a 1:1 image will have half the depth of field on the near side, and the other half behind, the sharp focus point.

Depth of field can be influenced or manipulated be means of adjusting your aperture. Indeed, aperture may at times become quite critical, because light levels underwater are so much lower.

You can also use the depth of field concept and its limits to help you to place the sharp point of focus anywhere you choose. While limited in application for the Nikonos V macro set-up, it is this option that gives SLR cameras superior flexibility in macro photography.

When a fish faces the camera in a full-frontal position, its nose could extend well forward of its eyes, as will the tentacles of an approaching cuttlefish. When such forward extending parts *exceed* the depth of field area present in front of the sharp focus point, undesirable out-of-focus softness occurs where the subject is closest to the lens. With long-snouted subjects like crocodilefish, this can become an almost insurmountable problem.

The trick is to move your sharp focus point forward of the eyes, so that the protruding part of the face falls within this partial depth of field. The eyes and major part of the subject will then still fall in the safe area behind it. Thus, the bulk of your subject will appear 'in focus'. Any visible softness will occur gradually and acceptably – towards the rear of the subject image.

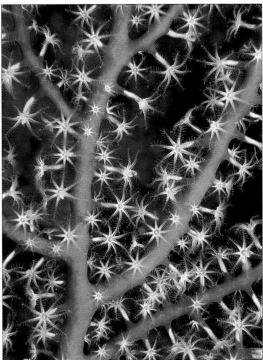

Left Prelocked focus applies to both the Imperial shrimp and the coral polyps. This leaves you free to compose and refine focus before you release the trigger.

Opposite Macro depth of field is extremely small. Placing sharp focus on the goby's eyes 'pushes' soft focus toward the background.

PARALLAX ERROR

The wide-angle lenses of the Nikonos system are used in conjunction with special view-finders. These viewfinders are top-mounted on the camera and slightly tilted. Nevertheless, there is a marked difference between the images the lens and the viewfinder 'see'. This aberration occurs with all non-reflex cameras. The difference – called 'parallax error' – is negligible at further subject distances, but increases trem-endously with close distances. This must be consciously cor-rected to avoid excluding large parts of the image.

The 15mm viewfinder is marked with frames for specific subject-to-lens distances: 0.3m = 1ft; 0.6m = 2ft; and 1.5m = 5ft. The latter is used for any dis-tance from 1.5m (5ft) onwards. To the uninitiated, these mark-ings can be confusing, but the problem is soon overcome by understanding how to correct parallax (*see* page 59).

FOCUS

Old-fashioned fixed lenses were focused by moving the camera toward and away from the subject until it was seen as sharp. Technology drastically changed that. Even so, there is still a marked difference be-tween focusing with a viewfinder camera, such as the Nikonos V, and a housed SLR camera.

SLR LENSES

In **modern SLR cameras** lenses or their elements can be moved until an image appears 'in-focus' in the viewfinder. In macro/micro, the lens barrel extends for close focusing and retracts for wider focusing. This also means that you can preset focus for a required distance and fine-tune focus once it is reached. You will thus only have to move if you want to recompose the picture from another angle or distance.

You can focus and fine-tune manually, or auto-matically if you have autofocus lenses. Sophisticated cameras offer several focus modes: continuous focus, single-shot focus priority and motion- (trap-) triggered freeze focus. These can make the life of an underwater photographer easier, but they are not necessarily the most creative or effective methods.

Nevertheless, the old **fixed lens** focusing method is still used, especially in situations where marine life is extremely nervous. This is done by focusing on a fixed surrogate subject, at a distance you expect to attain with the real subject. You lock this focus in by keeping the shutter release *halfway* depressed. When you reach the planned distance, fine-tune focus by gently shifting the camera to and fro until the subject appears sharp in the viewfinder.

This method is called **prelocked focus** and is extremely useful in several tricky situations where constant refocusing would be impractical or even impossible. Autofocus lenses, for example, tend to hunt in low-contrast situations. By 'locking' focus on another contrast-rich subject, you can move the camera to the actual scene and shoot.

For **SLR macro lenses** a new equation appears: *magnification vs. distance.* It is important to under-stand that, irrespective of the lens used, the depth of field at a given aperture will remain the same, if the rate of magnification is the same.

The illustration overleaf demonstrates clearly that three macro lenses with different focal lengths will deliver identical photos for the same magnification rate. What differs is that the longer focal ranges allow greater distances between lens and subject. However, when the same three lenses are placed equidistant from the subject, their rates of magnifi-cation increase with focal length.

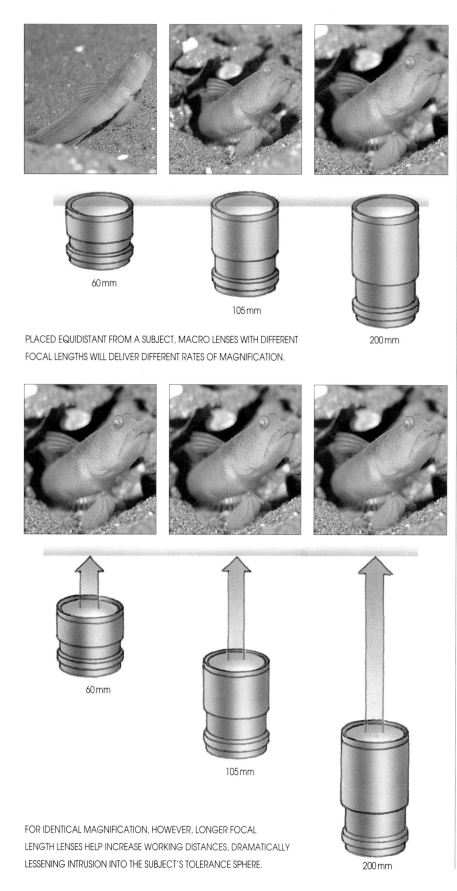

PLACED EQUIDISTANT FROM A SUBJECT, MACRO LENSES WITH DIFFERENT FOCAL LENGTHS WILL DELIVER DIFFERENT RATES OF MAGNIFICATION.

FOR IDENTICAL MAGNIFICATION, HOWEVER, LONGER FOCAL LENGTH LENSES HELP INCREASE WORKING DISTANCES, DRAMATICALLY LESSENING INTRUSION INTO THE SUBJECT'S TOLERANCE SPHERE.

Your choice of a specific focal length must, for this reason, match your subject – and, if it moves, your ability to approach it successfully.

If colour is richer and crisper the closer you are, increasing distance logically leads to a loss of colour saturation. On the other hand, this may be necessary for capturing extremely skittish creatures.

So, while 50mm and 60mm SLR macro lenses can take care of a wide range of situations, they can become as intrusive as framers at distances of 30cm (1ft) or less. A magnification ratio of 1:1 is extremely difficult to attain if the lens must be placed within centimetres of the subject. Your lens port may also block out your strobe light. This situation calls for longer focal length 100mm, 105mm and 200mm lenses that will allow the same composition from a greater distance, with better illumination and without scaring the subject away.

There are three ways to focus macro lenses:
• You can use **autofocus**, in which case the sound may scare shy creatures. Autofocus also limits the control of changes in magnification ratios.
• You can focus **manually** by manipulating the focus control lever until sharp focus is acquired.
• The third, and indisputably best, method is to **use the autofocus lever as a compositional tool** to attain the precise magnification ratio and image size you want. Then move the camera forwards and backwards until the subject 'pops' into focus, and refine by positioning the sharpest point of focus exactly where you desire.

As precision of composition is so coveted and the placement of the point of sharpest focus so crucial to macro photography, it would be silly to surrender manual control for the comfort of autofocus. Remember that an actionfinder will considerably ease viewing.

THE NIKONOS V

With manually focused viewfinder cameras such as the Nikonos V, all this changes dramatically. The Nikonos V does not, in fact, focus in the traditional sense at all. This is confusing for anybody who has focused an SLR camera topside because the Nikonos tends to 'feel' much like an SLR camera. The pitfall is that everything appears sharp and clear through the viewfinder, leading you to believe that

The powerful magnification ratios of SLR macro lenses enable you to capture very tiny, fragile subjects.

Framers must be carefully placed to attain this kind of composition.

you are focused. *This is not true!* Instead, the lens is manually set to specific, calibrated focus distances – a method known as 'presetting focus'. This makes it essential to master the art of correctly estimating distances underwater! (*See* page 59.)

When the focus distance is set, a red calliper marker displays the range within which acceptable focus (depth of field) is achieved. As long as the subject falls within the displayed distance range, focus is sharp. Of course, when you adjust aperture and/or focus distance, the range of acceptable focus also changes.

This gives you no accurate guide for placing the point of sharpest focus, but these areas of acceptable focus have been worked out so well (especially with the 15mm lens), that the camera is perfect for shooting quickly. The system also enables you to remain prepared between shots in anticipation of unexpected events or behaviour. By prefocusing the lens for a specific average zone, you need not waste valuable time fumbling with focus in the event of sudden

opportunities or fast moving subjects. With wide-angle lenses that zone can range between 60cm and 3m (2 and 10ft)!

For the Nikonos V to be efficient in close-up shots, the barrel extension of the macro lens is simulated by using lens-matching extension tubes. The sharpest focus point, approximately indicated by the frame boundaries, can be positioned fairly accurately where you wish, provided that you also take depth of field into consideration. This ease of use makes the system attractive to many photographers and particularly to hobbyists.

There are, indeed, some subjects that are much easier to control and capture with a framer than an SLR macro lens, even if professionals refuse to admit this. They simply use their framers secretly! A further plus factor that is rarely mentioned is that photographers with astigmatism who find focusing underwater extremely difficult, even with prescription lenses in their masks, find that the Nikonos V solves their problem.

Reluctant movers like scorpionfish are excellent subjects for both SLR lenses and the Nikonos close-up kit.

When feeling threatened, clownfish are extremely active. Patience will soon have them swim into a carefully positioned framer.

SLR AUTOFOCUS UNDERWATER

The options:

1. *Focus priority – the single shot mode –* this prevents you from taking a picture unless the subject is in focus.

2. *Continuous autofocus (AF) –* provides continuous focus on moving subjects so pictures can be taken at any time. Some cameras cannot be focus-locked in the continuous mode, and thus the shutter can be released even if the subject is not in focus.

3. *Trip-focusing –* the camera is focused on a preset distance and the trip mode is engaged. When the subject enters the prefocused zone, the shutter is activated. The photographer must ensure that no unwanted motion occurs in the prefocused zone.

AF systems usually have audible or LED signals to confirm or decline focus.

The limitations:

1. *Focus target:* this is usually any subject filling a middle rectangle. If the focus target area of the camera is large, a too-small object will confuse the AF system. Also if the subject is not centred in the composition, the camera must be focused on the subject, the focus locked and the camera moved to recompose and shoot.

Problem areas: two subjects, neither in the centre; when focusing slightly in front of or behind subject is required for better depth of field; in continuous AF mode, the action of the subject must be in the central target rectangle to be in sharp focus. Manual-focused SLRs with focusing screens allow focus on objects anywhere in the viewfinder.

2. *Low-light ability:* SLR AF systems currently work down to an equivalent that corresponds to one second at f/2.8 with 100 ISO.

This limit encompasses most underwater lighting situations.

AF systems also require a degree of contrast in the subject (usually in the form of vertical lines), which causes problems in low-light situations. The target must have a contrasting subject edge such as the rim of the eye in a fish subject, for example. Sometimes problems can be overcome when short distances are involved by prefocusing on another equally distant contrasted area, then locking and shifting to the low-light area.

3. *Time lag:* when the shutter release is pressed, there is a time lag during which the AF system is activated. Typically one-eighth of a second passes before exposure begins.

Movement and 'peak of the shot' fractional moments are problem areas. Therefore focus should be activated well before you are ready to take the picture. By pressing the shutter release halfway down the AF system is activated. When you are ready to shoot, press down further to expose. A manual focus camera is almost instantaneous, but focusing takes longer.

4. *Speed of focusing:* an experienced photographer can turn a lens focusing ring as fast as most AF micro-motors can. The AF, however, stops when the subject is in focus (humans tend to 'hunt' around the point of sharpest focus).

5. *Moving subjects:* AF has problems focusing on subjects that move rapidly toward or away from the camera. Trip-focus may help, as may models in which continuous focus can be locked, but manual prefocusing is usually the best method.

6. *Confusion:* kelp forests and shark-cage bars confuse AF systems into focusing on the nearest object. Manual focus is usually required for perfect focus.

7. AF works best in sunny conditions for fish portraits and general photography if the AF system is fast tracking.

Slow film has fine grain and an incredible capacity for capturing the intricate colour and pattern of macro subjects.

FILM SPEED

Film speed is predetermined and indicated by ISO numbers. The standardized ISO rating tells you, and the camera, how sensitive the film is – or how much light is needed for 'proper' exposure. The lower the ISO number, the slower the film speed and the more light it needs for an exposure, and vice-versa. When the film is loaded, its speed must be set manually to enable camera calculations by turning the film speed dial to a corresponding ISO number, unless the camera has a modern automatic DX coding feature.

Film speeds are selected to match specific underwater light conditions, while different brands are chosen for their characteristic colour bias, or palette. While professionals hotly debate these properties, the amateur need not pay too much attention to this aspect yet – modern films deliver spectacular results anyway. Fuji Velvia is the most popular slow speed film for macro (50 ISO) rendering brilliant colours, while Kodak Ektachrome, Fuji Sensia and Fuji Provia are the most popular medium speed films for wide-angle photography. Use the slowest film speed that lighting conditions will allow – in clear, tropical waters this means ISO speeds of 50, 64 and 100.

Slow films with their much finer grain structure and many more colour emulsion cells, record sharper images, brighter colours and more defined contrast. But the increased contrast also means less exposure 'latitude' – how forgiving a film is of under- or overexposure. Fast film speeds allow you to take pictures in dark conditions with small apertures for better depth of field, or to use very fast shutter speeds to freeze action. The faster the film however, the more grainy or 'rough' the image.

SLOW FILMS (ISO 25 TO 64)

Slow films are best for close-up and macro photography, because here the light source, strobes, is placed close to the subject and delivers plenty of light. The resolution of slow film is ideal for the fine, highly magnified detail and vivid colour typical of these images. Slow film is, however, also suited to colour-rich wide-angle soft coral scenics.

MEDIUM SPEED FILM (ISO 100)

This is a good general purpose film for underwater photography, suited to macro and medium range photography, but which is more usually selected for

wide-angle purposes. If you prefer to use only one kind, this is the film to choose.

FAST FILMS (ISO 200 AND HIGHER)
These are used in very low-light situations, such as on deep wrecks, where you would otherwise have to use very slow shutter speeds or much wider apertures in order to capture any picture at all.

We can also misrepresent film speed to the camera, tricking it to make different light value calculations. This is done by changing the film speed dial underwater to a speed representing full, half or fractional f-stops either way – forcing the camera to treat the film as if it were more or less sensitive. In Chapter Seven we will discuss how to use this creatively.

Remember: Each time the film speed is doubled, the film requires one f-stop less light for an exposure. An ISO 200 needs half as much light as ISO 100, ISO 400 half as much as ISO 200, etc.

DISTANCE UNDERWATER

Photographers have to accurately estimate subject-to-lens or subject-to-strobe distances. *Actual* distances differ from *apparent* distances underwater by about 30%. Thus we see our subjects about one-third closer to the camera than they are in reality. So where do we focus? The camera 'sees' exactly like our eyes through a mask – thus we always focus at the distance our subject *appears* to be. But to correctly light our subject with a strobe, the light must bounce off the *real subject* – not the *apparent image* – thus we will aim our strobe further away by one third.

While you need to learn to estimate distances for either camera system, it is *crucial* for the Nikonos V. Underwater, educate your eye by training on a stationary rather than a moving subject.
Stretch your arm out towards this subject:
• If you could reach out and touch the subject easily (don't!), the distance is about 45cm (1.5ft). This is too close for 35mm and 28mm lenses. With wide-angle lenses you could move much closer.
• If you could barely touch the subject with your fingertips, you have a distance of about 60cm (2ft).
• When your reach is about halfway to the subject, you have a distance of approximately 90cm (3ft).
Find and remember other simple 'measurement standards' like these.
Note: Corrections of one third must be applied when using Nikonos 35mm or 80mm lenses, as the focus scale on these is marked in air distances. Corrections are not required with SLR lenses.

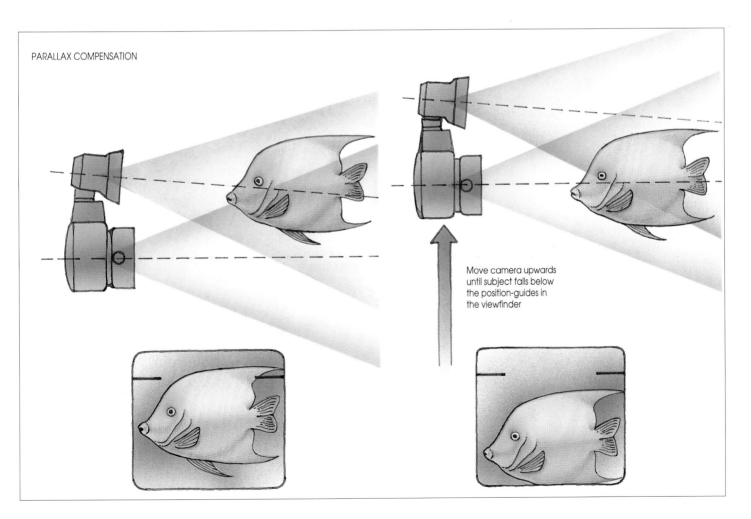

PARALLAX COMPENSATION

Move camera upwards until subject falls below the position-guides in the viewfinder

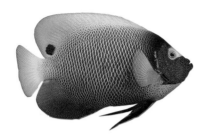

EXPOSURE

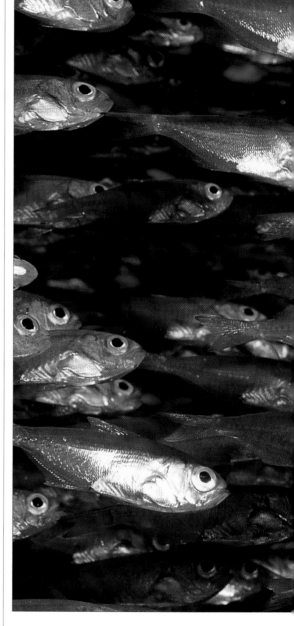

E xposure control is the single most important
technical aspect of underwater photography.
In this chapter you will combine your understanding
of camera control and underwater light with the fun-
damentals of exposure, thus acquiring the founda-
tion for expert exposure manipulation – an ability
that will, with experience, enable you to produce
some stunningly sophisticated images.

PHOTOGRAPHIC LIGHT

A photographer's light underwater has two distinct
components: natural light derived from the sun and
artificial light emitted by strobes. Each of these
makes a contribution and complements the other.
But each also calls for entirely different exposures.

Natural light is provided by the sun penetrating
the water, and is commonly referred to as ambient
light. To gain an accurate idea of its intensity, we use
a light-meter. Modern light-meters are usually built
into cameras, but separate instruments still exist.
*Rule 1: Ambient light is responsible for all background
exposure. It has very little or no effect on subject or
foreground exposure, except close to the surface.*

Artificial light is generated by a flash or strobe. It
restores the vivid colour that is lost at depth through
selective refraction. It is possible to measure and
regulate strobe light, but this is discussed later.

*Lettuce corals can provide
many different photographic
perspectives.*

*Rule 2: Artificial light does not have any effect on
backgrounds, and its effective use on a subject and the
foreground is limited to about 1.2 to 1.5m (4 to 5ft).*

Combination light results from blending and
balancing artificial and ambient light in different ways
to obtain different results. The artificial light may
play only a partial role, perhaps to fill shadows cast by
natural light or to add gentle, delicate colour to a
subject. But artificial light can also be used to make
subjects stand out from their ambient-lit background,
by giving it the richest possible colour saturation.

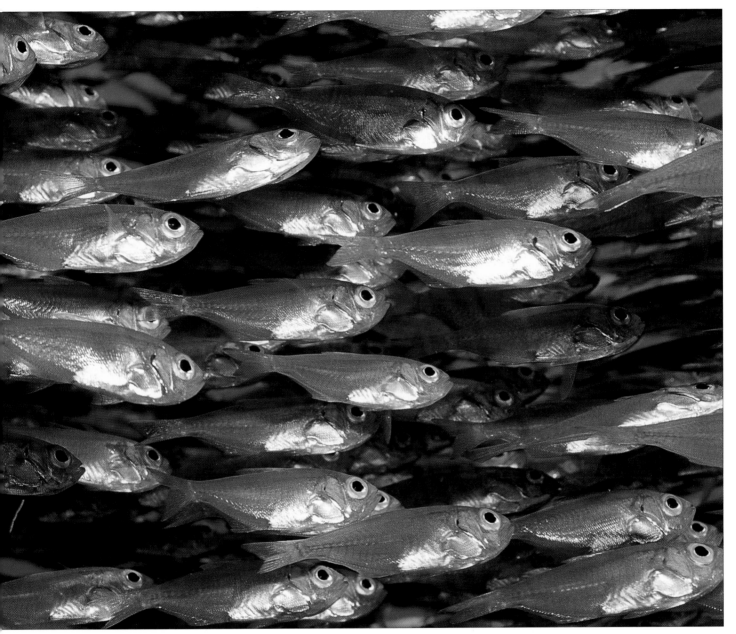

Once exposure is mastered, there is no limit to painting with light.

Whenever combination light is used – and depending on the results desired – *both natural and artificial rules come into play.*

TAKING CONTROL OF LIGHT

The exposure of an image is achieved by controlling the light that registers on the film. Whether light is natural, artificial or a combination of the two, there are only four factors that *influence* an exposure, and only these can be used to control it:

1. Film sensitivity or film speed (ISO) – a set film sensitivity

2. The amount of light, or light intensity

3. Shutter speed

4. Lens aperture (f-stop).

Logically, it is impossible to implement any camera controls without knowing light intensity values. This information is gained by metering the light reflected off a subject into the lens, done these days with the built-in light-meters of modern cameras.

MANUALLY METERING
LIGHT IN WATER

First, film speed is relayed to the camera by setting the film speed dial to the ISO number provided. Once programmed, all light-meters (and cameras) present a rather strange problem: they 'think' of light and colour in terms of tonality and use a range of precalibrated, graded tones – from black through several greys to pure white – for the process. When set to automatic, cameras and light-meters always consider universal 18% grey as ideal – the perfect 'medium' or 'average' light exposure. They will therefore always render their choice of shutter speed and aperture to attain this 'perfect exposure'. If you – for personal or artistic reasons – do not agree with

Below Metering a value too close to the sun would have underexposed the foreground.

your camera's choice, you can override it manually by changing the shutter speed or the aperture, or by manipulating the film speed.

If we meter light manually, the next question must be: what or where must we meter? Quite simply, light and therefore exposure cannot be the same for different parts of the picture. **When close to your subject, the decision is always based on that part of the scene that is most important.** Yet, if your picture contains both highlights and dark areas, there can be as much of a difference as five f-stops between them! This means that a correct exposure for your main subject may leave other areas either over- or underexposed. The final result will depend to some extent on the latitude or 'forgiveness' of your film.

This also changes when a strobe is the only light source, because the strobe flash is of such short duration. While the aperture setting may have considerable influence, especially when the main subject is reflective, a variation in the shutter speed will have no effect. Cameras synchronize with strobes at predetermined shutter speeds. The intensity of strobe light therefore makes it necessary to always evaluate a subject and adjacent reflective surroundings such as sand for its brightness and potential for reflection. Reflected light is often forgotten, as it exists only for that brief period when the strobe triggers. Compensate for this with a smaller aperture.

These widely differing situations can easily be catered for if we now break down all underwater exposures into two further categories: photographs that contain background water and photographs that do not. This allows us to consistently apply the two most crucial rules for exposure underwater (*see* page 60). Ambient light anywhere underwater is determined by the amount of sun present, its orientation, its penetration depth and its clarity. **Ambient light, and *only* ambient light, is what we meter when blue water forms part of our image.**

If any subject is positioned in the path of bright sunlight shining into your lens, it will photograph as a silhouette and lack detail. Any attempt to correct exposure for the subject will overexpose the background. So, if you do not want a silhouette, you have to compromise by exposing for the medium-bright areas in the scene and get close to your subject to gain some detail.

Thus, for all photographs that contain blue water you must evaluate the scenes for their brightest and

Far left *Metering a value deeper into the blue would have overexposed the reflective batfish.*

Left *Finding and exposing for the perfect medium results in balanced, harmonious overall colour.*

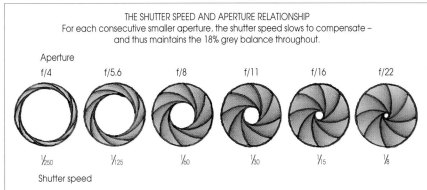

THE SHUTTER SPEED AND APERTURE RELATIONSHIP
For each consecutive smaller aperture, the shutter speed slows to compensate –
and thus maintains the 18% grey balance throughout.

Aperture

f/4	f/5.6	f/8	f/11	f/16	f/22
$\frac{1}{250}$	$\frac{1}{125}$	$\frac{1}{60}$	$\frac{1}{30}$	$\frac{1}{15}$	$\frac{1}{8}$

Shutter speed

darkest areas, then find a pleasing *average* and expose for that. In wide-angle scenes with large blue-water backgrounds this is unproblematic – you will obviously avoid the brilliant sunburst, as well as the deeper dark blues, settling instead for a beautiful medium blue, usually somewhere around 30° to 40° off the sun.

On the other hand, a subject with many very dark and very light areas will force you to take several readings to arrive at the true average. Called 'selective metering', this initially takes some time until your eye becomes experienced at light variations. Thereafter, you will expose almost by intuition. Selective metering is particularly helpful when difficult colour tones are encountered – usually brightly reflective surfaces, or mat hues notorious for 'swallowing' or absorbing light.

The final question is this: at which aperture and shutter speed do we expose? To determine this we must understand the mutual or reciprocal relationship between shutter speed and aperture.

The correlation between the specific apertures and shutter speeds is precalibrated. Each aperture and shutter speed combination will render a 'perfect exposure' based on 18% grey. If you photographed an identical subject from an identical distance, in identical light conditions at each of the above combinations, then all the exposures will be *identical.* This, in effect, is how cameras work when set to automatic. The camera will meter light and select one of these combinations (or fractional combinations in between) as being the correct exposure. Manual changes allow us to achieve different results from these relationships.

While either aperture or shutter speed can be used to control exposure, there are certain constraints that determine which one we use to control light. These include motion in either camera or subject, depth of field, and whether you are using natural light or a strobe. We must therefore predetermine what kind of exposure we want to make.

While the very idea of still photography is to capture the present moment, if the shutter is kept open for an extended time in natural light, both camera and subject motion will result in smearing or blurring – usually an undesirable effect. Shutter speed enables us to freeze movement, whether it is caused by a subject or the hand holding the camera.

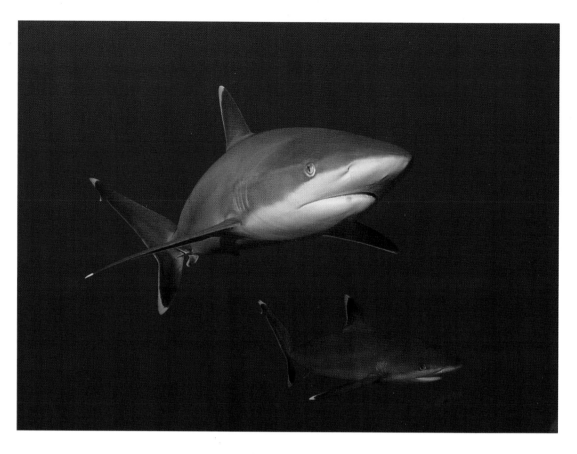

Fast shutter speeds freeze movement, but result in reciprocally larger apertures.

In either case, priority is given to shutter speed and we must, by opening and closing apertures, find an f-stop that will provide the speed we need!

Underwater we seldom require shutter speeds faster than 1/500 or slower than 1/15.

- 1/30 allows large f-stops which brighten low ambient light in deeper water
- 1/60 is used for stationary and slow-moving subjects
- 1/125 is used for capturing moderate speeds
- 1/250 is used for fast movers and silhouettes.

If no or slow movement occurs, we give priority to the aperture and will adjust it until we attain a 'normal' shutter speed of 1/60. But apertures are also limited underwater, for if they are too large we lose depth of field and if too small they may not cope with extremely low-light conditions. So while small apertures provide depth of field – a creative tool we try to maximize – compromises are often necessary:

- A high shutter speed may force you to use lower f-stops – you can freeze motion at the expense of depth of field.

- A high f-stop provides increased depth of field, but compels you to use either slower shutter speeds or faster film.
- Fast film speeds will allow high shutter speeds or smaller apertures, but at the expense of increased grain and less colour saturation.

Let's assume that there is no motion. Set the camera to automatic and set a shutter speed of 1/60. You can activate your light meter by halfway depressing the shutter release and aiming the camera at your subject. Starting at f/22, begin to open up your aperture and continue to do so until the shutter speed is confirmed in the LED display of your viewfinder.

At this point, symbols in various cameras differ, but they all essentially do the same: they 'protest' at too little light for the set shutter speed by blinking, flashing or pointing arrowheads towards underexposure; they confirm the correct aperture by glowing steadily or displaying a dot; and they 'protest' again by flashing, blinking or displaying warning symbols when the aperture will overexpose.

It is essential for you to know what your camera's symbols are.

Once you reach a confirming symbol in the LED display, your aperture and shutter speed are in harmony and your exposure should be perfect.

The process also works in reverse: when you select aperture, your camera will select the shutter speed, while the symbols will indicate when the chosen aperture is not adequate.

Since most underwater images are taken between f/5.6 and f/22 and at shutter speeds between 1/30, 1/60 and 1/90, and rarely 1/250, **a choice of only five apertures with one of only three (and rarely four) shutter speeds emerges**, that will cover 99% of all underwater situations you are likely to encounter! You will find that the most frequent apertures are:

- f/11 close to the surface
- f/8 for depths between 10m (33ft) and 20m (65ft)
- f/5.6 or even f/4 in water deeper than 20m.

Finally, remember that light varies drastically: bright sun, cloudy days, deep dives, bad visibility and your own position in the water will all change exposure values. While your eyes automatically adjust to changes, your camera does not. You must meter often, adjusting as conditions change.

SLR tip: when shutter speed is selected, the camera automatically switches to manual mode.

Tip: The Nikonos V light meter is lower-centre weighted – aim accordingly when metering. SLR light meters are usually centre-weighted and may display a circle in the viewfinder to indicate this.

BRACKETING – EXPOSURE INSURANCE
Bracketing is a photographic measure against variables, i.e – extra exposure insurance. It is done by taking several identical photographs but changing camera settings for each shot, usually in small increments both above and below the originally chosen setting. This ensures that at least one of the images will be exposed correctly or more pleasingly.

Example: Take one shot at f/8 and 1/60, a second at f/5.6 (a full stop under the original f-stop) and a third at f/11 (a full stop above). This also applies to fractional, ½ and ⅓ f-stops. While you can carry on

When bracketing an identical image you may have equally pleasing results. Or you may clearly prefer one of the images to the other.

bracketing forever, a measure of intelligence is called for. It is silly to bracket towards underexposure in low-light conditions, instead of toward overexposure.

Bracketing is useful, especially with rare shots, unpredictable lighting and reflection off subjects such as white-bellied sharks and barracuda schools.

Bracketing as a learning experience is essential for beginners, who will better understand correct exposure when evaluating results.

Log your bracketing information on a self-made chart, including film speed, apertures, shutter speeds and changes. Over time this enables you to pick up any irregularities. If the irregularities are consistent, your equipment calibration is out; adapt your exposures or have strobes and light-meters calibrated. If they are inconsistent, you are at fault and may have to review the chapter on exposure.

WORKING WITH AMBIENT LIGHT

Photography in ambient light without a strobe is easy. It requires the minimum equipment, produces dramatic, moody results and is deliberately chosen to create silhouettes.

Ambient light exposures are predominantly blue and undertaken in shallow waters when conditions are bright, when subject distances fall outside the strobe range, to create deliberate silhouettes, or when a subject is too large to be strobe-lit. It may also be your only option should your strobe malfunction or run out of battery power.

In any ambient light situation, the camera should always point upwards to produce the most desirable water background – a rich royal blue graduating from dark at the bottom to light at the top of the picture. This also enables you to include the sun as a compositional element. If upwards aiming is not an option, at least point horizontally. If less exciting, this will still produce a deep neutral blue background exposure. *Never* point the camera down to the bottom. Consciously resist the natural urge to do so, as not even the largest aperture will allow enough light for an exposure.

Of course you can meter ambient light and manually select your own apertures and shutter speeds. You can also give priority to shutter speed when dealing with moving subjects under controlled circumstances, as described earlier.

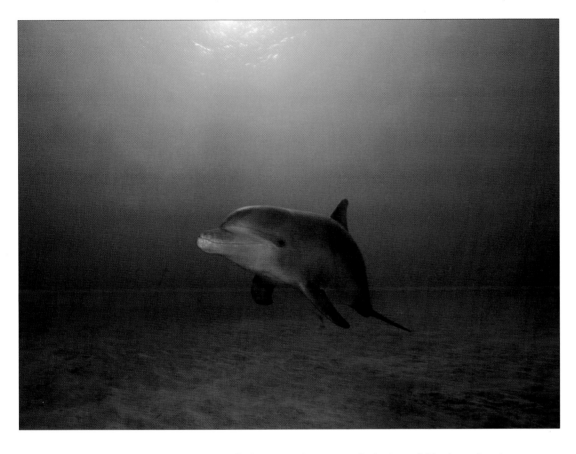

Left *Ambient light photography of stunning subjects such as dolphins is possible with the bare minimum of equipment.*

Opposite *Predominately blue, the impact of ambient light images depends on large, recognizable shapes and interesting composition.*

Remember to adjust your aperture until the set shutter speed is displayed as confirmed, and then compose, focus and shoot. Such exposures take more time and effort as you must adjust your aperture *each time* that lighting conditions or camera angles change.

While manual exposures provide most control, there are situations for which automatic features may prove to be the better choice. You can, for example, set your camera to the **aperture priority mode**. Then, when metering the ambient background (or subject), the automatic exposure control of your camera will select and display a suitable shutter speed.

Adjust your aperture, by starting at f/22 and then consecutively opening up until you see confirmation of the recommended shutter speed in your display. Stay close to your subject, adjust your focus, compose and shoot.

In a Nikonos display you may see two numbers confirmed, for example 60 and 125. This simply means that the automatic control has selected a number between them, which could be 1/75, 1/115 or any other speed in between.

Aperture priority is useful in three situations:

1. When **fast action requires fast shooting** and you have no time for individual manual exposure settings, aperture priority provides a compromise in a difficult situation. This usually entails photographing only with ambient light in bright, shallow waters with subjects like stingrays, seals and dolphins. As you move with the camera to follow the subject, your actual shutter speed should in reality vary around the speed selected and set via your prioritized aperture and you may get some incorrect exposures. But, without constantly fiddling with exposure and missing excellent opportunities, you will still obtain a *large majority* of correctly exposed images. If you disagree with the camera's selection because your subject requires a different shutter speed, you simply override the recommendation by selecting an aperture that will give you the required shutter speed.

If you use a strobe, set it to TTL and pre-aim it for a distance you think you can attain.

2. In **low contrast situations**, such as that encountered on wrecks, there is enough brightness for an available light exposure, but too low a contrast

between bright and dark areas. The subject, while exciting, is also too large to be lit by strobe. Because the scene is low in contrast, the automatic exposure gained by selecting the aperture priority mode ('A' on Nikonos) will be accurate. You open the aperture until the desired shutter speed for your subject (1/30) is indicated by your light meter. Again the actual shutter speed may vary from that selected. In this case, bracket to cover the odds.

3. A **high contrast situation** occurs when you look up from beneath and see an attractive **silhouette** – a diver, a boat, a large coral feature, a shark about to swim across a sunburst. Such subjects are only very rarely static, their relative positions change constantly, and you simply do not have time for manual exposures. Aperture priority mode will expose the majority of your pictures correctly (unless you are in shallow water). Even though the bright and dark subject areas are constantly moving and shifting, the automatic exposure control will average the brightness it registers and select a shutter speed near the average for the aperture you have selected. The secret for successful silhouettes is to find recognizable subjects with strong form, shape and contrast.

Fast shutter speeds produce crisp silhouettes and freeze subject motion.

You can apply creative **manual bracketing** to these exposure methods, provided you always consider light variables and adjust settings if you reposition:

• When photographing silhouettes, meter your ambient light manually for the correct aperture, but then set the aperture one or two f-stops smaller. This will give you a very crisp resolution. If, for example, the light meter tells you to use f/5.6, shoot at f/8 and f/11, or for bracketing, shoot at all three.
• You can use fast shutter speeds by selecting apertures that will allow them. This will 'sharpen' the shimmering of sunbeams, give crisper silhouettes and freeze motion.
• You can change your shutter speed, which will change your aperture: a faster speed = a smaller aperture, which will darken your exposure. A slower speed = a larger aperture, which will lighten your exposure.
• You can open or close your aperture in full stops or small increments.
• You can manipulate film speed by selecting a rating different from the actual ISO: rating it faster will darken your exposure, rating it slower will lighten it.

There are however some tricky conditions for which you must adjust differently:

• In **deep water**, subjects such as large shipwrecks or sunken aeroplanes may require both slow shutter speeds and possibly fast film to compensate for the low light conditions.
• When shooting in **extremely bright ambient light**, usually close to the surface, you will get some 'natural' colour in your subject. But 'too bright' should set off blaring alarms, warning you to 'open up'. However strange it sounds, intense brightness is countered by opening the aperture by at least one full stop. Theoretically you could meter such conditions correctly were it possible to get extremely close to your subject. Alternatively, substitute the palm of your hand for the subject, taking care to duplicate its orientation relative to both camera and water surface. Then open up one additional stop above that metered, to compensate for the reflective surface of your hand.
• The same rule applies if you take a reading from a **large, bright subject** such as white sand – open the aperture one additional stop. On the other hand, if

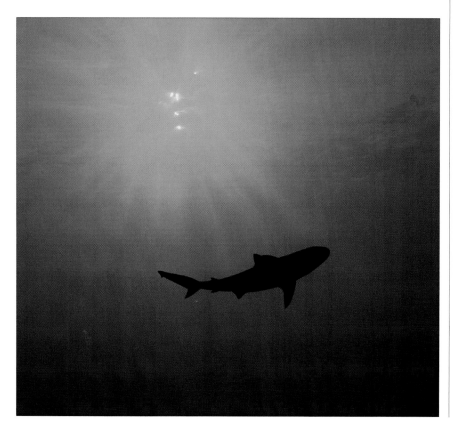

Ambient light always dictates the blue water exposure, while strobes affect only the near foreground subject.

your light reading is taken close to a **large dark subject**, you must compensate by closing down one additional stop.

• A third way to handle tricky subjects of **over-average brightness** is to take the reading from a medium-bright subject nearby. This method works particularly well if there are several objects of different or widely varying brightness in the picture area.

• A tricky situation occurs whenever there is a **'window effect'** – cave mouths, shipwreck portholes and crevices in which you want to place a silhouette. *Beware:* you must swim to the opening and meter *only* the ambient blue water, to get a correct exposure, as surroundings will cause incorrect readings. Your aim is to register everything, except for the blue water, in crisp blacks. With wide-angle lenses even a tiny keyhole can be made to look like an enormous cave – but meter the blue water beyond it before you position your camera!

CONTROLLING STROBE EXPOSURE

Whether you use a blend of artificial and ambient light or only artificial light, it is vital to know how strobe light affects a subject.

In daylight, combined light is used on the widest variety of subjects, for all techniques and with all of the lenses available. This can include near subjects, wide-angle panoramas with a primary foreground subject, blue water and secondary subjects such as distant divers, marine animals or sunbursts. In effect, these are always **two-in-one exposures**. But ambient light – whether reflected by a reef background or water – still affects every situation. This is of paramount importance. If you forget ambient light, you will get incorrect exposures.

The next most important factor is strobe light, which is governed by the artificial light rule:

Close-up and macro excepted, artificial light has no effect on backgrounds. Its effect on a subject and/or the foreground depends entirely on strobe-to-subject distance and is limited to subjects being positioned within a range of ± 1.2 to 1.5m (4 to 5ft).

When triggered, strobe light must travel to the subject, strike it and reflect back over the same distance to reach your lens and film. This, in effect doubles the total strobes light path! Just how great this influence is becomes evident when we look at it mathematically:

Each time that the strobe-to-subject distance is *halved*, the light intensity that strikes the subject

Opposite When lit entirely by strobe, ambient light has no bearing on the subject.

increases by two full f-stops! If we, for example, use a strobe and if f/4 is the correct aperture at a subject-to-strobe distance of 1.2m (4ft), then f/8 will be the correct aperture when the subject-to-strobe distance decreases to 60cm (2ft), and f/16 when it decreases to 30cm (1ft). Vice versa, if you move away from the subject, you would have to open the aperture by two f-stops for every time you double the distance. *But* if you move too far away, your subject will fall outside the range of the strobe beam and it will then no longer have any effect at all.

The important aspect to remember here is that **a strobe can only light one distance correctly**. If you aim the strobe and expose for a subject 1m (3ft) away, everything in front of this distance plane will actually be overexposed and everything beyond it under-exposed, albeit gradually.

This is significant for large subjects like barrel sponges, since their size necessarily causes them to partially fall outside the strobe range. Were you to use only one strobe, it would have to be angled in such a way that its light spreads across the most important part, simultaneously modelling and sculpting 'body' into the sponge. When properly used, this can render an exciting light blend, since ambient light gently illuminates the remainder of the subject beyond the strobe range. However, optimum illumination of large subjects is better achieved by using two strobes.

Subject reflectivity is another important factor for strobe light – a diver in a dark wetsuit is less reflective than a shark's white underbelly or a school of silver fish, and will require more light. In portrait format, the same diver's face will be more reflective than his dark wetsuit and will require less light.

In all cases, the effect of strobe light can and must be controlled or manipulated with the aid of a strobe exposure chart. There are four ways of doing this:

- changing the strobe-to-subject distance
- changing the strobe power settings
- adding a diffuser
- juggling film speed.

STROBE EXPOSURE CHARTS

Manual strobe exposure charts are based on **strobe-to-subject-distance at given apertures.** They are vital for controlling and using a strobe creatively.

If you employ a strobe exposure chart, it means that **the moment you use a strobe, you can ignore changes in the camera-to-subject distance** (although you must, of course, adjust focus).

Although usually provided by manufacturers and often given in photographic handbooks, strobe exposure charts may not be entirely correct for your camera/lens/strobe combination. There is really no 'standard' strobe exposure chart, because strobes differ widely, not only between different brands, but even between strobes of the same make and model. They are also not based on your strobe/camera/lens system. These tables may additionally refer to 'guide numbers', a method I avoid entirely, because it is based on a system meant for air and calls for unnecessarily complicated computations underwater that are not always dependable.

The strobe exposure chart opposite is a simplified one, but works pretty well in most photographic situations and circumstances. Obviously you must omit strobe power settings that you do not have.

Refine **apparent distance values** by shooting test shots, once for ISO 50 and once for ISO 100.

For each given distance shoot at:
a) given aperture
b) one stop under
c) one stop over.

Below In macro photography, the strobe is your main, and often only, source of light.

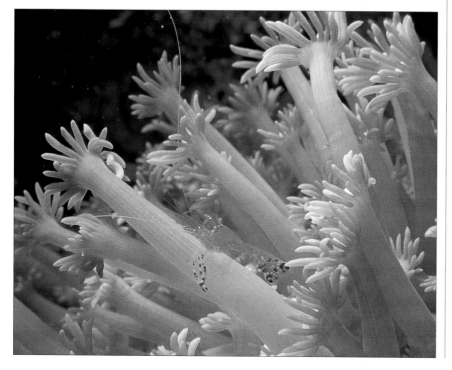

STROBE EXPOSURE CHART

MEASURED STROBE DISTANCES

	ISO 50	ISO 100
20cm – 8in	f/16 – 22	f/22 – 32
30cm – 12in	f/16	f/22
40cm – 16in	f/11 – 16	f/16 – 22

APPARENT STROBE DISTANCES

30cm – 1ft	f/11 – 16	f/16 – 22
45cm – 1.5ft	f/11	f/16
60cm – 2ft	f/8	f/11
90cm – 3ft	f/5.6	f/8
1.2m – 4ft	f/4	f/5.6
1.5m – 5ft	f/2.8	f/4

NIKONOS EXTENSION TUBES

Strobe distances

1:3 – f/22	13-23cm/5-9in	18-33cm/7-13in
1:2 – f/22	10-20cm/4-8in	15-30cm/6-12in
1:1 – f/22	7.5-15cm/3-6in	10-20cm/4-8in
2:1 – f/16	7.5-15cm/3-6in	10-20cm/4-8in

STROBE POWER SETTINGS

Full Power = total power

½ Power = reduces light by 1 f-stop

¼ Power = reduces light by 2 f-stops

⅛ Power = reduces light by 3 f-stops

¹⁄₁₆ Power = reduces light by 4 f-stops

Add Diffuser = reduces light by 1 f-stop

If the diffuser is compensated for = no exposure change,

 but warmer, softer light

Decreasing strobe to subject distance = increased exposure

Increasing strobe to subject distance = decreased exposure.

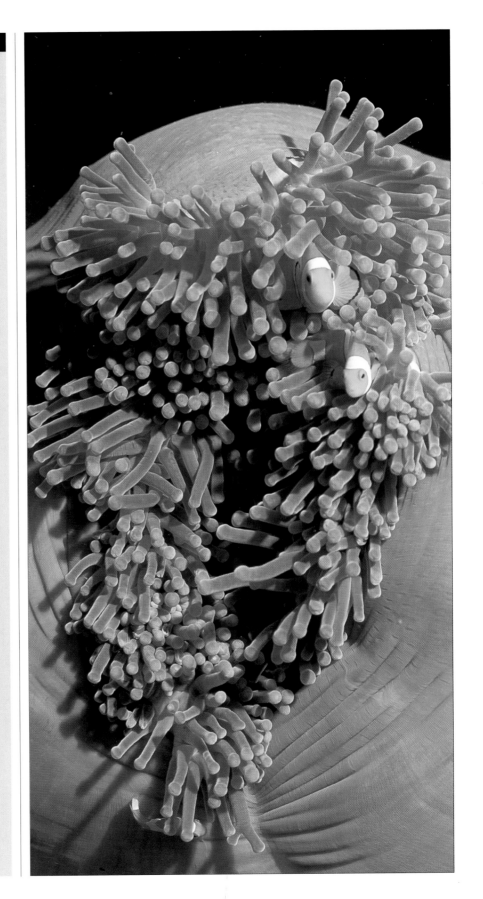

You could underexpose the ambient background by one f-stop for artistic reasons.

Evaluate your results for the best exposure for each given distance and replace the given f-stops where necessary. A waterproof felt-tipped pen and duct tape work well and can be stuck to your strobe. If your strobe has only the full power setting, you must manipulate strobe output by increasing distance and/or adding diffusers with differing f-stop values

However, if you aspire to excellence, you should develop your own chart by test shooting exposures for **each lens and each film speed** you use, in combination with the camera and strobe dedicated to it. Base your chart on the style of the given example, and expand or contract it to your personal taste.

Let's refer back to the sample exposure chart: Note how strobe-to-subject distances have corresponding aperture or f-stop numbers. This allows the chart to be easily read both forwards and backwards – a benefit which will soon become obvious.

There is only one basis from which to evaluate and calculate the correct blend of artificial and ambient light. Ambient light is always the 'constant'. Thus when you include blue water/ambient light in your image, you *always* meter ambient light to arrive at the correct aperture. Let's assume this is f/8, and

that you are using ISO 100. Now use your exposure chart to confirm the correct strobe-to-subject distance. If you are indeed at 1m (3ft) your ambient and strobe light is in harmony and should result in a perfect exposure. If you are not at the correct distance, you must make changes, and these depend on whether you want to retain your distance for compositional reasons. Also, nothing forces you to accept the f/8 exposure as correct.

For personal or artistic reasons you may wish to darken both fore- and background by one stop and thus set f/11. You may want to attain greater colour saturation and underexpose your entire image by a fraction like ⅓ or ½ stop; do so by rating your film slightly faster, e.g. an ISO 50 at 64. You may want to slightly underexpose only your strobe-lit portion; do so by changing your strobe power settings, moving your strobe slightly back and/or using a diffuser. To have your foreground pop out of the image background, you could slightly underexpose only your water and decrease your ambient aperture, but retain your strobe output strength.

However, drastically decreasing distances can present a catch! If your composition calls for you to be very close to your foreground subject, yet an f/11 aperture is indicated for the ambient light, you should know that you will overexpose your foreground. Check distance and aperture on your chart. If full power at 60cm (2ft) indicates f/11, which you know is overexposed, half-power will let your strobe attain the equivalent of an f/8 output, without changing your aperture for ambient light. Shutter speed cannot manipulate exposure in any of these situations, as it is restricted to the predetermined strobe synchronization range, usually at 1/90th second.

The following information is important: when metering light, we arrive at an f-stop which, once set, influences our ambient light or background exposure. But now we also talk about strobe output in terms of f-stops. It may be less confusing to remember strobe output power in terms of 'the exposure value equivalent' of one or more, or partial f-stops.

In all of the situations above, ambient light is *always the constant* and you will always determine where the equivalent of 18% grey is in the water: metering too close to the sun will underexpose; metering lower, in too dark water will overexpose your image. The effect of the strobe is *always* the *variable* and its light *only ever has bearing on the close*

foreground subject. It is therefore always the strobe that is manipulated for foreground exposure, without changing the f-stop that controls ambient light exposure, except when you also want to change the ambient exposure. By using manual exposure, you are in complete control of the balance between artificial and ambient light – and thus also the results. Few of these subtle and beautiful variations would be possible with your camera and strobe set exclusively to its automatic features.

WORKING WITH STROBE LIGHT
Whenever you combine strobe light with available light, you need to decide:

• whether to balance exposure between them, or
• whether one light source must play the dominant role, and if so, which one.

In **very bright conditions**, sunlight is stronger than strobe light and the strobe will only provide fill light on the near subject – just enough to gently enhance colour and to illuminate detail in the darker or shadowed areas. This situation is usually encountered in shallow water and the images look very natural.

In circumstances with **less natural light**, usually in deeper water, the strobe must provide almost all the light for the foreground subject, and its effect is therefore dominant in spite of there being a measure of available light. Provided you are at the correct strobe-to-subject distance, this dominant strobe and weak ambient light combination lets you attain vibrant colour and lots of detail in the subject.

When exposing for **overall bright conditions**, most slow moving subjects are successfully captured at a shutter speed of 1/60. With an SLR camera, with strobe settings on manual, set your film speed. Then, while aiming the camera at the subject, adjust your aperture until 60 is confirmed in the LED display. Check that the strobe-ready light is on. Now refer to your exposure chart to confirm your strobe-to-subject distance and adjust your strobe power setting accordingly. Then compose, adjust focus and take the picture. Bracket by taking two more pictures, one at a half stop less, the other at a half stop more than the first aperture. (If you make a mistake with your strobe power setting, it is always better to under- rather than overexpose, as you will then still have a sunlight exposure with strobe fill.)

When using one strobe on large barrel sponges, aim it carefully to highlight their shapes and textures.

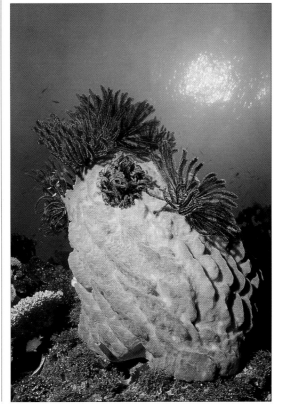

Because two strobes light this barrel sponge evenly, it focuses the viewer's eye on the featherstars.

At night, your strobe is the only source of light.

You may have **bright sunshine** and want to light **both far and near subjects** in one picture – usually for wide-angle shots. You want an ambient light exposure for the background and any secondary subjects it may contain, but simultaneously want to brighten the colour of your near 'feature' subject with your strobe. Set your film speed, and a shutter speed of 1/60. Aim your camera at the *background* and find the aperture that confirms 60 in your LED display. Now, look at the lens to see which f-stop has been selected. Find this aperture on your strobe exposure table and verify the correct strobe-to-subject distance. Now hold or move the strobe at the correct distance from the near subject, then compose, adjust focus and take the picture.

At night or anywhere in the dark, there is not enough light for metering. Then exposure is determined only by the strobe, as it provides all the light for the subject. However, you still need to select the correct f-stop. Thus you will set the shutter speed, set the strobe for full power, and then select the f-stop corresponding to the strobe-to-subject distance from your strobe exposure table. When the strobe-ready light turns on, compose, adjust focus and take your picture.

A 'velvet' exposure lets you attain an even, velvety-black backdrop, even when photographing by day.

It is perfect for excluding distracting backgrounds, but also serves to isolate and enhance the colour, shape and detail of vivid fish or the translucency of sea jellies and the iridescence of creatures like squid. To achieve this you must make three adjustments:

You need to stop down to f/22 (this may not be possible with film speeds such as ISO 64 or slower) so that the camera 'sees' only the light of the flash. The second crucial factor is strobe-to-subject distance. Your decision must be based on which lens or which close-up converter you are using; in either case the strobe-to-subject distance is very small as can be seen on your strobe exposure table.

With an unconverted lens, you are looking at 30cm (1ft), with a 1:3 extension tube, at about 10 to 18cm (4 to 7in). *Do not* point the camera upwards. Since the aperture is so small, the distance so close and the camera pointed horizontally, the ambient light cannot be registered.

CREATIVE BRACKETING
You can creatively manipulate your combined light in many subtle ways, if you work on manual settings:

You can influence the entire picture:

• By changing the aperture: wider to increase exposure, smaller to decrease exposure. This is usually done in half stops. An aperture change affects *both* the ambient and artificial light exposure.

You can manipulate only the foreground strobe exposure:

• By manipulating the power settings on your strobe.
• By using a diffuser with a known f-stop value together with strobe power settings, to reduce the light by smaller or larger increments than that provided by the power settings alone.
• By moving the strobe closer or further away from the subject, as shown on the strobe exposure chart (or distances between, although it is almost impossible to predetermine the exposure value accurately).

You can manipulate only the ambient exposure:

• By changing the aperture to reduce or increase ambient exposure. But you must then also compensate with your strobe to retain the illumination you

desire for your foreground subject, usually by decreasing strobe-to-subject distance. However, circumstances dictate whether manipulation by strobe power settings and/or diffusers may also apply here, especially if you are very close to your subject. Verify this on your strobe exposure chart.

None of these situations should imply any creative limitation! Factors like distance, subject, colour, size and composition, together with different methods of exposure control compute into an enormously diverse range of possibilities.

TTL EXPOSURE

There *is* one modern technological miracle we can indeed embrace! A feature known as through-the-lens (TTL) auto flash exposure can automatically measure and control almost all of the factors that influence artificial light exposure.

In essence, TTL employs a light-sensing cell adjacent to the film plane, that calculates how much light to put out and meters the exact amount of strobe light that passes back through the camera lens onto the film. When it senses that enough light has reached the film for an exposure, the TTL automatically turns the strobe off. This will happen irrespective of which camera and strobe you are using, provided your system features TTL and your strobe is set to it before you photograph. TTL can be used with all ISO film speeds from 25 to 400.

While TTL is a wonderful tool for controlling strobe exposure, particularly in macro and close-up photography, there is a catch! In the Nikonos system the TTL feature *cannot* determine ambient background exposure. TTL only controls strobe exposure for the near subject and does so in conjunction with the aperture you select. You must still meter and select an f-stop. If you choose an incorrect aperture, you will get an accurate foreground exposure, but everything else will be out of kilter.

However, you do have some measure of control over your exposures. By *slightly* varying the apertures determined by your ambient light, you can darken or lighten your background. This technically causes slight background under- or overexposures and is frequently used for bracketing. You could employ the method specifically to emphasize a near subject and get greater colour saturation (smaller

A frame-filling leaf fish is ideal for TTL strobe exposure.

aperture), or to highlight a subject further away from the camera (larger aperture). Your foreground TTL exposure adjusts correctly in either case.

The only other change you can make with TTL is to fool the camera by under- or overrating your ISO film speed in increments. A 50 ISO film rated at 64 equals one-third f-stop faster and at 80 two-thirds f-stop faster; both reduce exposure. Underrating in one-third stops to 40, 32 and 25 will increase exposure. Some cameras have an exposure compensation dial or button, which should be set only after the aperture indicated by your light meter has been set.

TTL works best for close-up photography: when a subject of average or medium reflection fills at least one-third of the *centre* of the picture area and when the strobe, rather than sunlight, determines your exposure. At close distances, day or night, the TTL strobe provides virtually all the light for such an exposure. Here the situation is simple: the aperture can be set for f/16 or f/22, and the TTL sensor will control the amount of light accordingly, by varying the flash duration.

But TTL has definite limitations:

• TTL does not work in close-up photography if the subject is small or slim. A good example would be a fairy basslet against blue water or a trumpetfish

against a dark background. In both cases the background constitutes the major portion of the picture and is seen as more important than the small/slim foreground subject – this confuses the TTL sensor. As any light emitted from the flash will **pass** the subject it is never reflected back to the camera lens for measurement; TTL thinks that its light output is too small and thus increases it, which results in an over-exposed foreground.

• TTL does not work well at longer distances, because the subject will then be beyond the TTL automatic range.

• TTL does not work with very reflective subjects such as a barracuda, because the sensor thinks it is receiving more light than is needed and decreases strobe light, resulting in an underexposed image. You can trick the camera into thinking that it needs more light by setting the ISO dial to a lower number.

• TTL also dislikes small, off-centre subjects, because almost all TTL sensors are centre-weighted and take their reading from the middle of the picture. Thus, do not use TTL unless the subject fills *at least* 50 to 60% of the picture, especially in wide-angle photography. Multi-segmented TTL systems may however cope with these circumstances.

Although TTL varies light output by varying flash duration – **it cannot provide more than a full-power flash**. If the sunlight in water is brighter than a full-power strobe exposure, the TTL system becomes pointless and you must manually expose for the sunlight. Even then you will gain only fill-flash from the strobe, whether it is set to TTL or not!

The **maximum automatic range** of TTL is about 1.8m (6ft), but this is somewhat more intricate. For there is correlation between aperture and strobe-to-subject distances, called the 'coupling range'. This means that for any given distance there is a maximum and minimum aperture, which limits the use of TTL. Turned around, this also means that for every aperture, there is a minimum and maximum distance for TTL to function correctly.

You can add these corresponding f-stops and *maximum* distances for TTL to your exposure chart:

• for f/11 it is 60cm (2ft)
• for f/8 it is 90cm (3ft)
• for f/5.6 it is 1.2m (4ft)
• for f/4 it is 1.8m (6ft).

At distances of 30cm (1ft) or less, provided you use film speeds of 50 to 100 and extension tubes or close-focusing lenses, TTL works extremely well.

These limits of the TTL exposure system should convince you how extremely important it is to learn to expose manually for strobes.

THE STROBE AS CREATIVE TOOL

Artistry with strobes goes far beyond just technical exposure, and since most underwater images are captured with strobes, it is prudent to consider those other influences here. Light can be a powerfully creative element. If anything transforms an underwater image from the mundane to the magnificent, it is artificial light. But strobe light introduces another and equally powerful partner – shadow – and it is this that defines light and its mood.

APPARENT FOCUS VERSUS ACTUAL FOCUS

Incorrect: Aiming the strobe at the apparent subject

Focus on the apparent subject

Correct: Aiming the strobe at the actual subject

One vs. two strobes

Beginners usually start with only one strobe and obtain reasonably pleasing results. But this is already problematic because macro photography requires a small strobe, while wide-angle is best served by a larger, stronger strobe with a wider beam angle.

Even if more expensive, the ideal lighting set-up for wide-angle photography is indisputably two strobes: to be versatile, these must be identical and of a size and weight that is easily managed on very long jointed strobe arms. Such a combination wipes out major photographic problems such as backscatter and hot spots, while allowing the greatest creative freedom.

One strobe, even with an extreme 100° wide beam angle can never match the combination of two with moderate, 90° to 95° beam angles. In fact, ultrawide beam angles make backscatter extremely difficult to control.

Two identical strobes are also ideal for macro- and close-up photography (one being set to fire at half power or less). They should be small and handy for tight corners, and yet sufficiently powerful to be fired repeatedly in rapid succession. Some can achieve an f/22 exposure on ¼ power and recycle within four seconds.

Consider the creative options open to manipulating two strobes for either situation:

• you can eliminate the harsh shadows caused by one strobe
• you can light scenes evenly without encountering hot-spots
• you can light two different near subjects, at different distances and at different intensities (e.g. half power on very near coral, full power on model behind coral with ambient light for the background)
• you can control the density of shadows, or eliminate them altogether
• you can position shadows where you want them
• you can almost always eliminate backscatter completely, even in quite turbid water
• you can 'design' light effects by dedicating one strobe to slave status, and detach and position it anywhere you wish. The slave will be triggered by the primary strobe
• with identical strobes, either strobe can become secondary and decreased light intensity can come from either side

• with identical strobes, you can switch off either one entirely and use the other alone
• particularly with wide-angle, two strobes allow illumination of much larger subjects.

Clever strobe placement can highlight the exquisitely delicate detail of a Porcelain crab's feeding snares.

Diffusers

Diffusers are often sold to adapt a strobe chosen as compromise, rather than as a creative tool, or to eliminate hot spots. They usually serve to spread a strobe beam that is too narrow for wide-angle photography, although this technique requires at least a 100° angle or ideally, two strobes for even picture area coverage. Diffusers are also used to temper and soften a too powerful light output, in the process swallowing about one f-stop.

For a strobe with only full-power setting, diffusers are essential as they provide the only alternative to intensity control except strobe-to-subject distances. But diffusers can be used with different power settings and strobe-to-subject distances to provide an amazing variety of subtle, creative lighting effects in addition to softness and spread. That range increases even further when applied differently to each strobe in a two strobe combination. For example:

Problem: In wide-angle photography, aperture is chosen for correct exposure of the blue background water. But, if you are very close to your primary subject, your strobe will overexpose it at that aperture.

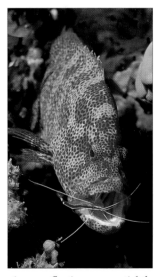

A non-reflective grouper tightly framed is a perfect candidate for TTL strobe exposure.

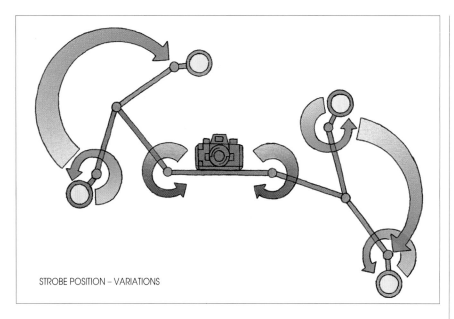

STROBE POSITION – VARIATIONS

Options: A change of aperture will influence your ambient background or even expose it incorrectly. You could move further away from your subject, but may spoil your composition or its impact.

Solution: By changing the strobe power settings *and/or* adding a diffuser, the effect of your strobe light can be manipulated in smaller degrees – to pre-vent overexposure or to soften the light altogether.

Here is the proof: If your ambient aperture is f/16, switching from full to half power reduces your strobe output from f/16 to f/8. While this now provides half the light, it in effect constitutes a two f-stop differ-ence. You may only want or need a one f-stop reduc-tion – a diffuser provides this. If you still needed strobe light reduction, your next choice is ¼ power, which halves the light again, and will give a strobe output as if for f/2.8. However, add a diffuser to the half-power setting and you reduce light only by one further f-stop to f/5.6 – a gentler decrease, halfway between half and quarter power. This exercise applies to every strobe power setting, and is an option that power settings alone can not provide.

You could of course change strobe exposure on your primary subject by moving your strobe toward or away from it. If you double the distance, you halve the strobe effect – a two stop difference. If you halve the distance, you double the exposure, again by two stops. This may be limiting in terms of composition or even reef topography. There is another solution.

Interpret your strobe-to-subject distance chart for near subjects differently! Instead of moving, verify at which aperture you would have had to photograph for a correct foreground exposure if you stayed in your chosen position. With this knowledge, change your strobe power settings, and/or add a diffuser so that the strobe will output light, *as if* for that correct foreground subject aperture.

Note: Because of the correlation between aperture and strobe-to-subject distances (coupling range) when using TTL, and also the fact that TTL is largely an automatic feature, diffusers will not be suitable in this case and there is therefore little scope for artistic bracketing.

STROBE EXTENSION ARMS

Versatility in strobe placement is paramount and it is extremely important that strobe arms be very adjustable! For macro photography with SLR sys-tems, versatility is vital because of the length of macro ports. In my opinion the knuckle-and-joint arms shown on page 23 provide the best flexibility.

COUNTERING BACKSCATTER

However clear the water, backscatter (suspended particles) is omnipresent. Since the particles block or reflect light, even if really tiny, they visibly regis-ter as underwater 'snowstorms' on your images. This is perhaps the most annoying problem encountered when strobes are used.

The nearer the strobe is held to the camera, and the more incorrectly it is tilted or aimed, the more light is reflected from the particles and directed towards the lens – ruining your images. Amazingly, most standard strobe arms are too short. Furthermore, most manufacturers advocate the standard style of lighting: placement of the strobe at the left, at a tilt of 45° to the camera. This is often the worst possible configuration for backscatter.

To minimize or completely avoid backscatter, mount or handhold your strobe/s in the following way for macro and medium-range photography **with one or two strobes**, or for wide-angle photography with **one strobe**:

• Ahead of and above the camera – this spreads light better across the picture, avoids backscatter in the top left-hand corner of the picture, and deflects particle reflection back to the strobe, not the lens.

• At an angle that will deflect particle-reflected light to outside the picture area – rather than at the lens.

• So that the edge of the light beam cuts just in front of the subject – this minimizes the number of particles illuminated between lens and subject.

• From any side that will direct reflection of particles away from the lens. This is useful in dirty water.

For wide-angle photography with **two strobes**, use suitably long extension arms to position them further away from the lens:

• Aim your strobes straight ahead. Contrary to standard belief, *never* angle your strobes at 45˚ to the subject for wide-angle photography!

• Adjust the strobe arms so that the two strobes are as far to the left and right as practically possible.

• For **close-up** wide-angle photography, aim the strobes straight ahead, overlapping the beams at the centre of the subject and have the beams cut off just in front of the subject.

• For **longer shots**, aim the strobes *slightly* outward from the straight-on position (good for 'dirty' water).

• Always **bracket** lighting in dirty water by using extreme side-lighting – aim your strobe from either side of the subject at an angle of 90˚, with the beams intersecting across the actual subject.

Aimed ahead, there is no hot spot problem. Lighting across a large subject is evenly distributed, while the layering of the two light edges have a cumulative effect that matches the rest of the light.

A strobe well placed and angled to avoid backscatter.

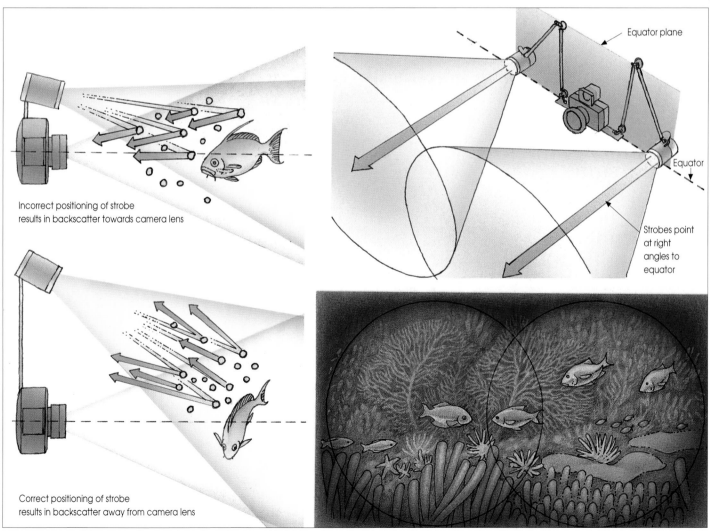

Incorrect positioning of strobe results in backscatter towards camera lens

Correct positioning of strobe results in backscatter away from camera lens

Equator plane

Equator

Strobes point at right angles to equator

BACKSCATTER

STROBE POSITION AREA OVERLAP: CORRECT POSITIONING RESULTS IN EVEN DISTRIBUTION OF LIGHT

PERFECTING YOUR PHOTOGRAPHY

With the fundamental photographic basics mastered, you should be able to advance to the different underwater photographic techniques with confidence. The following section covers:

• macro and close-up photography
• wide-angle photography
• medium-range photography.

While it would be wonderful to possess the ideal photographic set-up, one should never see the lack of a large variety of lenses as limiting. Each lens has unique capabilities and limitations, which will take time to master. Whether you have a choice array or a minimum of lenses, stick to one at a time and perfect your handling and photographic technique.

TOP TIPS

• Keep your camera still when shooting
• Shoot from the reef bottom whenever possible
• Squeeze the shutter, don't punch it
• Exhale just before you shoot
• If you can, without doing damage to the marine environment, kneel or wrap your legs around a solid object
• Keep your arms in, stabilize your elbows against your body
• Maintain slightly negative buoyancy if there is a surge
• In midwater, control your buoyancy with breathing only

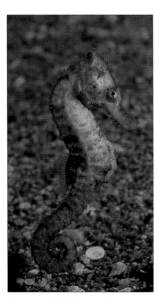

In poor visibility, perfect your macro photography.

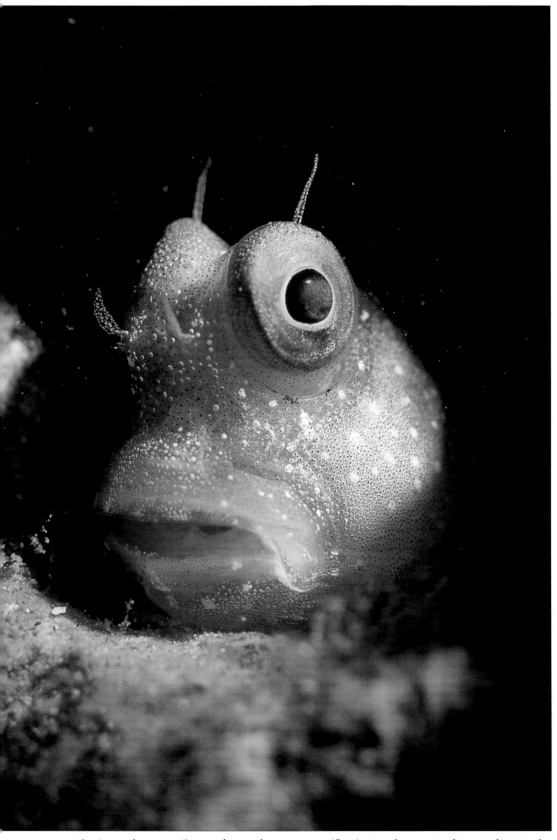

Intricacy of pattern, vibrant colour and extreme magnification are the essence of macro photography.

MACRO PHOTOGRAPHY
When miniatures turn into monsters

Macro photography is fascinating! It captures the most beautiful and bizarre miniature creatures of the reef at tremendous rates of magnification, rendering them in vibrant colour and exquisite detail as if viewed through a magnifying glass. Breath-taking detail is often only discovered once the film is developed, providing an extra thrill for the photographer.

Known as the 'anywhere, anytime technique', macro photography is one of the most satisfying and easiest forms of underwater photography. It is ideal in less-than-perfect water conditions and is the only successful technique at night. What's more – it concentrates on the largest sector of reef inhabitants, and immediately delivers prize-winning photographs.

The hardest part of macro photography is finding suitable subjects. A keen eye for reef minutiae and a thorough understanding of symbiotic relationships,

behaviour and potential habitat is important. So are consummate skills for close approach, without having subjects flee, at least until you capture the shot.

The point of macro photography is to capture the subject at actual or larger than life size. This is usually accomplished by positioning the camera lens very close to and filling the picture area with *all* of the subject. This produces unmatched colour richness. Simultaneously, the small aperture delivers breathtaking sharpness of even the tiniest detail.

THE NIKONOS SYSTEM
Macro photography with this system is perhaps the easiest and most immediately rewarding technique for beginners. Its simplicity together with predetermined camera settings requires no great experience to produce acceptable, even outstanding results.

The 35mm, 28mm and 80mm lenses are all used for macro, but since the 35mm lens is the popular macro workhorse and the best beginner's lens, we

MAKE DECISIONS BEFORE THE DIVE

Your state of mind and body profoundly influences your capacity to make sound judgements and creative decisions underwater. Haste, panic, arguments, hangovers and ill-preparation are factors that adversely affect your safety and enjoyment. Make decisions before the dive – and that may include the decision to miss out the next dive!

Proper preparation puts you in a relaxed state, ready to enjoy your dive. Are you familiar with the dive site or is it entirely new? Are you diving with your buddy, or in a group with others? Will there be a dive guide with photo subject experience? Are you diving from shore or from a boat? Each situation presents unique considerations that must be addressed beforehand.

Since each lens is limited to specific capabilities, you cannot photograph everything you encounter on the reef during one single dive. This necessitates a pre-dive evaluation of conditions and photographic opportunities, followed by the selection of an appropriate lens and its corresponding technique. If the water is clear, or if it is the middle of the day, you will want to shoot wide. In lower visibility and/or early and late in the day, you are better off shooting macro and close-up. This kind of intelligent approach allows you to concentrate and deliberately seek subjects that are suited to this lens, technique and dive.

Remember that diving equipment in perfect order, packed to a checklist and ready to go, allows you to concentrate on your photography. Prepare your camera in advance, in a quiet, clean and dry environment. If necessary, run through photographic procedures and techniques and add 'reminder' stickers to the back of your camera. Create a camera preparation checklist – it can save you from making expensive mistakes.

Ensure that subject spotters know your desired subject range, but will remain well out of shot and avoid stirring up sand or sediment. Prearrange special signals that pertain specifically to photographic subjects or situations. If possible, research the environment, its specific creatures and their habits.

Ask your buddy to monitor depth and bottom time, but always assume responsibility for yourself.

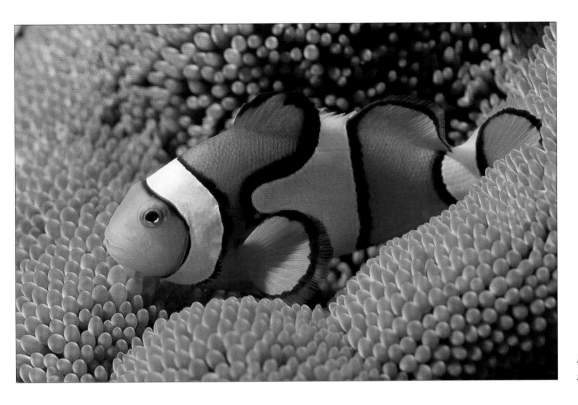

Left: Patience is rewarded by stunning images.

will use it as our example. The techniques discussed here also apply to the other lenses.

The 35mm lens is used with any one of three extension tubes/framers. For each, the picture area, the magnification rate and the depth of field at f/22 are different. While the largest, the 1:2 tube/framer, does not produce macro pictures in the strict sense, it is the best choice for beginners or when you are unsure what subjects occur on a new reef. More creatures will fit into this larger framer. The smallest 2:1 tube/framer is very limited, while the middle-sized 1:1 tube/framer fits only certain creatures. Graduate to these, and to coupling several extension tubes together for higher magnification, when you are more experienced.

It is vital that frames and extension tubes match each other and their designated lenses, otherwise your pictures will be out of focus. They are marked for this purpose. Once your chosen macro set-up is assembled, you are locked into that specific frame size for the duration of your dive.

The macro formula

Irrespective of which macro set-up is used, Nikonos recommends that beginners set the shutter speed to 'A', the focus to **minimum focus distance**, the aperture to f/22, and the strobe to TTL.

CLOSE-UP PHOTOGRAPHY

This lives in the nether world between macro and medium-range photography, but as the techniques are similar, we discuss it here. Again all three of the above lenses can be used with the close-up outfit for close-up photography. The 28mm lens is however considered the vital **close-up** lens. This technique is extremely useful for larger subjects and results in the same crisp focus and colour-rich image quality as macro. Here a single auxiliary lens is clamped *over* any of the three primary lenses, and each is combined with its specific frame. The set-up works at a preset distance of 23.5cm/9.25in for all three combinations. These extensions *can* be removed during a dive for photographing larger subjects with the 35mm lens alone, an option usually used by day.

The close-up formula

Nikonos recommends that beginners set the shutter speed to 'A', **focus to infinity**, aperture to f/22, and the strobe to TTL, for the duration of the dive.

MORE ABOUT YOUR EQUIPMENT

The **framer** outlines your picture area, *except* for a small 0.6cm (0.25in) buffer zone around the inside. This excludes from an image both the framer and anything positioned inside the buffer zone. Thus

Opposite To attain results like these, deliberately position your framer for the most pleasing composition.

important parts, like claws and antennae that contribute to a subject's 'completeness', must not extend into the buffer zone. The framer also approximately outlines the **plane of sharpest focus**, and must be positioned *around* that part of the subject you wish to see sharpest. Test yours for its accuracy. It is important to understand that depth of field is very limited in close-up and macro photography.

The macro depth of field at f/22:
• For a 2:1 tube-and-framer is 0.3cm (0.125in)
• For a 1:1 tube-and-framer is 0.6cm (0.25in)
• For a 1:2 tube-and-framer is 1.2cm (0.5in)
• For a 1:3 tube-and-framer is 1.9cm (0.75in).

Obviously there is very little room for error. The placement of your subject within the safe zone is therefore critical. This always applies, irrespective of whether you photograph all or part of the subject

There are limitations to framers. Not only are they incapable of some angles of perspective, they are also intrusive. It is difficult to coax fish into them, except where they have been 'tamed' and very nervous creatures are always problematic. You must accept that some subjects are simply inaccessible to this system, either by being too tightly tucked into small spaces or by being too skittish.

THE HOUSED SLR SYSTEM

The macro lenses (50mm-60mm, 90mm, 100mm, 105mm, 200mm) combine tremendous magnification ratios with virtually unlimited versatility in perspective, composition and photographic angles. They deliver intimate eye contact with marine creatures while avoiding intrusion into their spheres of safety. So, while mastering housed macro lenses may be slightly more difficult and may not immediately yield the same ratio of success as framers, perseverance and practice will render the most gratifying rewards.

TECHNIQUE

The most important rule for macro photography is to choose your subject with care: colour reigns supreme, followed by personality, detail, beauty or rarity, and interest. Good subjects photograph well.

A common beginner's mistake is to take a top view of the subject. This produces a boring, flat image that lacks perspective and depth. Whether creature, polyp or reef feature, always have your subjects face the lens and photograph them either from the horizontal or in three-quarter profile. With framers the buffer zone can cut off lower parts of the subject. One option is to slightly bury the framer in the sand, short of the subject, and then to slowly advance it in position. Don't push too far, position

Right A low viewpoint creates a sense of intimacy with this tiny nudibranch and its world.

Far right Delicate polyps positioned against a black background to emphasize their translucency.

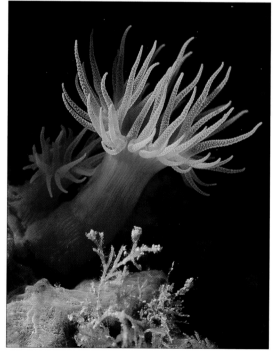

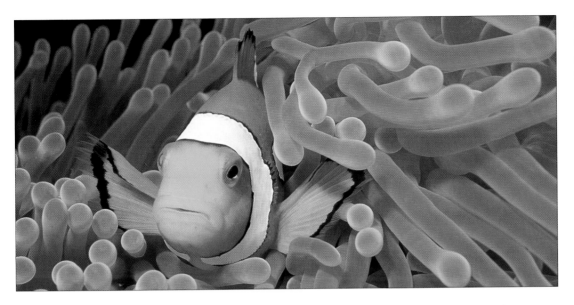

Left In one single moment, mood, focus and personality suddenly come together. This is called the 'peak of the shot'.

the frame outline – the approximate sharp point of focus – over the creature's eyes. Grazing molluscs, hermit crabs and nudibranchs can be shot like this; if they retract their eye-stalks, antennae or gills, simply wait. Reposition yourself and try different angles that will best isolate and portray the subject.

Here are other useful macro tips:
• You may have to capture a creature unexpectedly and quickly, so avoid rapid hand and fin movements at all times. Even the slightest pressure wave could stir up storms of sediment that will ruin your shots.
• Always wait for and capture action, or the sense of it – a lift or tilt of the head, claws to the mouth, a beautifully flaring fin, a yawn. This 'peak' will lend impact and immediacy to your image.
• Capture 'couples' – two of a kind in the same image seem to create a special sense of endearment.
• Do not cause egg-producing creatures to move – photograph the behaviour.
• Diaphanous or translucent subjects such as Spanish dancer spawn-roses, tube anemones, and larger coral polyps are extremely beautiful when back-lit, or against a black background.
• For subjects that shy away or retract from light, fit your dive light with a tiny slip-on diffuser which will dim the beam.
• If your subject stays put, compose a variety of shots. If the creatures you are photographing are initially skittish and move around a lot, be patient and try again, but avoid any stressful tactics. If you're gentle they usually realize quickly that you

mean them no harm and they will then pose more willingly for you.
• By day, consider using a restful blue-water background for macro and close-up subjects. But meter and expose manually!

Perfecting the image

The narrow depth of field with macro photography forces you to consider the plane of the subject in relation to the orientation of the film plane. If these are kept parallel, you will attain maximum sharpness. Flat subjects close to their background are easily oriented this way. But a parallel plane is less ideal for creatures or small fish.

Thus, if your subject is situated at an angle, you must decide where the 'in-focus' area is. Place your subject towards the front of this area, and only then decide where to position your point of sharpest focus. This is done more accurately with an SLR camera than framers, although experienced Nikonos photographers know their set-ups so well that they almost consistently attain perfect placement of the sharp focus point.

When focus cannot simultaneously be sharp on the mouth and eyes of a subject facing the camera, you must compromise. While keeping depth of field in mind, place sharp focus somewhere between eyes and mouth, so that both are rendered acceptably sharp. Otherwise change your composition to a sideways shot for sharpness, but compensate this less interesting angle with a more creative perspective, perhaps shooting upwards from below.

Portraying a diver in the underwater world makes it accessible to the viewer, as if they were sharing in the beauty and excitement.

WIDE-ANGLE PHOTOGRAPHY

Looking through the wonder lens

To capture the very essence, the adventure and the mystery of the underwater world, there is only one lens – wide-angle. If you are a photojournalist at heart this is your tool! Wide-angle is the technique of the advertising, editorial and publishing photographer – these images are more popular and more widely utilized than any other.

The very magic of the wide-angle lens depends on close proximity and sharpness. While combining flexibility and variety with unbelievable depth of field, these lenses allow the photographer to be extremely close to subjects, yet still record breathtaking wide views. The result is a sharp, colourful and awe-inspiring image.

EQUIPMENT

The Nikonos system offers the coveted 15mm and 20mm lenses. Because these combine with top-mounted viewfinders, parallax error occurs. This aberration usually only becomes critical in subject distances of 60cm (2ft) or less. The range is further extended with the Aqualens in combination with certain top-side lenses.

For SLR a wide range of focal lengths like 14mm, 15mm, 16mm, 18mm, 20mm and 24mm can be used, or can be extended by the more specialized extreme fish-eye lenses.

Wide-angle lenses are ideal for capturing large subjects in their entirety, at close range. Because of their extreme depth of field these lenses are forgiving of focus, although this does not mean that focus control should be ignored. Since they can be used at short distances they are very useful in turbid water.

SUBJECTS, COMPOSITIONAL CONSIDERATIONS AND TECHNIQUES

The **paramount rule** for wide-angle photography is getting close. This is crucial and cannot be emphasized enough! You will get sharper, clearer and more richly coloured images the closer you are to your subject. But decreased distance has other effects: it shortens the path of your strobe light to and from your subject. This is essential particularly to attain richness of colour for subjects like fans and soft corals. On the other hand, for subjects with

extremely reflective white underbellies, like sharks, a reduction of strobe power may be required.

Generally, try to shoot at smaller apertures as they increase sharpness and depth of field, while decreasing subject-to-strobe distances; f/22 is preferred and more easily attained if you shoot upwards toward the surface, but sometimes circumstances may force you to use larger apertures.

As wide-angle lenses are ideal for wildlife, a knowledge of subject behaviour is extremely important. Obviously scenic fixed subjects like huge soft coral trees and fans do not swim away, but for marine wildlife, the question must always be: whether you can get close enough for the wide-angle of your lens. Some creatures may shy away from close encounters. Others – like sea lions – although usually tolerant, may become increasingly frantic the closer you get.

The **second important rule** is to *always* compose through your viewfinder. If you compose by the naked eye, your subjects will not only look distant, but the final result may be very different from what you had anticipated.

The **third rule** is that *unless* you can get extremely close to the subject, a very wide-angle lens is not recommended. Here behavioural knowledge allows you to make correct choices between modest wide-angle lenses, such as 28mm and 20mm for shy subjects like sharks, or ultrawide 15mm, 14mm and 13mm lenses for subjects like manta rays, dolphins and whale sharks. Remote subjects will appear too small in extreme wide lens images to have sufficient impact. The exception, of course, is silhouettes.

There are several different wide-angle situations, any or all of which can be encountered during a single dive.

Available light silhouettes: This style, while in tones of monochromatic blue, captures the scale and magnitude of the ocean like no other. Silhouettes may occur at any time during the dive, thus remain alert to the possibility as you may suddenly have to switch off your strobe. Diver and marine life combinations may leave you only seconds to get your shot. Strong graphic shapes and suitably large, recognizable subjects always work best for silhouettes. Try to include a sunburst – a strong compositional

For wide-angle impact, move closer to your subject and always compose through the viewfinder.

WIDE-ANGLE PHOTOGRAPHY SECRET

For optimum impact for fixed features such as corals and fans, do not take the shot unless you can almost touch the subject. A good wide-angle lens can focus down to as little as 25cm (10in).

87

Right *Silhouettes require large recognizable subjects and perfect ambient light exposure.*

Opposite *Large wreck structures cannot be lit by strobes. Good composition and ambient light mood creates the impact.*

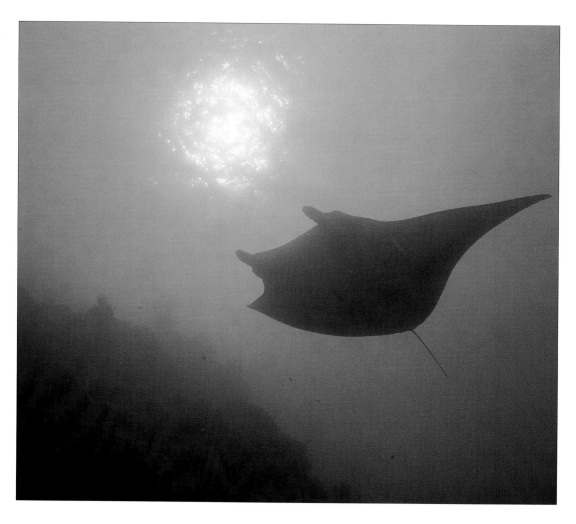

WIDE-ANGLE SUBJECT DISTANCE TIP

A common error made by beginners is to have too much space between their subject and the picture frame edges. This is because the picture area of this lens is so large.

If the composed scene looks just about right to your naked eye, you need to at least *halve* the camera-to-subject distance before you compose in the viewfinder and release the shutter!

element – while cave-, crevice-, and key-hole openings offer a beautiful window effect that is dramatized when filled with divers, fish and possibly light beams.

Available light scenic seascapes are possible, but less spectacular than their strobe-lit counterparts. While ideal for large marine life close to the surface, try more unusual subjects such as coral heads, groups of sea fans, schools of fish, huge sponges. Don't forget the shallows, where you may very well obtain interesting sunlit colour to convey a variety of moods with subjects such as coral, fish, divers, canoes and boats.

People and marine wildlife: Divers in underwater images give a sense of scale and create the sensation of the viewer 'being there' – even if they are non-divers. Photograph divers interacting with large groupers, eels, manta rays, stingrays, dolphins, turtles, sharks and seals – *but* please do so in an environmentally friendly way. Ego-tripping divers hanging on to creatures are *out*!

Divers photographed on their own will appeal to the audience only from a human 'adventure and discovery' aspect. Thus they should be shot looking active and interested, exploring the reef walls, swimming next to or through huge schools of fish or observing reef animals. A sense of activity can be introduced by having the model light or point at a subject as if it were just detected.

Marine animals on their own and huge schools of fish are superb, if sometimes difficult, subjects. But photo dives with manta rays, whales and dolphins, or the stingrays at the legendary Stingray City in the Cayman Islands are almost unthinkable without wide-angle lens capability.

Wide-angle wreck photography: If you are a wreck nut, wide-angle is your lens. It is useful in turbid water as it can focus at short distances, taking in all of the scene, even interiors. Since the most photogenic wrecks tend to lie in deeper water, where they remain intact longer, the photographer must deal

with the additional limitations posed by decreased bottom times. Plan such dives even more carefully; tuck in, clip and streamline your diving hoses and keep your camera system to the absolute minimum with synchro-cords coiled out of the way.

A camera-free dive may be needed to scout out the best features, props and angles, as well as available light, sun position, effects and dramatic blue water backgrounds for depth and contrast. If you plan to use a model, he/she should accompany you on this reconnaissance dive. Even then you may need several dives to get the ultimate shot.

Do not be tricked into boring (and confusing) images that show flat wreck features against a distant wreckage background. The secret is to position yourself for dramatic perspective. Look for suitable angles from way down below that will give you an impressive 'towering' effect and that will isolate the subject against water.

Wrecks also offer opportunities for capturing divers in structural 'frames' or actively discovering interesting artefacts. If you are using slow film speeds, you may have to drop your shutter speed to 1/30th second for still subjects, provided that you can brace your arms or hands and squeeze the release rather than jerk it. Ektachrome will render royal-blue backgrounds and even tint slightly green water blue. On really deep wrecks you may have to use much faster film.

With experience you may want to consider using slave strobes for interesting light effects. For now use your buddy as model, watchdog and assistant and have him/her 'hide' a hand-held light behind portholes and galleries or inside a cabin. As you start the ascent, remain on the lookout for wreck inhabitants, which look stunning against the angular lines of a wreck.

Perspective trickery: An interesting aberration of wide-angle lenses is that objects close to the lens appear disproportionately larger, while those further away appear disproportionately smaller. Usually called 'steepened' or 'forced' perspective, this can produce dramatic, creative wide-angle photography. Nevertheless, care must be taken when using this distortion, especially when photographing people. Any parts extended forward of the body plane toward the lens, such as arms and hands, will be treated similarly by the lens and thus will look dreadfully unnatural.

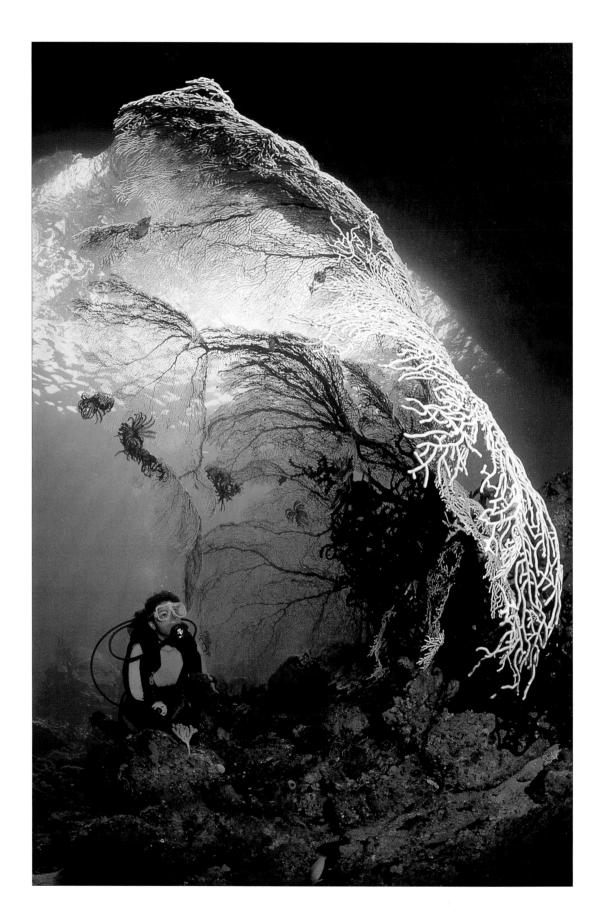

Sophisticated use of CFWA produces impressive scale. This diver is seemingly dwarfed by the sea fan.

CLOSE-FOCUS WIDE-ANGLE PHOTOGRAPHY

This is a technique that delivers perhaps the most beautiful, dramatic and creative of all underwater images. However, while we frequently gasp at these astounding pictures, we usually fail to classify them as anything other than 'wide-angle' shots. In reality, these images combine two techniques in one – stunning and detailed near subjects with the colour and quality of macro photography and the big picture drama of the wide blue underwater background.

TECHNIQUE

Although simple, the technique is not used nearly enough, perhaps because it is not fully understood. Because wide-angle lenses can focus down so closely and have such extreme depths of field, all of the compositional elements can be captured in sharp focus irrespective of their distance.

Just a single twist of the focus distance to minimum turns the wide-angle lens into a close-up lens with a 94° angle of view – no close-up attachments, no extension tubes, no wire framers! One minute you can shoot a creature as large as a whale shark or manta ray; the next, you can zoom in on a grouper that is just 30cm (12in) long, and include the little cleaner wrasse in its mouth!

The secret is to select a subject and position it so that, however small, it will completely dominate the foreground and indeed, the image. It must be colourful and dramatic and have a beautiful backdrop of blue water. The dominant subject is illuminated entirely by strobe, and is placed extremely close to the lens – as close as 25cm (10in): set your lens to the minimum focal distance (prefocus SLRs) for the foreground subject and move correspondingly close to your subject. Remember, this is essentially a close-up shot – accurate distances really are crucial. For a background variation you can include distant subjects, like a diver or a burst of sun with glimmering shafts piercing the water.

Shoot at f/22 if possible. To achieve the smallest possible aperture, meter and shoot at an upwards angle. This increases depth of field. If you can steady the camera and no other movement is involved, this can be enhanced by a low shutter speed (1/30). These measures help increase depth of field and decrease strobe-to-subject distance. A slow shutter speed may

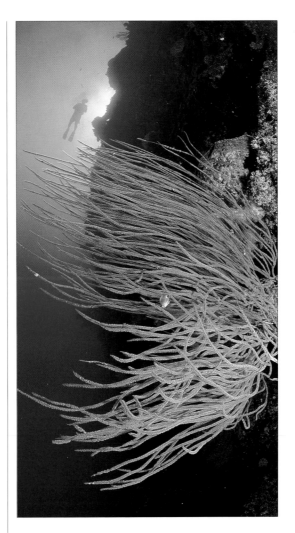

A distant diver, positioned beyond a stunning foreground subject – this is a popular and easy-to-duplicate CFWA technique.

also help you to retain detail in the ambient light background. You may however have to adjust your strobe via power settings or diffusers in order not to overwhelm the foreground subject with light. Use your exposure chart.

Foreground exposure is a critical tool for creating dominance. As your foreground subject is the dominant one, rather compromise in your background exposure if you must. Aim your strobe to eliminate backscatter. If you shoot with one strobe, try top- and side-lighting the subject to distribute your light more evenly and to avoid the flash fall-off sometimes encountered with an f/22 aperture.

Finally, include vertical picture formats as they work very well for this technique, but remember to reposition your strobe.

A word of warning for Nikonos V users: you must be adept at correcting for parallax because of the close distances at which the image is shot.

THE SUNBURST TIP

Use aperture control to expose for the sun: stop down to f/16 and perhaps even f/22. This will give you a small sunburst that adds to the picture, rather than overpowering it.

To capture sun rays in water, use a fast shutter speed.

MEDIUM-RANGE PHOTOGRAPHY

With standard lenses

Medium-range photography produces close intimate images of the reef. But in many instances, close-up photography bridges the twilight world between macro and medium ranges and it should not be forgotten. This is particularly so for housed SLR cameras, as 50mm, 55mm and 60mm macro lenses are capable of both techniques.

EQUIPMENT

For the housed SLR, medium range is accomplished with 50mm to 60mm lenses, or with any medium range zoom lens. The techniques remain the same as for any of the macro or wide-angle situations, and therefore need no elaboration here. The rules for success though, are very similar to those for the Nikonos system.

Small schools of fish are ideal standard lens subjects.

For the Nikonos V system, medium ranges are achieved with standard lenses and this is therefore an important technique for beginners. The 35mm and 28mm lenses are the most economical and usually the first that beginners use. The 35mm is called a standard lens because it has the same angle of view as both a 50mm top-side lens and our eyes on land; it covers a picture area of about 60 x 90cm (2 x 3ft) at an apparent distance of 90cm (3ft).

The biggest error that photographers make is to use these lenses like snapshot cameras – the results are almost always disappointing. Usually the images are a monochromatic blue, with the subject appearing much smaller than anticipated. This is not the fault of the camera; the lenses must be used within the range of their capabilities and limitations.

Both the 35mm and 28mm lenses are excellent for diver head-and-shoulder photography, large fish portraits, small fish schools, large anemones, and small reefscapes. Of these two lenses, the 28mm lens has a closer minimum focus distance. The 28mm

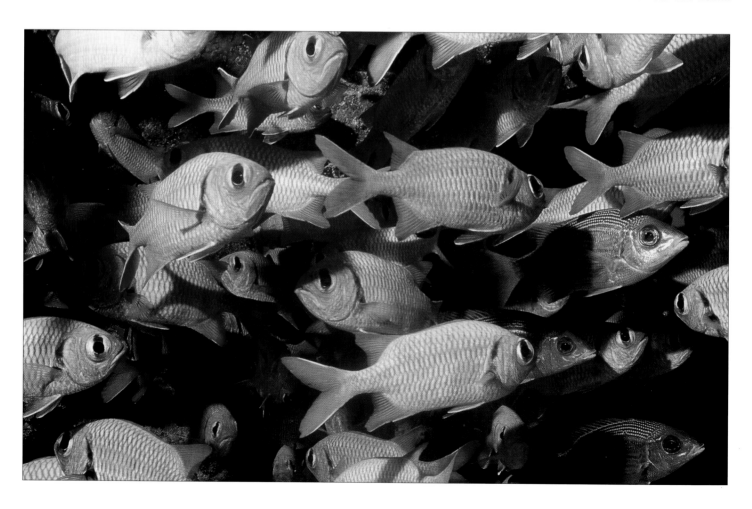

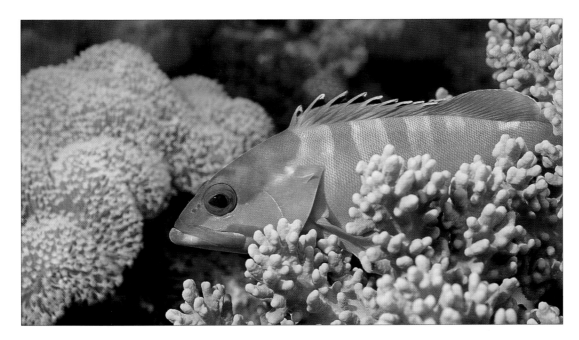

An intimate mood is best attained by moving in close and framing tightly.

lens also gives a somewhat wider angle of view, but should under no circumstances be considered a true wide-angle lens. These lenses are for getting close – face to face – no further than 60 to 90cm (2 to 3ft) from your subject; that is, just about an arm's length away! The only exception to this is when capturing diver silhouettes.

The secrets of medium-range lens success are:
• Never aim your camera down. At least aim it horizontally, but preferably with an upward slant.
• Small subjects are simply not suitable for photography with the Nikonos 35mm and 28mm lenses – subjects *must* be at least 60cm (2ft) long. Groupers, stingrays and large moray eels make excellent single subjects. If you cannot find a fish this size, look for a small school! Grunts, emperors, snappers, jacks, and soldierfish are excellent schooling subjects.
• Shoot only if *at least* 60% of the viewfinder frame is filled with your subject – preferably more. Ideally fill the frame so that the subject appears almost too close to the edge of the frame. Note how 'wrong' this picture looks in the viewfinder in order to compare the result and adjust your composition in future. An anomaly of the Nikonos V built-in viewfinder is that it shows only about 85% of the true picture area, while small subjects appear much larger than they will in the photograph.
• If you get blurry results with the Nikonos 35mm lens, it is due either to camera motion or the limited depth of field of the lens; correct lens-to-subject distance is critical. As it requires less light, a higher ISO film will allow smaller apertures and thus greater depth of field.
• The true picture area is even larger for the 28mm lens, so, while you can use the primary viewfinder of the camera, better results are attained with the special 20/28mm auxiliary viewfinder with the 28mm mask in place. But then you have to refer back to the primary viewfinder for metering and seeing the LED display. Don't become confused! The parallax markings in this accessory viewfinder are easy to use and apply to the minimum focus distance, which is 60cm (2ft). The trick is to first compose your picture in the viewfinder, then tilt the camera up until the parallax indicators are exactly at the top of your desired picture area.

TECHNIQUES

Silhouettes: Upward silhouettes are wonderful for introducing and ending underwater slide shows and can be taken from much further away with these lenses. The further the subject distance, however, the greater the loss of colour, contrast and sharpness. Defined large shapes work best. Don't forget to switch off your strobe and change the shutter speed. Outline silhouettes against bright surface water, point your camera at an acute upward angle and get as close as you possibly can, particularly if you want detail in coral subjects.

THE EASY RECIPE FOR HOLIDAY PHOTOGRAPHERS

• Use ISO 100
• Set the camera to 'A' (Nikonos) or 'Aperture priority' (SLR)
• Set the strobe on TTL
• Set an aperture of:
 f/11 between the surface to 10m (33ft) f/8 between 10 and 20m (33 and 65ft) f/5.6 or f/4 in water deeper than 20m (65ft)
• Nikonos: Preset focus for 90cm (3ft), with either a 35mm or 28mm lens and stay between that and 1.2m (4ft) away from the subject
• SLR: Prefocus 50mm lens for 90cm (3ft) and get this distance from your subject, then fine-tune focus
• Compose and shoot.

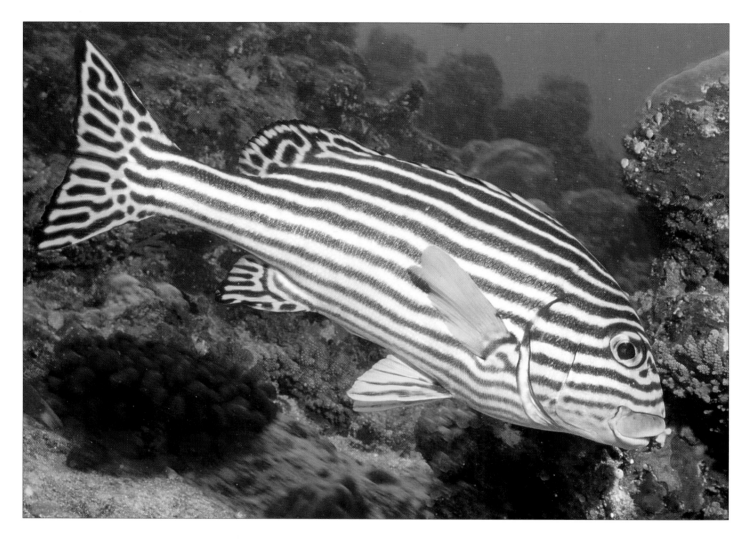

Above Large fish are ideal subjects for imposing standard lens photography.

Opposite Composition is, in effect, cropping on the reef.

Fish: The easiest recipe is to preset focus for the minimum distance – which is different for the 35mm and 28mm Nikonos lenses! You can shoot with your strobe on TTL, but beware if your subjects are off-centre, small or slim. If the TTL feature is thrown off, your exposures will be ruined! In such cases, switch to manual strobe exposure.

A mounted strobe is easier to handle and usually kinder to the environment. Change to hand-holding strobes only when more experienced and when you are able to control circumstances.

Divers: Preset the lens for its minimum focal distance and use either TTL or manual strobe exposure. Rather than just photographing the diver/s, find beautiful soft coral features to frame them or a marine animal such as a friendly grouper for them to interact with. Measure the distance from your diver: for the 35mm lens your outstretched arm should be just beyond fingertip reach; with the 28mm lens lessen the space to about mid-wrist. Lift your camera and shoot, while maintaining this distance.

Snorkellers: These, along with divers near the surface, make excellent medium-range subjects, provided you set your strobe for bright exposure and aim it upwards to illuminate any shadows. In this case the camera-to-subject distance can be slightly more, about 30cm (1ft) beyond your fingertips.

Special effects: Air often becomes trapped inside caves and wreck compartments, forming mirror-like pockets. These can reflect divers for a stunning special-effect shot. Avoid exhaling into the air pocket and disturbing the smooth and reflective surface. Aim your strobe down to the diver so that it will not light the reflection. Expose for skin tones and if possible, bracket f-stops. Remember, if you can't see the reflection in your viewfinder; then neither can your camera. Reflections in divers' masks can result in prize-winning images.

EVALUATING RESULTS

This is the moment of truth! For those of you using slide film, hopefully the fortune you spent on photographic equipment and film left you with some small change to buy a good quality photographic loupe (eyeglass) and light box. The results of your first roll, neatly snipped into lengths and slipped into protective sleeves, finally awaits inspection.

There are no bad shots, only learning experiences. The evaluation and analysis of your photographs is your final and perhaps most effective learning tool. Good shots confirm success, but should nevertheless be appraised, either for repetition or further refinement. Less successful images should clearly show specific problem areas: composition, exposure, lighting, focus or backscatter. There is great merit in logging errors under such headings, using the shot numbers imprinted along transparency frames. This clarifies which problems occur most and whether they do so intermittently or sequentially. It clearly pinpoints occasional mishaps or areas that need further attention. Over time even your camera may emerge as the culprit. While the idea is to persevere, you can now do so intelligently. Do not let initial disappointments dishearten you. Analysis, understanding and subsequent practice will drastically improve your success ratio.

LEARN FROM CROPPING

Once a film is developed, gone are any chances to change focus, composition, perspective, depth or mood. This is where you learn that composition is essentially cropping on the reef. The expense of ignored compositional rules catches up with you on the light table. But unlike the multitude of opportunities you had underwater, you are left with only one further choice on land – cropped duplicates.

Yes, you can retain the most pleasing portion of a picture and enlarge it to fill the frame. Yes, you can change horizontal into vertical format, eliminate some backscatter and cut away errant diver fins or hands at the edges. You can also compensate about half a stop overexposure and about one stop underexposure – within limits.

This is a job for the experts and proportionately costly. The trade-off is always sharpness, detail and perhaps even colour saturation. The more an image is manipulated, the higher the price.

Film laboratories employ something called a 'cropper' to experiment with different options for cut-aways. Make your own economical version: expired credit cards, cut into two durable L-shaped angles, make an admirably adjustable cropping frame. By moving these in or outwards, you will quickly see whether a shot is worth saving.

In money terms, cropping by duplication is usually only worthwhile if you are dealing with a rare shot, although its value as a publishable photograph is then lost. Changing from horizontal to vertical format, for example, may lose you as much as half of the image quality.

However, even if it is not executed, the cropping exercise is invaluable as a learning tool. The mere visual impact of how composition should have and could have been will undoubtedly teach you much.

NIKONOS V – FRAMING FOR FORMAT WITH PARALLAX

For a horizontal picture format, frame your subject in the lower half of the picture area in your viewfinder.

For a vertical picture format frame your subject in that half of the picture that is closest to the camera body. Beginners should remember that the strobe should always be at the top for a vertical frame.

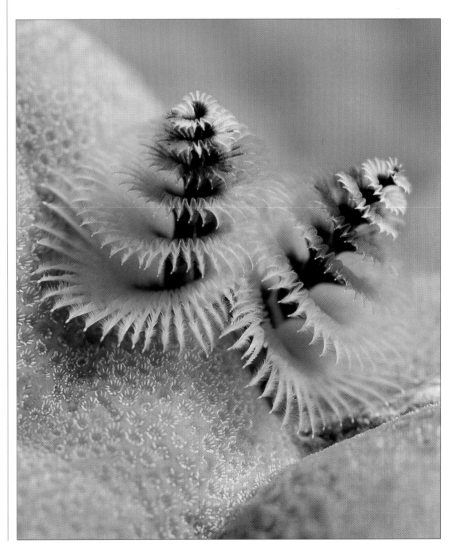

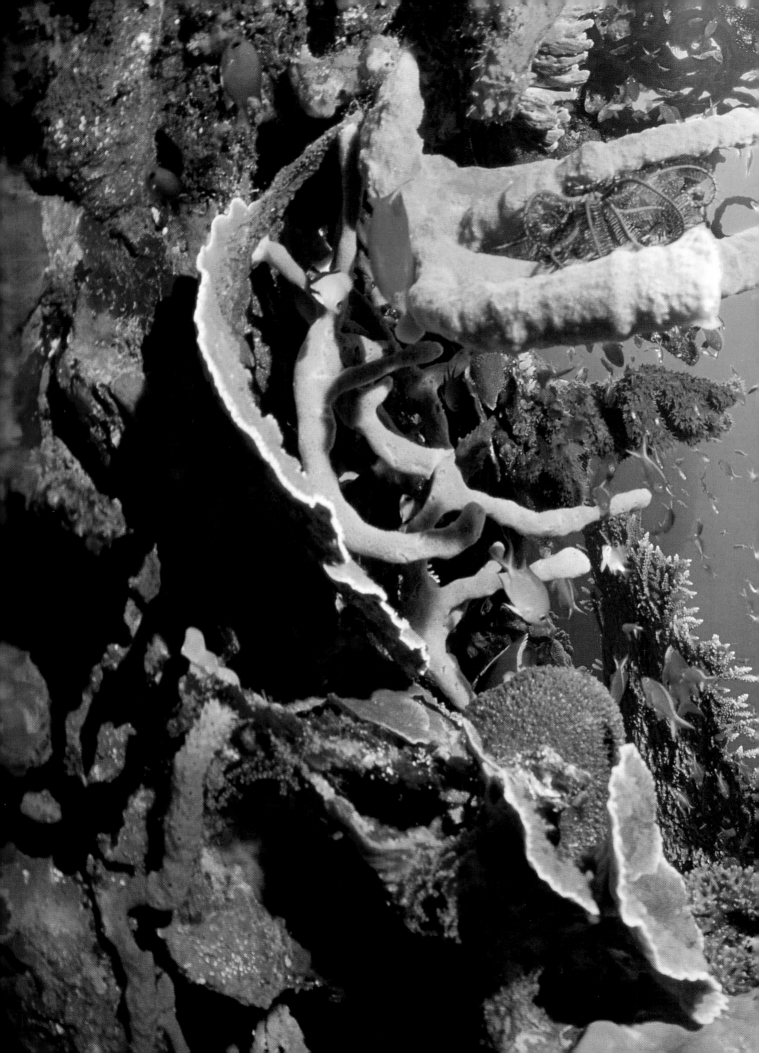

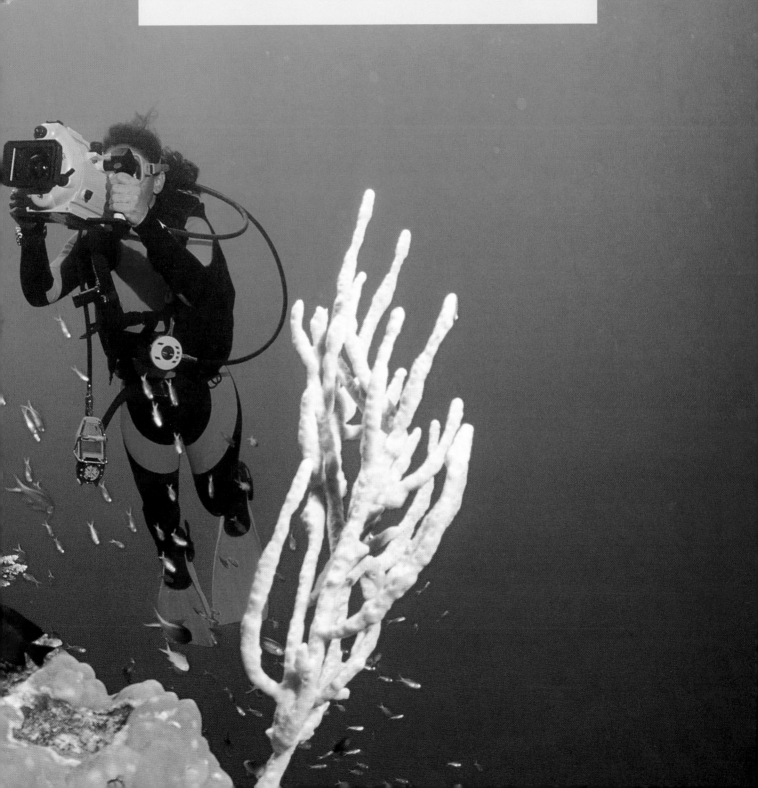

VIDEOGRAPHY

VIDEO – DYNAMIC MOVEMENT

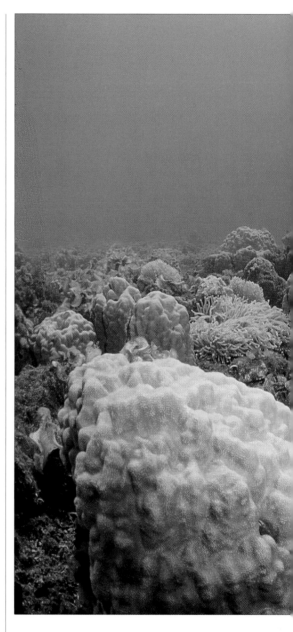

You will be astonished at how easy it is to shoot video underwater! You can do it even before understanding any photographic principles or techniques. Set the camera to automatic, load it in the housing and go! Underwater, aim at your subject, press record and shoot. Your camera will automatically adjust exposure and focus. When you get out, plug into your television set and relive the excitement of the dive – in awe of your photographic skills, you will probably be instantly hooked on video.

Looking at your tape a second time round, you'll be struck by some wobbles and incorrect angles which will invariably have you say: 'Hey, I can do that better!' That is the beauty of video – it is an instant instructor that makes it easy to learn as you go along. Suddenly you will realize that however exciting the results, and however thrilling it is to see yourself and your buddies perform, there must be more to video than this! There is.

VIDEO TECHNIQUES

Simple video camera housings usually restrict the control of functions to the bare necessities of on, off and zoom – in which case the camera is operated in the automatic mode. As housing sophistication rises, so does the choice of control buttons and the freedom to manipulate camera capabilities. The most

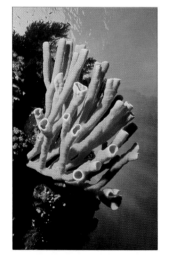

With stationary subjects, it is the photographer who provides the movement that retains the dynamics of video.

sophisticated housings allow access to virtually every camera control with a choice of operating in the automatic or manual mode, different shutter speeds and apertures. These can broaden the scope of videography considerably.

However, it is not technical features that make videos good. Many international awards have been won by videographers who shot in the automatic mode using simple domestic cameras. Enjoyable videos originate in the brain: with good techniques and camera control any videographer can make an interesting, polished production.

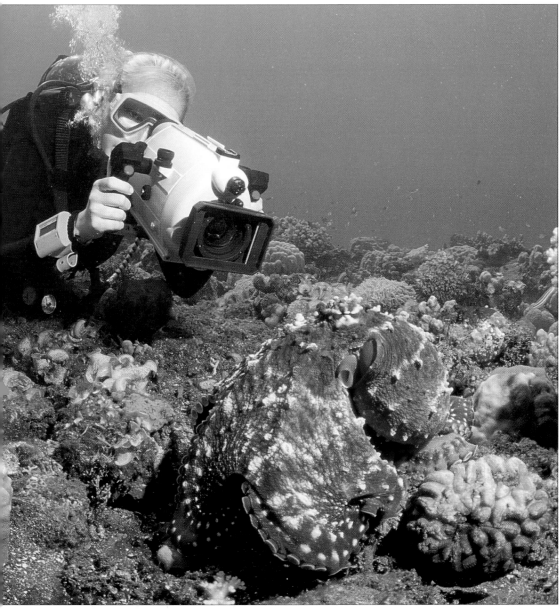

Video is the perfect medium for capturing marine animal behaviour.

CONTROLLING THE CAMERA

You will be free to employ your creative talents to the full if you know your camera and can operate it in its housing by feel and without hesitation. You need to fully understand the main features and their functions. Learn where controls are positioned, and whether they move forward, backward or depress. This should be practised on dry land. Don't try to solve problems underwater.

There is a great deal of variation to be found in cameras and housings, and it is therefore imperative that you read and follow your instruction manual.

Camera features and functions

Focus refers to picture sharpness: a camera focused for 1.2m (4ft) produces its sharpest focus at that distance. This can be done manually or with autofocus. In front of or beyond the set focus distance, things will very gradually appear less and less sharp.

If your camera has a **full-range autofocus macro lens**, it will focus from less than 2.5cm (1in) in front of the lens to infinity. If you have a **standard lens with macro mode**, you will be able to focus from 1.2m (4ft) to infinity – but for macro mode, you will have to depress and lock the macro mode button

with a cable tie. This enables you to focus from about 2.5cm (1in) to 1.2m (4ft), but you will be committed to macro distances throughout your dive.

Most lenses of either kind are **zoom lenses**, which means that you can set them for different focal lengths from wide-angle to telephoto. The zoom rate does not depict magnification per se; it only represents the magnification ratio between wide-angle and telephoto. Indicated in numbers like 8 x zoom, 10 x zoom and 12 x zoom, this merely means that if compared, a subject in wide-angle will appear 8, 10 or 12 times larger (closer) in telephoto.

The **focal length** and **angle of view** indicate how much of a scene the lens sees. When 'zoomed out', the focal length is shortest and the angle of view widest, and vice versa. Don't compare video lenses with still camera lenses. What you do need to know is that video cameras come with 'wide-angle' or 'normal' lenses and that these can be further converted. Housings usually come with or have optional accessory 'wide-angle' and 'macro' converters.

A **normal lens** shows near and far subjects with 'normal for the eye' perspective. A **wide-angle lens** affords a much wider view. This allows you to shoot much larger subjects, and include everything from much closer distances. The advantage is that it reduces the water column between camera and subject, resulting in sharper, more colourful images. A wide-angle lens, through its wide-angle perspective,

can also influence how two subjects, one behind the other, appear. To be successful for video, for example, a diver should be placed unnaturally close behind a reef feature in order to appear distanced normally on the TV screen.

An actual zoom with the zoom feature of your camera is very seldom used in the final production of a video, as it usually appears contrived. As a rule it should only be employed to decrease or enlarge the size of the subject in the viewfinder. For colour and quality retention, zoom with your fins – this gets you close to your subject, which is where you should be.

Depth of field is that area extending in front of and beyond the sharp focus point at a set distance, that still appears 'in focus' (*see* page 50). Think of it as a safe in-focus margin. With video, this is quite a substantial area. Unlike still cameras, video cameras do not have depth of field indicators because it is not such a critical factor with this medium.

Aperture is an opening that allows light to pass through the lens (*see* page 48). When we set a video camera to the auto mode, it will automatically select a suitable f-stop for exposure in any given situation, except when the lens points into the sun or at a very reflective area. In some housings, f-stops can also be set manually, allowing you to decide when to open up or stop down. This is useful when you shoot a dark subject against a reflective surface, such as sand. In automatic mode, the camera will incorrectly expose for the sand. If, however, the aperture control is accessible, you would *open* the aperture.

Screw-on conversion lenses are usually wide-angle and are thus added to the camera lens to change its focal length. This serves the major goal of underwater photography: to get closer to the subject and still capture it in its entirety, even if it is very large. Some top-of-the-range housings provide very sophisticated extreme wide-angle and macro accessory lenses for more dedicated, professional work.

Shutter speed is a system that controls how long an aperture f-stop remains open. Usually video cameras operate at 1/60th or 1/100th of a second. Higher shutter speeds are sometimes used for fast-moving subjects to avoid blurring.

White balance is one of the most important controls for video and can make or break the colour quality of the finished product. The white balance control 'instructs' the camera to treat whichever light source it uses as white. This becomes the point from

For a skittish subject, get as close as you can and then employ your zoom for a frame-filling image.

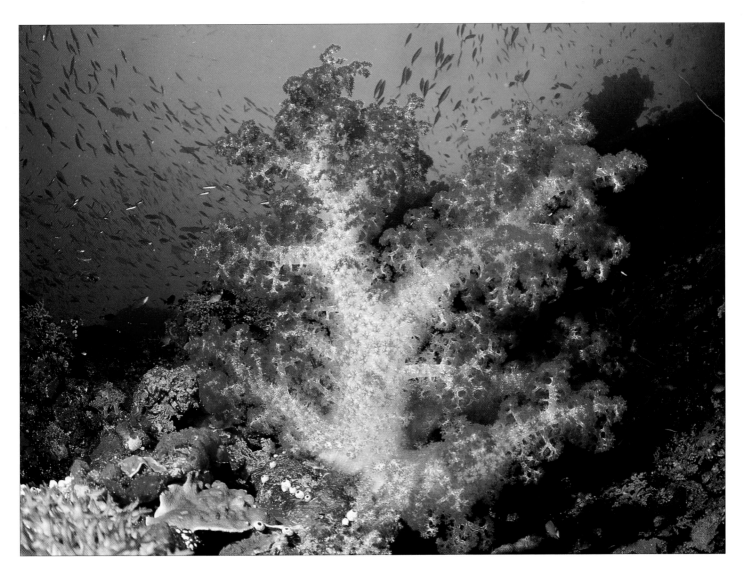

which all other colours are calculated. Correctly used, it causes all other colours to appear natural in the recorded image. A selection can be made between four basic automatic settings:

1) The **sunlight setting** is used when you are shooting in bright, naturally sunlit water, where you would use video lights only to fill in shadows.

2) The **indoor or artificial light** setting is used when the video lights provide most or all of the light (usually for close-up subjects). This should always be used with video lights at night. The setting can also be used if you shoot with a reddish colour-correcting filter in water shallower than 4m (13ft). When the camera is set to automatic, the white balance works quite well when you frequently change between sun and video light during the same dive.If you operate in manual mode, white balance must be preset.

3) The **hold white balance** setting can usually only be engaged in more sophisticated housings. This allows you to set or change white balance underwater. The feature can also be used for sophisticated colour effects. On land, for instance, a sunset can be made to appear more vibrantly orange by tricking the white balance sensor into accepting complementary blue as the white standard. As a result orange is overcompensated. Likewise, a blue seascape can be forced to appear even bluer if orange is the white balance point of reference.

4) The **auto-lock setting** of video cameras locks all functions in the automatic mode. It must be engaged if you wish all functions to be fully automatic and disengaged if you wish to control the camera manually. In housings which allow the use of both modes, the auto-lock is normally left disengaged.

A correct white balance setting is necessary to capture the vivid colours of corals and blue water.

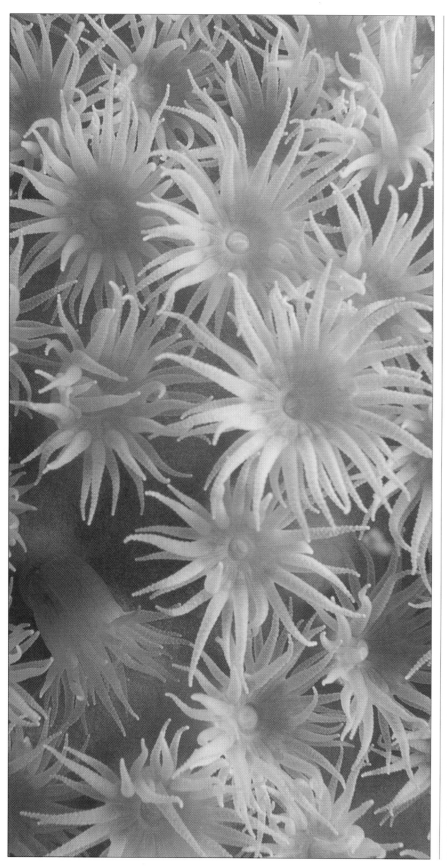

Focusing your camera

In **automatic mode**, your camera focuses once it sees the subject as constant. This causes a slight time lag before it reacts accurately. Sophisticated housings allow you to switch to manual focus at the press of a button, for situations in which autofocus does not function well, such as dim, low-contrast subjects, in extremely dirty water or during panning. A subsequent return to autofocus is achieved by means of another control.

As autofocus is triggered through the central area of the lens, you must take some precautions:

• Autofocus works well if there is both contrast and texture in the central picture area.
• Autofocus works well when a subject fills the central area of the viewfinder.
• Remember autofocus time lag. Trigger the camera to stand-by, aim it at the subject for a few seconds to engage autofocus, then shoot.
• Autofocus is unsuitable for panning because it gets confused. As the subject changes in the fast-moving scene, it starts hunting, searching continually for the best focus between minimum distance and infinity. In dirty water, autofocus tends to settle on nearby suspended particles rather than the subject, especially when you use lights.

Manual focus gives you more control, and allows you to avoid any such momentary focus shifts:

• First, however, physically establish the camera-to-subject distance.
• Aim the camera at that area which you want to be depicted sharpest – for people and animals, this is usually the eyes.
• Zoom to telephoto (the closest distance) and manually focus for the sharpest image in the viewfinder. In some cameras, telephoto may not focus closer than about 1m (3ft).
• Then, while retaining your camera-to-subject distance, zoom out until you attain the desired picture area (image size) in your viewfinder, and shoot.

If your camera is capable of the switch between **auto- and manual focus**, then you can use them combined. Autofocus determines the distance and manual focus then fine-tunes the focus:

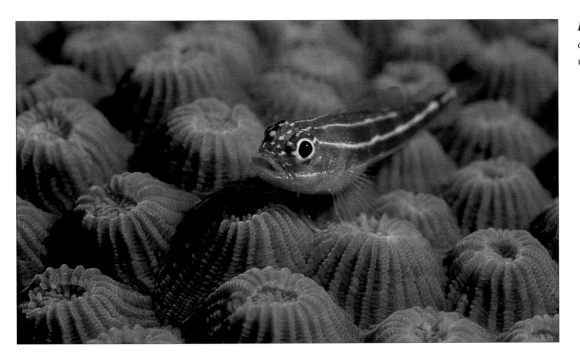

Left *Patience is the key to capturing the miniature worlds on a coral reef.*

• First establish camera-to-subject distance.
• Aim the camera, in autofocus mode, at the area of the subject you wish to be sharpest.
• Zoom in to telephoto and wait for the autofocus to react.
• Without changing your camera-to-subject distance, trigger the manual focus. Then zoom to the desired picture area and shoot.

The same procedures can be used with full-range autofocus macro lenses. Practise these focusing techniques on land until you can use them smoothly.

Macro mode focus

If your camera's macro mode must be engaged for it to be used, lock it in place with a plastic tie-wrap prior to housing the camera. Then focus as follows:

• With the macro mode button locked in, disengage the auto lock.
• Set for manual focus.
• Use the zoom control to focus.

The macro mode button must be locked, because the manual mode setting in this case has little to do with actual focus – zoom control takes over. Were the button not locked, you could zoom out of the macro mode and then be unable to reset it without taking the camera out of the housing.

Viewfinders

Most modern video cameras have adjustable electronic viewfinders. To enlarge the viewfinder image for comfort, housings usually have adjustable accessory magnifiers. Make the necessary adjustments to the viewfinder while wearing your dive mask, by rotating the magnifier and looking at the sharpness of the letters displayed in your viewfinding screen.

Most photographers secure this setting by gluing it in place. Multiple users may have to paint colour-coded marks, matching one on the fixed part with another on the rotating ring. This allows you to return to your particular setting easily if it has been changed, although checking the setting must then become a standard rule.

In water you will at times look exclusively through the viewfinder, which will stop you from seeing anything else coming from the side. Rather learn to establish the picture area in the screen, but then view over the top of the housing while holding it several centimetres in front of your mask, with both eyes open. This works especially well when shooting moving subjects. Another trick to get adept at is looking at the screen with one eye, while aiming along the camera side with the other. Of course, all of this is not necessary if your housing sports a small on-board accessory LCD (liquid crystal display) monitor.

The most common beginner's mistake is to search for the subject with the camera lens, thereby causing

Opposite *Video is capable of exquisite macro photography, but it needs a steady hand or another suitable method of steadying the camera.*

undesirable hunting camera movements that look awful on screen. Try the discussed method instead, using the viewfinder only for stationary subjects.

Signal displays

You may come across various signal displays on your screen underwater. They usually indicate things like low battery power or the end of the tape. But some are warnings for more serious problems, such as moisture condensation. Check your manual for signals that may apply to your camera.

Artificial light helps you to capture vivid colour. Don't forget to switch to this setting if you use a colour filter.

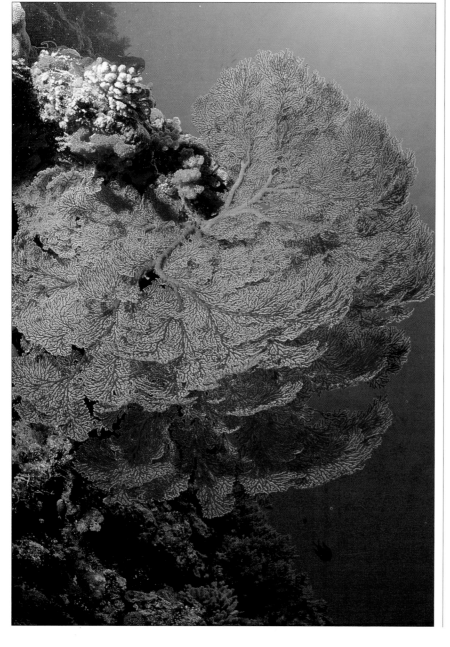

LET THERE BE LIGHT

In shallower tropical waters, most video shots are perfectly lit by sunshine. Even at considerable depths, video cameras are so sensitive to light that many scenes can be shot without video lights. Below 4m (13ft), you can significantly enhance colour and visual quality and dramatically improve the recorded quality of scenes if you use a red colour-correcting filter when you are not using lights. Above this depth the colour-correcting filter should not be used as it will cause an unpleasant overall reddish cast unless switched to the white balance artificial light setting. Deeper, below about 20m (65ft), the filter loses its effectiveness and should be removed.

If you want to both show detail and have vibrant, luminous colour bursting from your footage, however, you must use artificial light. Of course, this applies and is only effective if your subject falls *within the range* of your light beams. For example, if you glide towards a sea fan with your lights on, the image will gradually change from its apparent neutral colour to a gentle pink followed by a vivid orange-red as you get close enough for the light beams to reach the entire fan. To me it is quite simply unthinkable to shoot without video lights.

Artificial light cannot reach out far enough for extreme long shots and these will usually have a blue cast – a factor videographers are forced to work with; but for medium-close to close range, they make a world of difference to the visual quality and impact of a shot.

An added benefit is that using lights forces you to move closer to your subject, to place it within the beam range. You can use your colour correction filter with lights. But remember to *either* remove it *or* change your white balance to the indoor setting when working at close distances (around 1m [3ft], or less). This is one of the reasons why I favour colour viewfinders in underwater cameras. You can immediately see when the colour becomes too 'hot'. With most modern housings the colour filter can be removed with the flick of a lever; in others they must be pulled off or unscrewed.

Lights can also be effectively used to add both colour and silvery reflections to large moving schools of fish, even from as much of a distance as 2 to 3m (6.5 to 10ft). They must, however, then be repositioned for this purpose and aimed at the same wider angle and direction as the camera.

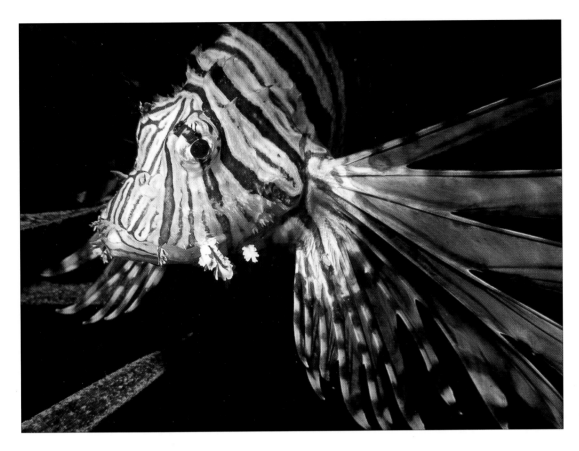

Because of their curiosity, it is easy to capture the beautiful patterns and haughty demeanour of lionfishes.

Because video lights give off a constant beam, they are much less complicated to aim than a still camera strobe; it is immediately evident when the actual rather than apparent subject is properly lit. But videographers often forget to check the position or re-aim their lights, which results in unexpected hot spots, uneven lighting or missing illumination.

Sunlight and contrast

Direct, bright sunlight is often more of a problem than a help because of its two extremes – overbrightness and/or high-contrast shadows in the same picture. Video cameras cannot record this evenly. The overbright areas record as 'burnt out', lacking all detail and appearing white, orange or yellow on screen. Deep shadows normally record only with very strong light which again aggravates brightness.

Photographing at depths below around 10 to 12m (33 to 40ft), where the light is more diffused, is better in overbright conditions. You should still take precautions as burnt out areas may still occur when you are shooting with the camera pointed upwards. Turning your back to the sun or getting in the shadow of a boat, reef wall or coral head will also help.

Alternatively, create silhouettes with a halo of radiating rays by placing your subject in front of the sun.

If you *increase your shutter speed,* your camera will prevent sunlight from overpowering the automatic exposure control. In manual mode, if you adjust the iris control to *decrease the aperture,* then you also decrease overall brightness. You may want to group your shots in separate high-contrast and overbright sections, so that you do not continually have to adjust. It is, however, usually safest to avoid high-contrast scenes except when you must have the shot.

Cloudy days

Contrary to logical expectation, cloudy weather is wonderful for video! Clouds diffuse sunlight into a much more flattering glow and remove all the high contrast problems that videos handle so badly. Most people look better photographed in diffused light, and overall scenes improve because harsh shadows are eliminated.

The only precaution here is to stay out of depths of more than 20m (65ft), which is not difficult because most of the best action takes place in shallower water anyway.

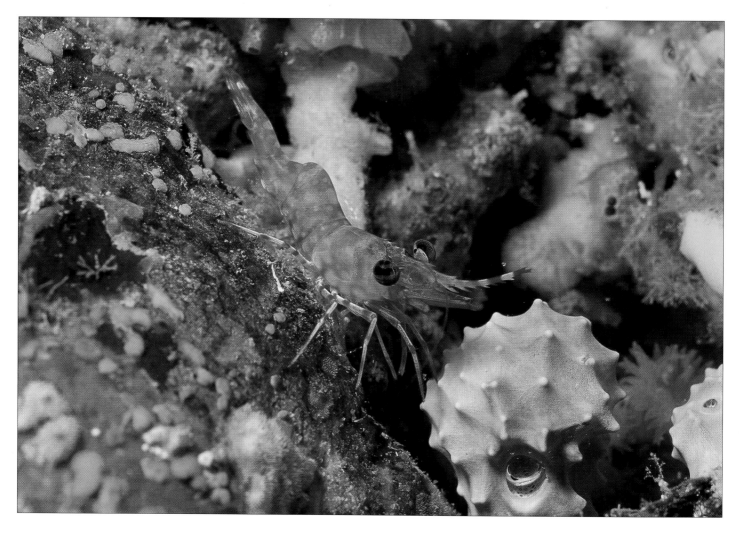

Flat ports are meant for macro subjects.

Lens ports

Simple-to-use housings usually come fitted with **flat lens ports** because they are able to cater for a wide range of situations.

The way in which light rays are bent underwater creates a magnifying effect and, as a result of this, subjects appear around 33% closer than they really are. This is because the lens registers the subject in exactly the same way as your eyes do when looking through the flat port of a face mask. Thus, what you see through the viewfinder is what you get.

More sophisticated housings come with both flat and dome ports, or can be so accessorized. A **dome port** is half-spherical and is used for wide-angle photography with the aid of wide-angle converters. Such converters should not be too heavy for the autofocus motor to cope with. The camera must, however, be able to focus down to at least 30cm (1ft), because the dome port acts like an extra lens:

focused on a subject about 2m (6.5ft) away, it will appear to the camera lens as if it were only 30cm (1ft) away. The wide-angle lens and dome port combination retains the focal length of the lens, and thus increases depth of field – as much as 30cm (1ft) to 6m (20ft) in bright conditions, adds sharpness at the edges and contributes to colour saturation. This can hide minor incorrect focus settings.

The **optical centres** of the dome port and wide-angle lens must be perfectly aligned. The centre of the lens diaphragm should be at the geometric centre of curvature of the dome port. If, in air, you take the port off from the housing while the camera is fitted, you can measure this and ensure that the camera is situated correctly. As the focus is usually preset, you must proceed according to the manufacturer's instructions. In the case of autofocus lenses the lens is allowed to find the subject's focus and can then be locked in by way of manual focus.

PRESETTING A CAMERA FOR FOCUS

There are several methods used to preset a camera for differing light conditions and different ports:

FLAT PORT AND SUNLIGHT

1. Disengage auto-lock
2. Set shutter speed to 1/60 or 1/100
3. Attach colour filter if necessary
4. Set lens for widest zoom setting
5. Set white balance for outdoor
6. Set auto-focus control
7. Set camera to stand-by
• Skip 8 & 9 to stay in autofocus
8. Zoom to telephoto to autofocus
9. Reset manual focus to lock focus
10. Load camera
11. Once in the water, zoom to desired picture area
12. Shoot the subject.

Note: External or lever-controlled sliding colour-correction filters can be removed or engaged underwater. Remove above a depth of 4m (13ft), or engage indoor white balance and remove below 20m (65ft) of depth.

FLAT PORT AND VIDEO LIGHT

1. Disengage auto-lock
2. Set shutter speed to 1/60 or 1/100
3. Set lens for widest zoom setting
4. Set white balance on indoor for close-up
5. Set white balance on outdoor when exceeding 60cm (2ft)
6. Set white balance to auto for mixed
7. Set for auto-focus
8. Set camera to stand-by
9. Turn video light on
• Skip 10 & 11 to stay in autofocus
10. Zoom to telephoto to set focus
11. Reset for manual focus
12. Once in the water, zoom to desired picture area
13. Shoot the subject and turn light off.

Note: Internal colour-correcting filters must be removed for close-ups with video light and medium distances when mixing sun and video light. External or lever-controlled sliding filters are removed underwater for the same situations.

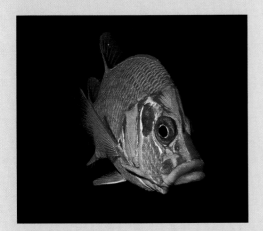

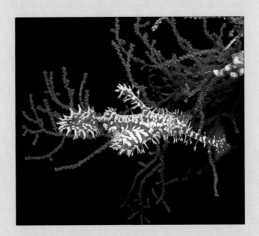

WIDE-ANGLE LENS, DOME PORT AND SUNLIGHT

1. Disengage auto-lock
2. Set white balance for outdoor and attach colour filter
3. Attach wide-angle lens
4. Set lens to widest zoom
5. Set focus to manufacturer's instructions
6. Set for stand-by
7. In water, shoot subject.

WIDE-ANGLE LENS, DOME PORT AND VIDEO LIGHT

1. Disengage auto-lock
2. Set white balance for indoor and remove colour filter
3. For wide-angle close-ups, set white balance to indoor and use no filter
4. Attach wide-angle lens
5. Set for widest zoom setting and set focus to manufacturer's instructions.
6. Set to stand-by
7. In water, turn video light on and shoot.

PERFECTING YOUR VIDEOGRAPHY

The wonderful advantage of videography is that you will almost certainly attain good results immediately and any mishaps and boring bits can be discarded during editing!

Videos are always more exciting if the videographer has a set goal and a positive prior attitude. The aim of a successful video movie should be to entertain, so imagination, creativity and an ability to see the unusual is vital.

Good video stories not only have a beginning, middle and an end, but also rhythm, drama and humour. By taking editing into account as you learn to shoot, your footage will become more versatile and concise for postproduction.

PREPARING FOR A SHOOT

Before installing the camera, submerge the housing in water to test for leaks. If it is going to leak, it will do so just below the water surface. Remove, dry and open the housing.

Clean and lubricate the sealing surfaces of the housing and close it. Preset your camera controls (if necessary). Place the camera carefully in the housing, and avoid pinching wires or bending rods. If the camera is mounted on a slide, look through the viewfinder while positioning it to check for vignetting – two darkened corners indicate that the

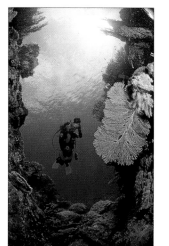

Wide-angle lenses best capture the grandeur of coral reefs.

camera is not properly centred, and four show that the camera is set for too wide an angle.

To test these control functions, close the housing and trigger the camera to stand-by, record, stand-by, off. Avoid preparing your camera in air-conditioned rooms. If you must, insert a silica-gel sachet and close the housing *before* you leave; condensation then forms on the outside of the housing.

In water check for leaks once again by holding the camera lens port pointed down, lifting it above your head and watching for droplets on the inside of the port. (Your housing may have a leak-warning signal.) You should keep the camera steady and aim horizontally or upwards.

After the dive – rinse your camera in fresh water. Rinse and dry yourself, and *then* dry the housing. Do not let *any* moisture into the camera. Unload the camera and prepare for the next dive. If you are returning to an air-conditioned room, wait until then to open the housing.

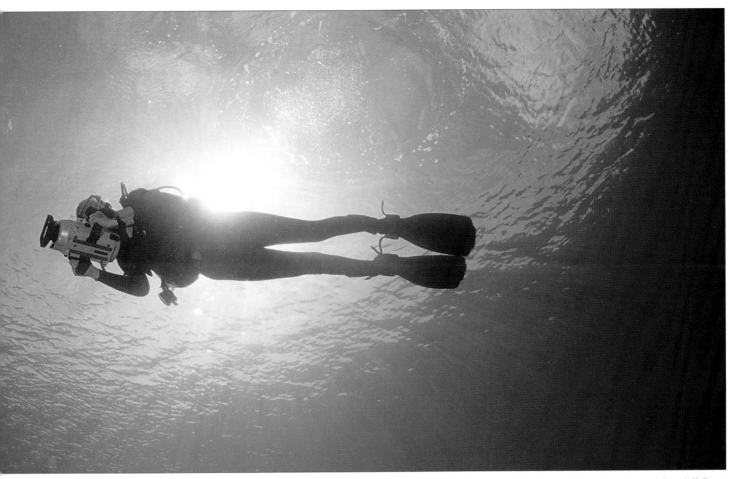

Perfect buoyancy is the secret of the frequently used mid-water free-fall float.

VIDEO SHOOTING TECHNIQUES

The key to success is mastering four techniques that will help you to produce a polished, professional-looking result:

- Hold your camera steady during shooting
- Practise camera handling techniques
- Use professional shooting techniques
- Understand how to shoot for editing.

Keep the camera steady

Video is intended to capture dynamic movement, both with a stationary and moving camera. To keep the TV screen image easy on the eye, the camera must either move smoothly without side wobbles or be kept absolutely still. The problem is that the camera is attached to your body – *you* are in control!

The secret therefore lies in **body control**. Without it, even the finest equipment money can buy is worthless. You cannot keep the camera steady if your fins and hands are constantly moving to keep you from sinking. You should be able to hang in mid-water, neutrally buoyant in a perfectly relaxed skydiver's **free-fall float**. While horizontally prone, hold the camera with your elbows slightly bent. Stretch your body gently, extend your legs, keeping your fins a little apart. You should be able to hold that position, almost motionless, for several seconds. Natural in- and exhalation should rise or sink your body ever so slightly, but don't deliberately try this; uncontrolled raising without exhaling can give you an air embolism.

You should also be able to hold a **vertical hover** for several seconds, again with your fins slightly parted. The secret is to be perfectly weighted and to have almost no air in your BC. Any shift of air or weights will throw you off balance; stop and adjust your air or reposition your weight belt if you tend to tilt during a video dive.

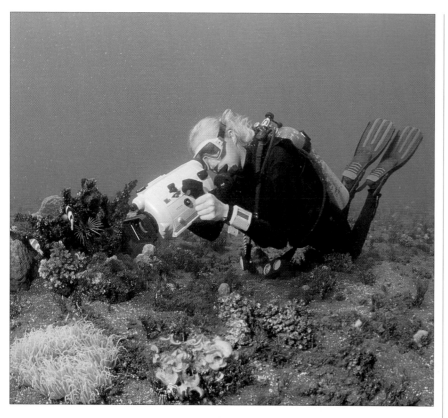

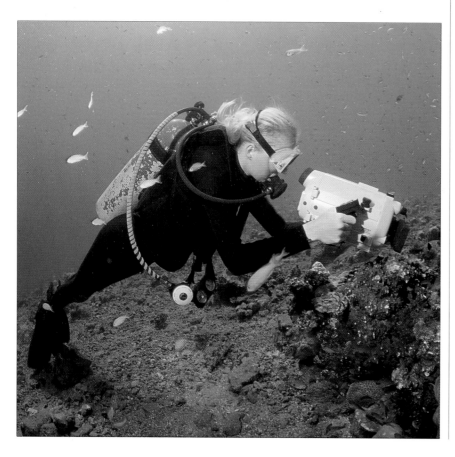

Your **camera** should also be almost **neutrally buoyant**. If it tilts in any direction it will unbalance you and cause wrist fatigue. Test your system in a swimming pool or rinsing tank. Add weight by taping squares of lead sheet to the housing with duct tape (better housings have weights for this). Increase buoyancy with taped-on neoprene or foam pieces cut from fishing-net floats. For overly heavy systems a neoprene body-stocking, holes cut to accommodate controls, works well and protects the camera from bumps. Or fit a hollow aluminium float.

Finally, deduct the weight of your camera from your weight belt, but remember that you may be too buoyant should you no longer hold it.

Camera handling techniques

Practise these techniques in water, while recording, for at least 10 to 15 continuous seconds each. Afterwards, evaluate the results: your subjects should appear steady on the screen and moving camera shots – such as panning, tilting, tracking or zooming – should appear smooth and natural.

1. **Stand or kneel:** Find an appropriate sandy or dead patch and practise shooting while standing or kneeling. Aim to hold the camera as steady as possible – brace your elbows against your body or stretch your arms out and keep your fins slightly apart.

2. **The self tripod** helps you settle on a sand or silt bottom without causing clouds of sediment. Find a patch where you would create clouds were you to make careless movements. Settle gently in the prone position. Brace yourself with your fin tips and the fingertips or knuckles of your left hand.

3. **The self bipod** follows the same method as above, but as soon as you are steady, reach up and add a little air to your BC. Aim for just enough to lift your upper body slightly so that you no longer require the support of your left hand. Your legs and fin tips form the bipod.

4. **The mid-water free-fall position** is used for shooting stationary subjects. Hold for 10 seconds, then change to the vertical position, fins slightly apart and pointing outward.

5. **The tilt:** Slowly tilt the camera upwards toward a stationary subject, while your body slowly sinks. Let some air out of your BC to become less buoyant, then sink with your knees bent. The rate of descent is controlled by pointing one fin outward and the other backward and down.

6. **The zoom glide** is a smooth, gliding shot that allows the image size to slowly change from small to large as you approach. Because focus problems occur easily during zooming, it is almost always better and more natural-looking to 'zoom with your fins'. Lying horizontally, give a few forceful fin kicks, then stop, stretch your body and use the impetus to glide smoothly over a distance. Practise the glide, photographing sideways, with upward and downward angles, and with level approach. Remember to exhale when you glide upwards! This method is very useful for fish photography.

7. **Circling around:** The aim is to smoothly circle around your subject without losing body control. Start with a strong gliding zoom, keep your body alongside the subject, but aim your camera at the subject throughout. Circle around the subject, steering gently with one fin, as you end the zoom glide.

8. **Follow the movers:** When following a moving subject, fin smoothly and follow the general direction – do not follow the subject's every twist and turn. Allow the subject to swim out of the frame from time to time, but then shift your camera so that the subject repeatedly re-enters from the same side (usually left) and exits on the opposite (usually right). The same method can be used for tracking up and over reef scenery.

9. **The slow pan:** Kneel or stand on the bottom, then twist your upper body to face where the pan must begin. Start shooting while stationary, then pan very slowly, 'unwinding' your body smoothly throughout until the end of the pan. The winding/unwinding movement gives you steadier control. Decide beforehand on the beginning and end subjects of the pan, and allow for some steady footage of those subjects on either side. Vary pan speeds – try slow, medium slow, and very slow. You will find slower speeds more pleasing visually. Be decisive – don't retract, search, or backtrack once the pan begins, unless you want to simulate a diver's searching viewpoint.

10. **The swim-along pan:** While swimming along slightly abreast of a moving subject, aim sideways and keep the subject centred in the viewfinder throughout. Either the subject or you must move slightly faster. If necessary practise this with another diver. As camera drag will slow you down, both of you should swim at moderate speeds.

11. **The overhead twist and turn** is a creative camera movement to show a subject approaching, swimming

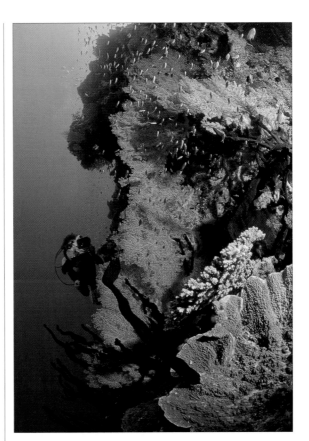

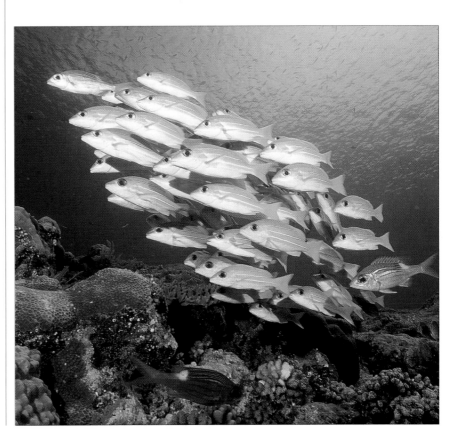

Left and Below
The zoom glide provides a sense of motion and dynamics with stationary subjects. It also helps you to retain the symmetry of a school of fish.

Opposite top
The kneeling posture. Always use an appropriate sandy or dead patch.

Opposite bottom
The self bipod posture. Do not touch live coral.

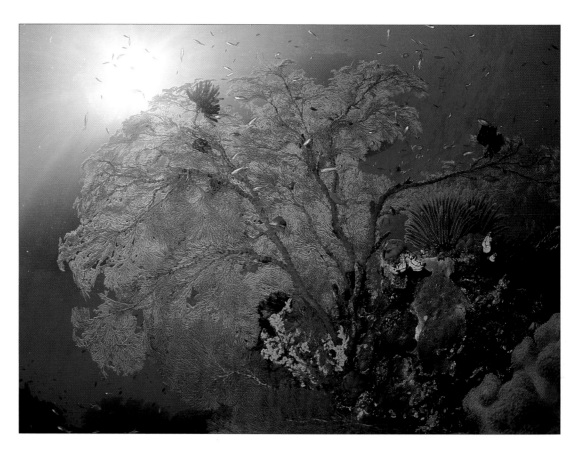

Use your fins, rather than the camera feature, to zoom in on your subject.

overhead and then away. Stand or kneel on the bottom. Have your buddy swim over you from quite a distance away. Begin shooting the approach. While shooting, begin tilting the camera upwards to follow the movement and at the same time smoothly rotate your body through 180° just as the diver passes directly above you, continuing as he swims away. Do not exhale as the diver passes overhead, to avoid your own bubbles in the shot.

12. **Scene entry and exit:** To help you start and stop your camera smoothly, leaving editing handles at either side of a shot, aim at a preselected scene and have your buddy swim in, stop, look at something, then swim out of the scene. Begin shooting early and stop well after the swim-through ends.

13. **The viewpoint swim:** To simulate the diver's viewpoint by aiming the camera ahead of you while swimming smoothly and slowly. Avoid camera rocking. When you simulate a creature's viewpoint, photograph the area it normally inhabits, simulating its movements. Surprisingly this is much easier than holding a camera still when you are stationary.

14. **The 'me-myself-I' scene:** You can shoot yourself against a moving background – by activating the camera, holding it at arm's length, lens pointing at yourself, twisting your body, and swimming at the same time. This sounds contortionist, but is actually easy to do. You can also rest and level the camera on dead coral, a rock or wreckage, and turn on record. Then swim into view, doing or looking at something actively and swim out. On the reef floor, position your camera on a mound of sand and turn it on. Swim around and approach from the opposite side, low down. Perhaps stop, and inspect a reef floor inhabitant. A proper tripod is ideal for this.

When you are adept at these techniques, begin to combine them. You can, for example, pan and tilt or glide and circle. 'Zooming out' can be done by swimming backwards, and often looks smoother for soft corals along reef walls than swimming forwards.

Sea conditions can also be turned into movie tools. Using my fins for control only, I have taken some of my most spectacular coral reef tilting and tracking shots in raging currents! Drift-dives are ideal to propel you smoothly while adding sinking tilts or rising tracking shots. These effects closely emulate professional film-making vehicles such as 'booms' and 'dollies'.

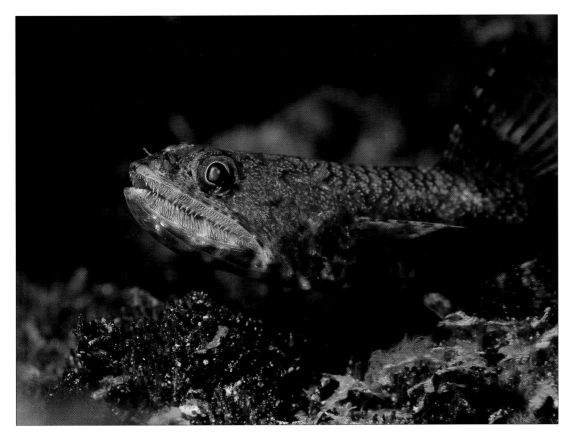

Always shoot for an audience. Viewers are intrigued by unusual marine animals like this lizard fish.

SHOOT LIKE A PROFESSIONAL

Video is ideal for portraying the amazing life styles of marine creatures within the brilliance of their busy environment. While you will seldom lack subjects or opportunities, *how* you shoot can have a profound effect on your final production. This is the raw material that will later tell your underwater story – whether it be real or fantasy – as if it happened before the viewer's eyes.

Three points to always bear in mind while you are filming are:

• Always shoot for an audience
• Shoot to edit
• Edit to keep your audience hungry.

A good subject should make you forget the rest of the reef; spend time with it and photograph it well. It is far better to emerge with two or three good sets of footage than a mixture of average or even indifferent footage. In this way you can build up a useful, high quality collection with a minimum of useless and tedious footage to spool through.

Building sequences

Professional movie and video makers use repeated combinations of three basic shots to 'build' sequences or parts of their story. These are the long shot (LS), the medium shot (MS) and the close-up (CU). Each of these shots has a specific purpose.

When assembled in editing, these shots create the lively visual variety, excitement and tension that is so vital in holding the viewer's interest. The pattern of shots and sequences can vary from scene to scene, a factor used in editing to quicken or slow down the pace of events through the story. This creates the rhythm, mood and suspense of a movie.

In practice, this makes videography much more manageable as it enables the photographer to focus on smaller sections. But remember: to attain the visual impact and colour of full-frame pictures, it is crucial to get close to the subject. This visually transports your viewers to the heart of the action.

The concept of distance underwater is dramatically different from that on land. A large primary subject should preferably be nearer, but never further away, than about 2m (6.5ft). Beyond this distance you will only produce 'blue' movies!

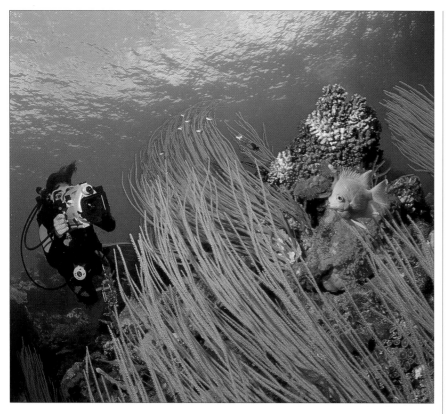

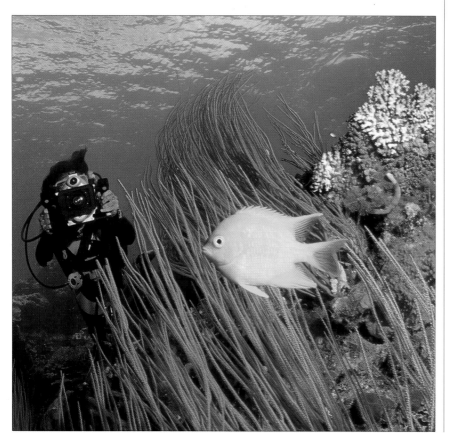

SHOTS AND SEQUENCES

The long shot (LS)

This is usually a wide-angle shot of a scene that serves to link the viewer to the environment – it **sets the stage** for things about to happen. This does not necessarily mean that you shoot the entire coral reef nor that you are particularly far from your subject; the distance span of an LS and the picture area depends entirely on the importance or size of the subject. You could for instance zoom glide in on a wreck, making it 'emerge' out of the blue until it is finally recognizable. You could also pan across a small, nearby section of the reef and come to rest at the den of an eel. The smaller the subject, the shorter the LS distance becomes.

When the LS serves to set the stage it is an **introductory shot** that shows the terrain and environmental conditions; it may or may not include the main characters or 'stars' of the show. The LS helps viewers to understand the situation and anticipate any action that will follow. We can, for example, have divers enter the LS scene of the eel's den. The ensuing action is shown with medium and close-up shots. An LS employed differently can **re-establish the location** with a wider view of the action. This particular LS may well be from a much closer distance – it may show the eel's body protruding from the lair, swinging from side to side.

The LS shot may also be used as a **transition to a new location**, to bridge the gap between the last and next scene without unnatural 'jumps'. The eel is now retracting into its hole and the actors begin to swim away, out of the frame, seeking a new experience – later edited to the next shot. Finally, the long shot can be used to **end a scene**: the divers wave goodbye and slowly begin to swim to the surface.

The medium shot (MS)

The medium shot is much closer, but in terms of distance again dependent on subject size and importance. A medium shot of a diver would, for instance, show him from the waist up to just above the head. A much smaller subject, like a crab, will force you much closer and will still include the entire crab.

The MS is used to **identify the main subject** or its actions, after the introductory LS. Were the LS to show a fish-rich reef, the MS selects one specific fish, e.g. a yellow butterflyfish, isolating it from the confusion as the 'star' of the story.

The MS is also used as **the link** between an LS and a CU. A distant diver in an LS cannot abruptly be coupled with a CU shot of his hand stroking the eel. An MS of the diver discovering and approaching the eel, will smooth the connection.

But the medium shot is also **the key 'action' shot**. This is the shot that shows divers and/or marine animals interacting with each other and the environment. A diver studying clownfish is a good example: LS: Diver swims across the reef towards an anemone – location, conditions and anticipation. MS: The diver settles and begins to watch the clownfish action – identification of the main players, emphasis on the action.

The close-up (CU)

Don't let the term 'close-up' mislead you regarding distance; including a whale shark's face in the picture is a 'close-up', but very different from a hermit crab face and eyes in CU. In addition the ECU, or extreme close-up, also falls in this category, either as a shock shot or to magnify detail. In either case, distance and picture area are determined by subject size and the importance of what we want to show.

The CU pinpoints **the heart of action and reaction**. If your LS sets a coral garden scene and your MS identifies an anemone with its dancing clownfish as the main subject, CU shots will show the delicate waving tentacles, the rosy anemone mouth and detail of the cheeky clownfish diving into and nestling in its protective home.

CU shots can also show the reaction of participating divers – eyes rounded in astonishment, the crinkling of a smile – or a curious trumpetfish face poking down to watch the action. The CU **adds interest and variety** – it is the spice shot of the sequence.

Of course, a CU can also be used as an **unusual introductory shot**, provided it is combined with another shot. If, for example, you shoot two clownfish in an anemone CU, you can pull back to show the entire anemone, then pull back even more while tilting your camera upward for an LS of a diver/school of fish passing overhead. You don't have to follow the second subject at all as you have now introduced the environment and the message is distinctly 'underwater'.

Opposite and Below
The typical sequence contains a long shot, medium shot and close-up image. This helps the viewer to understand both the environment and the heart of the action.

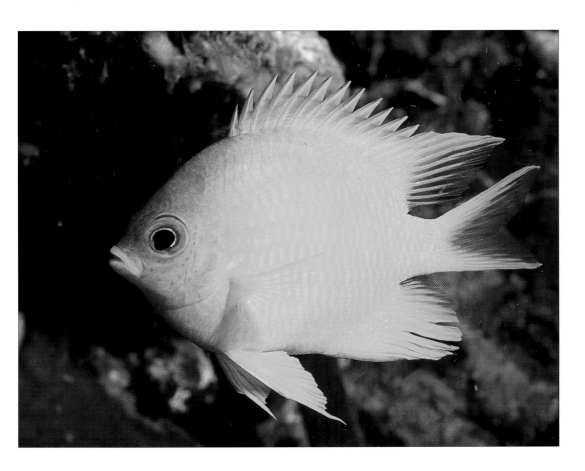

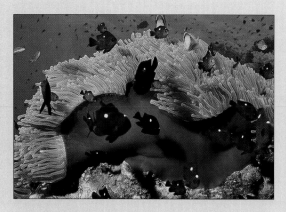

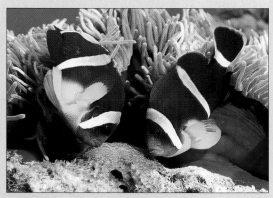

Think in sequence

The key to shooting a successful variety of shots is to **always consciously think in sequence**. This immediately directs you to look for the different shot lengths and angles, and to secure sufficient options for editing.

Of course, things do not necessarily get filmed in logical sequence! Situations frequently occur unexpectedly and may be over within seconds, so we must be practical. Any action, any 'uncontrollable' subject that may flee, and any rare or unique occurrence must be grabbed immediately. The more furious the action involved, the less you may be able to shoot sequentially. This does not matter as logical order can be created at the editing stage, provided you collect the other shots afterwards.

Stay with the scene after the action for matching shots and be alert to the potential of further matches on other dives. The movie cause-and-effect equation is a useful reminder: **cause, action, interest, resolve**. This with some imagination will help you find before-and-after shots with which to complete your story. Once action has calmed down, shoot long shots and stage them to relate to what happened. Edited, nobody will recognize that it was not taken before the action.

What happens if you simply cannot reconstruct a suitable beginning to some incredible, unexpected action? Shoot a diver who suddenly whirls around and looks astonished – the mood of 'surprise' should be very evident!

Time your shots

From pressing the record button until a picture actually appears and autofocus begins to react, there is always some time lag. Thus, good timing is essential for your sequencing techniques.

As a rule, start shooting early – preferably before the action – and stop shooting only when the action is completely over. A good five or 10 seconds either way will leave you comfortable before-and-after 'editing handles'.

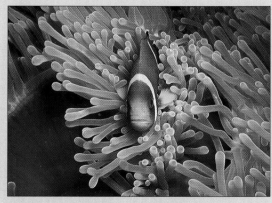

This first sequence of shots rapidly moves from LS to ECU, to tell the story of nesting clownfishes caring for their eggs.

When action is extraordinarily long, vary image sizes and camera angles by repositioning yourself frequently. To avoid surprises, leave the camera aimed and running while doing so.

Many photographers photograph and edit in-camera at the same time. I find it both difficult and limiting. In film-making terms, in-camera edits are called 'dirty', they seldom match the finesse, precision and effects of good post-production editing.

A **shot length** should rarely last longer than 15 seconds, unless the footage is really extraordinary. If you break this rule, make sure that you shoot for editing: allow the subject to move through the frame and to enter and exit intermittently, preferably always in the same direction. Also shoot complementary full-frontal 'into-the-lens' shots that can later be used to turn direction around.

Three single shots, lasting five or six seconds each, combine into a visually more interesting sequence, than one continuous 18-second, same-distance, same-image-size, same-angle shot. To train your eye,

watch action advertisements. Some have as many as 10 to 15 cuts within a 30-second period and yet, our eyes and brains register all the information! Variety keeps your audience awake, interested and hungry for more, thus riveting their attention to the screen.

Follow the **golden shooting rule**: if you change shots, also change angle or subject size or both. Use your camera zoom feature if you must, but only to change image size. You will seldom cut the actual zoom into your video since it is usually either too fast or too shuddery and, when overused, becomes irritating. For a zoom effect, use your fins to get closer to your subject.

Occasionally geographical features of a site or the anxiety of subjects make it difficult to reposition, forcing you to use your zoom for medium and close-up shots. Try to at least vary your camera angle when the necessary insurance shots are in camera. If possible, take extra shots of the same subject later.

Blend shots together: An MS of a school of fish, if done with the zoom glide, can effectively and very

The diver in this (second) sequence continues the story, and creates the impression that the first sequence is her viewpoint. The viewer identifies with her, creating a sense of active participation.

117

smoothly become a CU. A CU of an intricate subject can become an LS if you lift and tilt the camera or swim backwards. Analyze how certain camera-handling techniques lend themselves specifically to each of the basic shots. Combine them for creative effect.

It's okay to keep the camera still: Moving the camera continuously is one of the most common mistakes you can make with video. Keep the camera still and let your subject do the moving – let the action take over. Compare the effects with a moving camera for the same scene

Avoid vague direction: When the camera moves, it should do so with purpose and when it stops, it should ideally do so on a specific, preplanned subject. When panning, hold the camera still at both beginning and end. If you track upwards or sideways, stop and hold on the subject at the end. If you zoom, stop and hold on the subject. If you encircle a subject, hold at the end, then return and take an additional 'stationary' shot.

On screen, action and movement is exciting, but at times the viewer's eyes need to rest momentarily. By including controlled stationary shots you create the restful visual pauses.

Build a stock library

You will frequently find spectacular subjects that don't tell stand-alone stories. Shoot them nevertheless, with the same care you afford all important scenes. Close-up creature action and reaction shots with future potential can later be combined with other shots or interspersed as cut-away shots. Creatures emerging and peeping from their holes signal curiosity; creatures suddenly retracting indicate anxiety or flight from predators; a fish gill lifting for a cleaner shrimp is useful for cleaning station scenes; and territorial disputes for neighbourhood behavioural scenes.

Beautiful sunsets and sunrises, rainbows, canoes and boats from topside and below all can help relate to parts of stories, serve as transitions or effect powerful mood changes.

A systematically built stock library will offer you countless editing options later on. For example, subject action from one dive will be very easy to combine with diver reaction from another dive. I often edit together shots taken as much as three years – and sometimes continents – apart, with nobody being any the wiser!

Below right Decide on your picture size and then keep your camera still for active creatures.

Below Sunsets effect powerful mood changes and make perfect endings to dive stories.

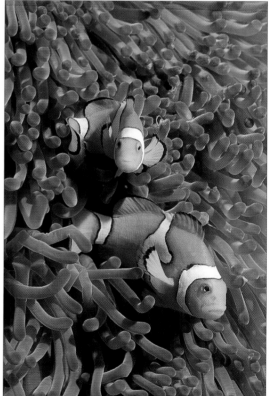

Add interest and variety

Because it records the world around us so well, we think of video as literal, as a transcription of reality. Not so! Reality only provides the raw material. Video material can be manipulated to exclude boring parts, compress time and to create action and tension, even if it did not exist originally.

The cut-in is essentially a CU or ECU taken when the camera moves in so close that just one important detail of the subject or action fills the screen.

Example:
- Your buddy is watching anemone clownfish (LS).
- You get closer and change position to shoot his upper body and facial expression, but include the darting clownfish (MS).
- Follow up with the diver's eyes, expressing surprise or astonishment (CU).
- In postproduction you will be able to link these scenes smoothly, regardless of the order in which they were actually filmed. What's more, you will be able to tell the entire story in about 20 seconds.

Remember: While furious action is going on, you must always look for other perspectives – perhaps some over-the-diver's-shoulder shots, full-frontal face shots, MS from opposite the diver with the subject wedged between him and your lens, fish darting out, others hovering, too shy to enter the fracas, the diver's eyes and smiles, etc. With these shots, you will later be able to make any scene lively and tense.

Adopt this style of shooting whenever it is possible and suitable. **Over-the-shoulder** shots provide both viewpoint and information – what is displayed when a diver reads his console, and what the 'something' is the diver has found in the MS. In close up the viewer 'discovers' that the diver found a delightful shrimp and in ECU he even sees the creature's eyes and feelers. Shots like these literally place the viewer in the diver's wetsuit.

The cut-away, as its name suggests, is a shot that is taken by moving the camera away from the present subject. It is also a CU or ECU that can be used alone or in combination with a cut-in to create an action and reaction sequence. This is usually used to introduce another actor into the action in progress. While it is not quite as subtle as a cut-in, it is one of the easiest ways to distract the viewer's attention. It can be inserted between two connected – but

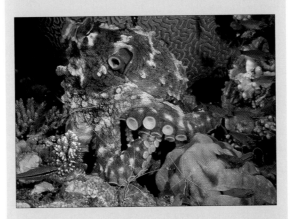

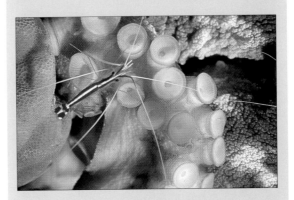

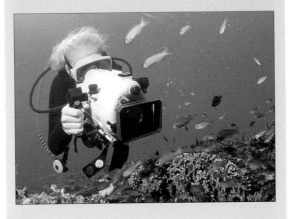

Left This small sequence of an octopus being cleaned by a shrimp can be tied to an entirely different scene with a cut-away – to the videoing diver, for instance.

119

Opposite top and Bottom
Interspersing video sequences
with extreme close-ups adds a
great deal of interest to your
video. Doing this requires
good stalking techniques.

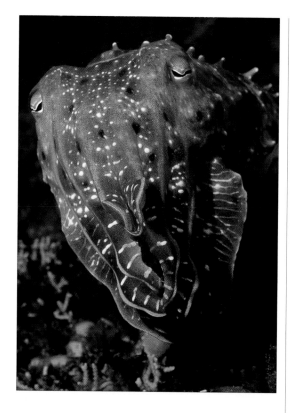

Right and Below Change your
angle of view and distance
when you change your shot.
This livens up a sequence and
provides the viewer with a
closer look at detail.

mismatched shots that could not otherwise be cut together, or be used to create complexity and tension. It can **lengthen a scene** that is so short that the viewer would have no chance to register or appreciate it, were it showed on its own. When cut-aways are cut fast and well, the viewer never notices.

Let's use the diver/clownfish scene to demonstrate. Straight after the fish darts and the diver retracts, a second, unplanned diver unexpectedly enters the scene and signals curiosity about the reaction, thwarting your idea of re-establishing the scene in MS. Meanwhile, the clownfish calm down and, hiding between the tentacles, refuse to cooperate further. Think quickly! Rewrite the script! Shoot the second diver's signals – if necessary, have him act this later. This shot serves as the cut-away. It introduces the outsider smoothly and will link to a MS shot of the first diver pointing out clownfish eggs, thus explaining the behaviour. Even these can be captured later or elsewhere. But capture a LS of both divers swimming away to complete the scene.

Cut-away shots can also **create suspense** by letting the viewer 'know' something that a diver or any other actor in the scene does not. Usually this is a deliberate 'plant'.

Example:
You video an octopus wandering across the reef. It is cooperative and allows you a nice mixture of shots, including close-ups. But, in terms of action, nothing much happens. The octopus gets bored, suddenly spurts off and disappears into its hole. Your shots are brilliant, you know you have super colour and good composition, even ECU detail. Still, without action there is little to tell. Keep the shots! Now look for and photograph special cut-away shots, or find them in existing footage. How about an eel – they are known as octopus predators – leering out of its den, gaping threateningly (only you know he is just breathing harmlessly). You can use such shots repeatedly as cut-aways. The viewer 'knows' that the eel is eyeing the octopus for dinner, but the octopus does not. Suspense! A further cut-away of the eel surging out of his hole can be used to 'cause' the sudden spurt and disappearance of the octopus. *Voila!* – with totally disconnected bits and pieces you have created a tense, predatory scene.

A **simultaneous action cut-away** helps to connect two totally different action scenes.

Example:

An ascending diver, already low on air, finds a turtle entangled in a net and begins to cut it free. While this underwater drama is taking place, the boat crew gets worried about the diver failing to return within the expected time. Imagine how dramatically these two scenes can be intercut.

The topside shots: worried faces, crew peering into the water checking their watches, the watch second-hand ticking, a crew member getting ready to take emergency action.

Below: the struggling diver and turtle, spurts of exhaled bubbles, the diver's knife cutting through netting, the diver's gauge moving deeper into the red (stage-shot under the boat on the safety-stop line).

The scenes are of course shot at different times. The importance lies in recognizing the potential of your captured events. The story idea originates with the trapped turtle. The dramatic impact comes from staged topside shots. By including similar subjects and creating actions that duplicate those underwater, you enable yourself to alternate between the different sequences – by cutting on the matching action. The topside watch cuts to the underwater gauge, and so on.

Overlapping action shots create a smooth transitions between two totally different perspectives on the same action situation, and are usually staged. The technique is frequently utilized in wreck or cave sequences: the first shot shows an MS sideview of a diver discovering an opening and beginning to swim through it. The second shows an MCU full frontal of the diver swimming through it, towards the camera.

Of course, the camera cannot be in both places at once – the diver swims through the opening twice, posing for each shot separately. You can shoot divers giant-striding into the water from topside, and on later dives record the second overlap shot – their submersion seen from beneath the water. Cut together on action, these overlapping shots are far more interesting than either of these sequences on their own.

Compressing time

Cleverly combined shots can help exclude large time periods without hampering story flow or reality. This is frequently used for the travelling part in a dive trip documentary, where three or four shots – for instance of passports, suitcases, airports and hotels – get you from home to your exotic destination.

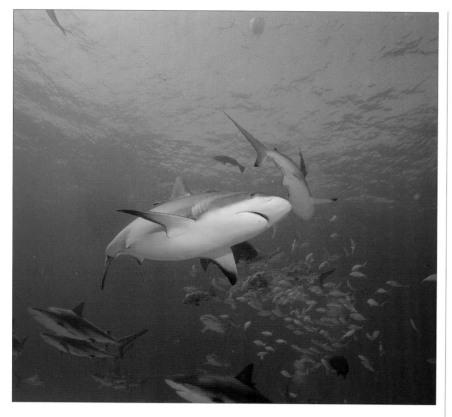

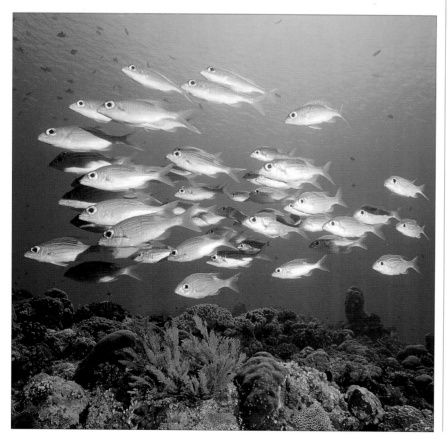

Example:

A suitcase or dive-bag is packed and closed, a glance at the tickets and traveller's cheques serves as the connecting cut-away; the suitcase is carried into a palm-surrounded holiday room and opened. Use this method to connect different diving days. A lingering shot on the staircase of a wreck at the end of a dive can be connected to the staircase of your holiday bungalow or homebound aeroplane. Similarly, dive-related sunsets can connect to the next day's sunrise and departing boats, indicating the passing of a night and a new day of adventure.

Think about the TV screen

Because video is displayed on the TV screen, you must consider factors such as **directional continuity.** This involves creating a logical flow of action across the screen, even for locations not evident on screen. Viewers fix remembered direction in their minds, expecting the invisible subject to be where it was last seen, at left or right of the present picture. This has a powerful influence on the mood, flow and credibility of your video. Our eyes are accustomed to expect movement from left to right.

Scene **entries and exits** are good examples. Pictures feel and look wrong if the diver or a marine star suddenly pops up in mid-screen. It appears more natural when they swim in from the *left.* Consequently we would also expect them to exit to the *right.* This pattern is repeated in ensuing shots. By turning them around, swimming right to left, we imply that they are returning to where they came from – an action more suited to the end of the scene.

When we **add a new character** to the story, however, they can enter from the right. This implies that something different is about to happen. When this newcomer leaves, turn the direction around. An alternative is having characters enter from the far middle distance, 'materializing' from the blue.

Crossing the Magic Line

Video does have one strange idiosyncrasy: 'crossing the magic line'. This imaginary parallel passes through the centre of your subject or scene. When crossed, it causes a subject seen on the one side of the line to appear exactly reversed directionally, when filmed from the other side. As long as you stay on one side of the line, screen direction progresses naturally. If you keep your camera running and

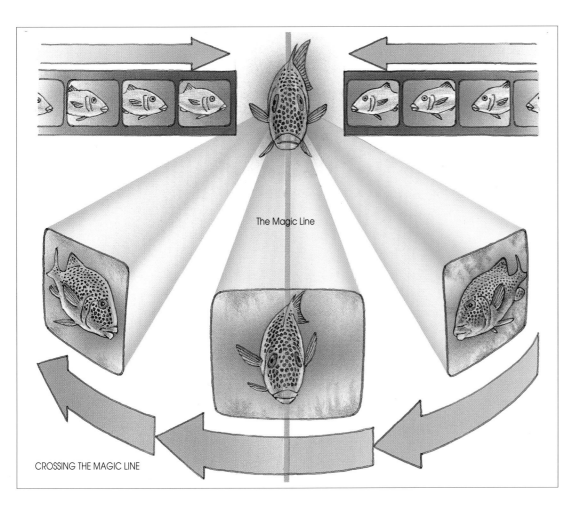

The Magic Line

CROSSING THE MAGIC LINE

aimed at the subject, while swimming across the line, screen direction will still appear normal, although it will end with a reverse view of the subject. It appears logical, only because you visually transport your viewer across the line to the reversed view. *But* if you switch off your camera, and cross over the line abruptly, then start recording again, your two scenes no longer match. Screen direction in the second shot is reversed. In postproduction it is extremely difficult to link such shots and usually one or two transition cut-aways must be inserted to distract the viewer. If you make the mistake and notice it while on site, you could correct or shoot suitable cut-in or cut-away shots; a full frontal close-up shot of your actor or marine life reaction will later help you cross the line 'naturally'.

There are exceptions to the rule. If a downward, map-like shot identifies the relative positions of the players, you can usually cross the line. You can also cross the line during fast and furious action, provided you re-establish the scene with an occasional LS or MS. When you assemble a collage with no strong indication of direction, you can usually ignore the magic line. You can also cross the line when photographing an actor, if you cut away to the actor's point of view. But be especially careful of any **implied or actual direction**, such as looking or pointing at a subject (at worst, you may be able to flip a shot in sophisticated postproduction).

Shoot tight scenes

A TV screen is much smaller than that used for slide displays. So, always move in close to shoot frame-filled shots for impact. This even goes for long shots. Essentially this means that 'actors' must be posed unnaturally close, divers sometimes even with shoulders overlapping; the latter image is further enlarged if you exclude most of the divers' lower body. In diver/marine life shots, distance becomes even more important. For CU shots creatures should be no further than 15cm (6in) away from the diver's face and both should display eye-contact. This may feel wrong

Opposite top and Bottom
Both character introduction and chase-and-fight scenes need to be directionally matched for the TV screen.

to the model, but looks natural on screen. Models can avoid close-up squints by looking slightly *past* the subject, instead of focusing on it. Place layered subjects close behind each other, especially in wide-angle pictures; a diver only centimetres behind a stunning reef feature, will appear much further away because of wide-angle perspective.

SHOOT WITH A PURPOSE

The traditional approach to making a video is to start with a scripted story before any filming ensues. However, premeditated stories and scripts are largely impractical, if not impossible underwater.

Your opportunities are limited to your dive sites, and the time you can spend there. You also function as sole planner director, camera person, lighting assistant and editor of your video production – with perhaps some assistance from your buddy. This calls for careful planning, imagination and innovation!

Furthermore, the sea is and always will be unpredictable. Some dives are action filled, and others supernaturally tranquil. You cannot prejudge the temperament of your marine actors. Most do not take kindly to being 'directed', and few will repeat scenes. The exception is of course when you know a

dive site and its characters – or can cooperate with someone who does. At least enter the water with some preconceived ideas. These alert you to seeing things you might otherwise ignore.

Develop a story idea

Rather than writing a story, develop story ideas or concepts. A beginner usually starts with a diving diary, much like a visual logbook. The only aspects that can be planned, directed and controlled are the divers. Everything else is a matter or fate. Of course, if you coproduce the video with other videographers, it is essential that everybody agrees on the concept of the story and that diving actors know what to do.

If you want your story to be original, think about why you dive and what fascinates you most. Marine life behaviour, courtship and mating, predation, cleaning stations, symbiotic and cooperative relationships, camouflage and armaments, all of these tell different and very interesting stories. Each of these themes can be either a main story or simply a sequence within the whole. Story ideas set you simple manageable limits, focus your attention, let you recognize potential, and remove underwater indecision and complexity.

Shoot with a purpose. If you tell a story of camouflage, deliberately seek all situations suited to this theme.

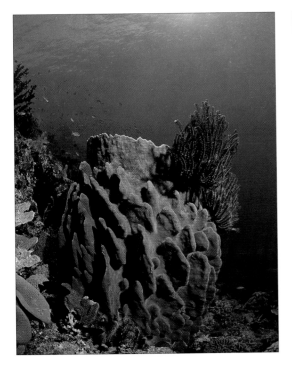

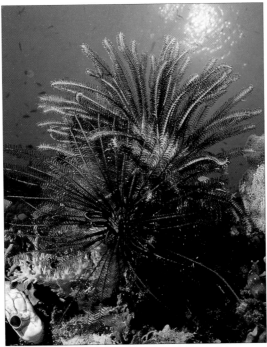

Interesting habitats – like feather stars and the adaptations of creatures that live in them – broaden the scope of your camouflage story and set it apart from others.

Crown the stars of the show

When you shoot scenes, define who the 'stars' of your show are. For a people-oriented video, you may have to acquire shots of aeroplanes, dive bags, hands assembling dive gear, gauges registering full tanks, kitting up, giant strides or back rolls, topside behaviour, jokes, dive briefings and group interaction. Declare one person your 'hero' and use this diver for your main underwater scenes. Having identified the supporting cast, they can now crop up intermittently without spoiling the overall effect, as the viewer realizes that they are in the water at the same time as you and the hero are.

For a wildlife 'documentary', define the behaviour you intend to shoot, then deliberately choose one character to be 'hero' and follow it around. You will understand how important animal reaction shots are once you begin to edit. Often a superb character occurs without specific action, or the animal's action is unrelated to another. Shoot anyway if it has potential. A few dives later, events may suddenly be perfect for combining with previous footage. Pay particular attention to interrelationship links.

Example:
Feather stars make excellent subjects. Show them perched upon the edges of large sea fans, sponges and high coral outcrops; then from below, isolated

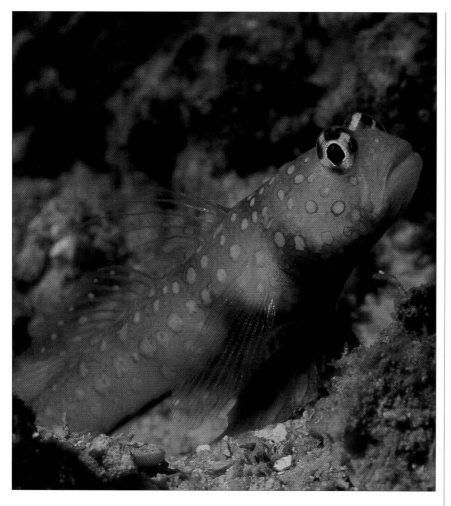

In bad visibility, concentrate on macro subjects.

against the blue. Take CUs of their colour, pattern and structure. Now add shots of the exquisite creatures that live within them. Rather than a casual reef scene, this then becomes an interesting story.

In bad visibility

I have dived on some of the world's most photogenic reefs in raging currents and really bad visibility. I used the spectacular footage to tell the incredible story of plankton; by deliberately lighting the suspended matter in both medium and close-up shots, I could later tie them up with plankton shots taken through a marine laboratory microscope.

Bad visibility makes any dive a close-up dive. Find smaller subjects and shoot in macro. Partner- and fire gobies, feather worms, Christmas-tree worms, leaf fish, nudibranchs, lobsters, and anemone shrimps are excellent subjects. Switch to manual focus, move in close, position your light creatively, back-light translucent subjects and have fun!

Diving with a tripod

Yes, tripods work underwater. They need not be expensive, but they must be sturdy enough to carry the weight of your camera system and must be weighted down. An excellent way to photograph extremely skittish creatures such as garden eels is to set up and weigh the tripod down, aim the camera, press record and leave. Return later to collect your camera and footage.

I also always take a simple unipod on dive expeditions. By removing unnecessary length it transports easily in water and helps to keep the camera steady for macro zooms on small shy creatures. It is also great along reef walls, where it is often impossible to remain steady long enough for macro work with creatures like longnose hawkfish, allied cowries, depressed crabs, coral gobies and blennies. By gently pressing the 'foot' horizontally against a small dead patch with my left hand, it becomes a 'stabilizing rod' that helps me brace and serves to rest my camera on. This leaves my right hand free to pivot the camera into position and engage the necessary controls. Thus stabilized, I can shoot for several minutes without any discomfort, and even change my camera angle.

A knuckle-and-joint strobe arm screwed to a baseplate under your housing makes a wonderful steadying pod for macro photography. It is extendable, flexible and can be gripped or steadied.

UNDERSTANDING EDITING

Editing does not only mean assembling your shots in a logical order. We are living in the electronic and computer age! What once was the sole domain of professionals is today freely available to amateurs at remarkably reasonable prices.

While editing cannot change your shot angles or improve the quality and content of your footage, it can do many other exciting and magical things. Shots can be reverse-flipped to match direction, forward motion can be played in reverse. A shot can be cropped, manipulated for effect, speeded up, slowed down, it can be mixed with another, open-dissolved or superimposed.

If you are new at shooting and editing, you will greatly benefit by understanding what tremendous scope and freedom the editing techniques of such editing programmes can provide. This knowledge will allow you to create or recreate missed scenes with greater success.

Example:

I once quite unexpectedly shot a violent battle between an octopus and an eel. It was over within seconds and super-rare! But the 'cause' part of 'action, cause, effect and resolve' was missing. I had plenty of eel and octopus library shots that could lead up to the fight and build tension, but needed the actual attack – the eel surging out of its den.

Solution: I subsequently shot a 'tame' eel in action. It habitually surged halfway out, and then retracted into its den. While editing, I noticed that its retractions appeared more dramatic than its out surges, and better matched my fight scene footage.

So, I turned a retract into a realistic-looking surge by playing it in reverse and drastically speeding it up. The resulting match was perfect!

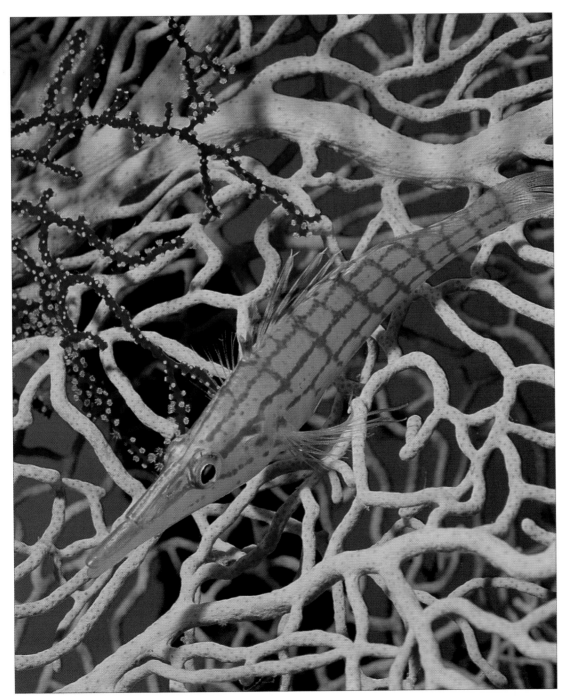

Retain any interesting footage, even if it seems unrelated to what you are shooting at the time. As your library grows, such footage might prove to be perfect for inclusion in another story.

POSTPRODUCTION AND EDITING

FISH & FINS

It is outside the scope of this book to discuss the very diverse editing equipment possibilities; the range – and that of individual tastes – is much too large. Modern computer software can make editing much easier and extremely rewarding, but it is also possible to cut brilliant videos with simple domestic equipment. Imagination always counts much more than any technical achievement. For either, there are proven step-by-step preparation techniques.

THE FINAL STORY LINE

You have learnt that, during editing, video can become a mixture of reality and fantasy. Review your video material and decide on an approach. You may want to create a simple dive diary or to concentrate mainly on marine wildlife. Either could be approached in documentary style or may be treated as a simple cut-to-music montage. Either way, your story needs a beginning, middle and end.

Above *'Diver down' is the traditional introduction to an underwater story.*

Right Top and Bottom
Opening titles set the mood of your story. The text should be clear and simple.

Selecting shots

Your best shots will be scattered over several tapes. The first step is to number your tapes, noting date and dive site. Then begin by logging each shot on an edit shot list (which is easily generated by computer). This simply means selecting and writing down shots in a logical, organized way. Don't be tempted to skip this step; editing stations can quickly turn into jungles of tapes, notes, cables and connecters. Without

TROPICAL *fish* **TALES**

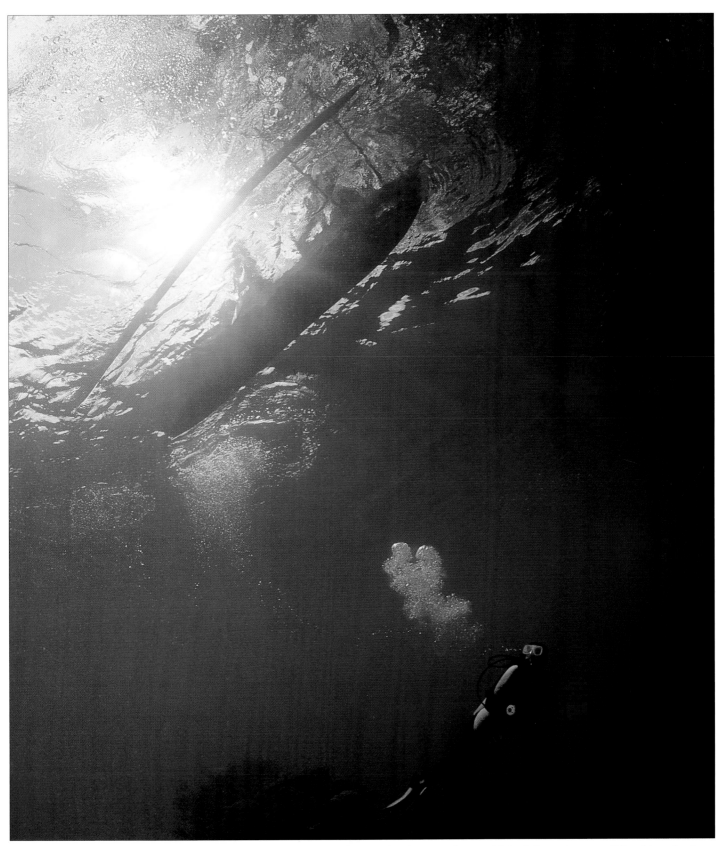

If you wish to be original, try to think of alternatives to traditional introductions.

DIVE LOG					
DIVE TRIP: MAURITIUS			DIVE SITE: CORAL GARDENS		
TAPE NUMBER	SCENE	IN	OUT	SHOT	COMMENTS
1	Description	0:00:01:02	0:00:01:09	WA	Excellent
1	Divers down	0:00:02:10	0:00:03:07	MS	Excellent
1	Honeycomb Eel	0:00:03:15	0:00:04:10	MCU	Good
1	Mary at	0:00:04:23	0:00:05:09	CU	Very good
1	Honeycomb Eel	0:00:05:15	0:00:05:24	ECU	Excellent
	Honeycomb Eel				
	Honeycomb Eel				

LIBRARY LIST					
EELS AND EELS WITH DIVERS			DIVE SITE: CORAL GARDENS		
TAPE NUMBER	SCENE DESCRIPTION	IN	OUT	SHOT	COMMENTS
1	Honeycomb Eel	0:00:01:02	0:00:01:09	WA	Excellent
2	Green Moray	0:00:02:10	0:00:03:07	MS	Good
4	Mary at spot Eel	0:00:07:15	0:00:08:10	MCU	Excellent
4	Mary at spot Eel	0:00:08:23	0:00:09:09	CU	Very good
6	Ghost Eel	0:12:05:15	0:12:05:24	ECU	Excellent

TAPE REVIEW

Record 15 seconds of blue water at the beginning of new tapes and at the end of each dive. The first allows sufficient pre-roll time for editing controllers and domestic VCRs. The second prevents breaking the video signal track, something which editing machines cannot cope with. This allows you to cut back (rewind) into 'dead' space rather than previous 'live' footage after viewing your tape, should you resume shooting on the same tape. The ensuing shot will connect smoothly over this buffer zone without accidentally taking a bite out of the previous shot.

a corresponding number, both on the tape and its container, you'll soon find yourself in editing hell.

Keep your original tapes if you can afford it. This is the only way to avoid losing quality if you generate analog copies (digital video does not have this problem). Create a concise 'library' system. Review and list, tape by tape, shot by shot as shown above.

If you store your original tapes, library style, make your shot lists by subject rather than by tape, as this makes them easier to work from later .

Preserving your original tape
During the editing process, tape gets spooled forward and backwards countless times. The secret to retaining your original tape in pristine condition is to dump its contents onto cheap 30-minute VHS tapes. Mark these cheap tapes with numbers corresponding to the original.

Example:
Tape 1 (a) Time code 00:00:00:00 – 00:30:00:00
Tape 1(b) Time code 00:30:00:01:00 – end.

A tape length of 30 minutes is quicker to spool through than longer tapes. These heavy-duty 'dump' tapes are now used during the entire *trial edit* stage. When a final edit decision list (EDL) is available, the master video is cut from the original tape.

Create a story board
Once you have reviewed and logged your shots, you will have a better idea of your footage and the story that it could tell.

Now create a story board with single index cards. Proceed logically from scene to scene and keep up tension throughout to attract the audience's interest – also dropping in special peaks of high suspense or moments of humour – to create a memorable video with an exciting rhythm.

Use one index card per event to briefly note the incident, the subject and the action, and lay these out on a table. Of course you will have a greater variety, or stronger scenes, for some subjects than for others. Shuffle them around, thinking about how they can be linked to other events, until you have a

logical and imaginative order. This becomes your story backbone.

Once your narrative order is established, lay the index cards from top to bottom on a table, outlining the story structure from beginning to end.

Combining shots into sequences

Once your have made up your shot lists and index backbone cards, it will be much easier for you to recognise the potential for linking certain shots together into sequences, and then for linking these sequences into themes.

Begin to add body to your backbone by placing new index cards to the side of each backbone scene. Describe those shots that will portray the event.

Example:
Scene Index Card: Mary tames the moray eel.

Shot index cards:
- Approach: Mary swims through coral reef scene – introduction (LS).
- Mary sees eel – subject (MS), eel surges out halfway – action (MS)
- Mary moves closer, looks doubting – reaction (CU)
- Eel sways and looks friendly – action (MS)
- Mary smiles – reaction (CU)
- Mary moves closer – re-establish location and action (MS)
- Eel emerges and winds around Mary – action (MS)
- Mary's astonished face – CU.

Log your shots, noting the date and dive site on numbered tapes. Include a short description and quality rating.

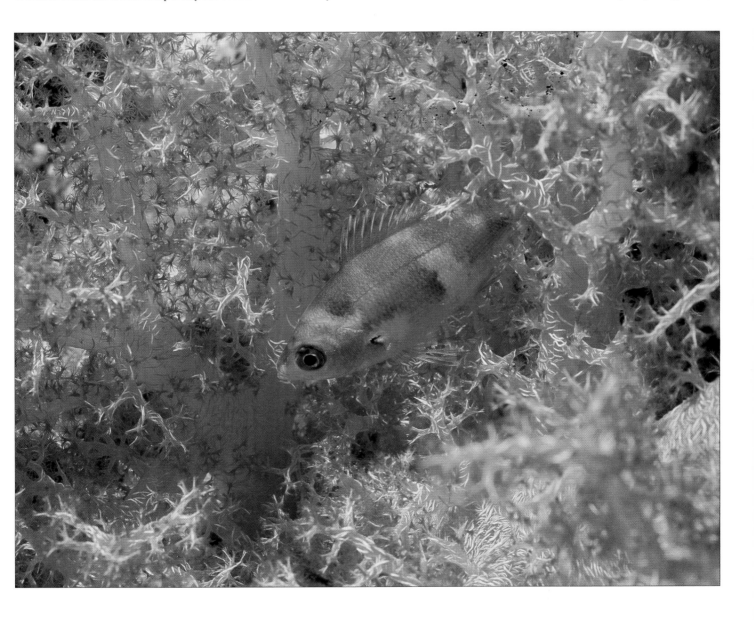

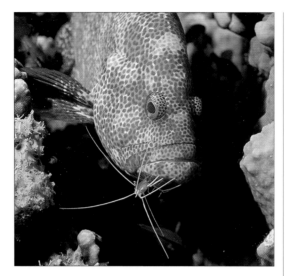

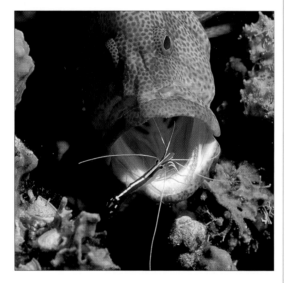

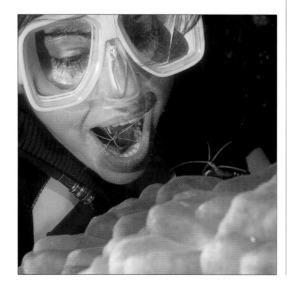

By matching the grouper's action with that of the diver, this cleaning sequence gains an interesting twist.

Make sequence edits

When all is to your satisfaction, make small preliminary sequence edits. The idea is not to look for perfection, but to get a feel for content, flow and timing. When seen visually, mismatches or illogical cuts jump out, while brilliant ideas may suddenly form. To keep track, make notes and rearrange your cards as you analyze. Don't even think about titles, music and effects before this stage is finalized.

I advocate this system because it avoids having to start all over again, should you need to break or insert sequences. It also helps you to get accustomed to your editing equipment, so that you can work smoothly when it really counts.

Titles and graphics

If you have not shot them yet, you will now begin looking for an original way to add a title, credits and perhaps some graphics.

When all problems are sorted out, string your sequences, titles and graphics together in a trial edit. Those that worked well in your sequence edits may be copied directly, even if the quality decreases (not a problem with digital video). Again, the idea is to get a feel for your video, rather than a final product.

The cutting secrets

Use fast or sharp cuts instead of dissolves except for beginnings, transitions and endings. Use effects like wipes and fades only to imply changes in location or time. Such effects can happen slowly, say, over a second, but as a rule, make them fast. Fill the screen with close-ups often.

Avoid contrary or arbitrary direction changes on the screen (computer programmes allow shots to be flipped). Use direction changes to imply new subjects, new action, scene changes. Resolve action – it must have a beginning and end.

Keep it short: 10 to 15 minutes with about three or four peak events that are interconnected is usually long enough! Short videos are much easier for you to control, both during shooting and editing.

Effects

With modern, and reasonably priced video-editing programmes, cross dissolves, speeding up or down, superimpositions, and a storehouse of other effects are possible. But effects should be sparingly used to avoid a gaudy, gimmicky result. To tell the same

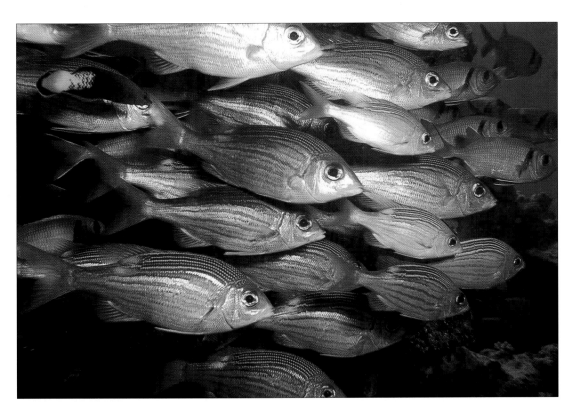

Schools of fish have a natural symmetry which you should always try to retain.

story, experienced editors, contrary to amateurs, rarely need shot lengths of more than three seconds.

Generally sound is added very much towards the end of the editing process, except if you include montages or sequences that are cut to music.

While you should know what you want to say, a concise narration script is much easier to write once you know the length of the relevant shots and sequences. The secret of narration writing is *not* to describe what is visually evident.

Example:
Let's highlight only the information that a viewer could not recognize or visually acquire from this incorrectly narrated montage of sponges:
'At the dive site called *Coral Gardens* there are many different kinds of *sponges*. Look at this pink barrel sponge, this one is bunched like grapes. I found it amazing that sponges can have such different shapes; *sponges are very old in relation to the evolutionary scale.*'

Here is a much improved version: 'At Coral Gardens, sponges abound. One of the oldest species on the evolutionary scale, they are today little different from millions of years ago – the sign of a successful lifestyle.'

Usually sound recorded underwater is indistinct and overpowered by diver breathing and bubbles. Moreover, continuous bubble-breathing soundtracks are irritating and uncreative. If you must, restrict this to the introduction. Then fade into a wonderful, creative soundtrack. Avoid mishaps on your master tape by creating, dubbing and mixing on *copies* of the final edit. Lay this down on the master tape only once the soundtrack is perfect.

THE MOST VALUABLE LESSON OF ALL
The experience gained from editing is infinitely more valuable than reams of written information. Just as your first mistakes were evident immediately on video, your first production will show how and why some scenes are more successful than others. You will immediately understand how missed shots could have aided creative editing or where you could improve your shooting techniques, decrease distances or use lights. Editing best illustrates the value of originality and the idea of staged shots – honing your senses for future opportunities.

If you retain your original tapes, as you create new more ambitious stories, the same shots may combine with new ones into a much more challenging production. That is why video is so magical!

THE COMPLETE
PHOTOGRAPHER

THE ART OF PHOTOGRAPHY

COMPOSITION AND AESTHETICS

Consider the difference between 'taking' – and 'making' – a photograph. The latter is the art of observing and truly seeing: be it visual elements such as colour, pattern, line and composition; or intangible components such as mood, character and personality. This art, in turn, is closely linked to the ability to isolate a subject, to define its essence, and lift it out from its bewildering background. This calls for previsualization – making conscious decisions on *how* to obtain the picture.

Beautiful images originate in your brain. The technique of isolation can be learnt: evaluate your subject, select one special feature about it, and make this the image backbone around which everything revolves. This clarifies the purpose of your shot, without robbing you of individual choices. It forces you to include only what is important and keep everything else simple. Previsualization is a vital link between imagination and technique. There is, in fact, nothing special about any image unless you *make it so*.

There are no absolute rules governing success and failure; capturing any image is dependent on the opportunities offered by the immediate situation and your recognition of its potential. But there are basic guidelines that, because they set limits and concentrate your attention, can help you to take better pictures and develop a personal style.

Photographing rare and shy creatures like this Bumble-bee goby requires great patience.

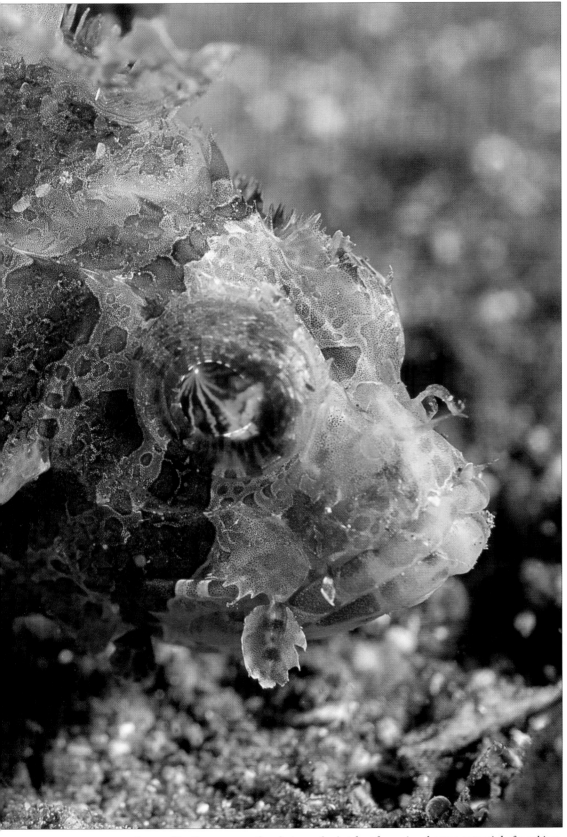

Images like these express the photographer's talent for seeing the true potential of a subject.

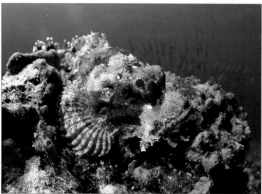

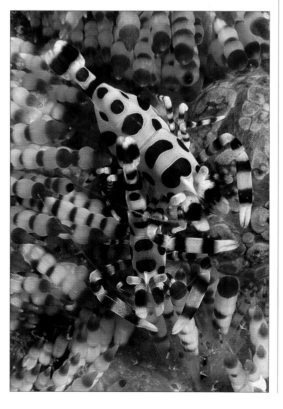

RULE 1

Shoot for an audience

The first rule for success is to pick a subject wisely – look for its excellence as a photographic topic. After all, it is pointless to shoot anything that does not have the potential to grab the attention of your audience.

The difference between professionals and amateurs is that the pro always considers marketability. If he knows that he cannot 'sell' the image, he will not bother to waste either time or film. While this sounds cynical, it is very useful in the broad sense; even if we usually 'sell' photographs only to our friends, it helps us put our subject choices into clearer perspective.

RULE 2

Define what you see

The very best underwater photography focuses attention on a specific aspect. Consciously think about your subject – its size, shape, personality, beauty, strangeness. Strive to portray this. Compose through the viewfinder, not with your naked eye. This narrows your vision to a much smaller picture area and shows instantly if you are too far from your subject. Think again before releasing the shutter. There is little sense in triggering the camera if the end result does not have at least a 90% chance of being good or outstanding.

RULE 3

Fill the frame

Shoot tight and fill the frame. By reducing subject distance your chances for attaining rich colour and fine detail increase by 100%. This applies irrespective of whether the camera is pointed vertically upwards or horizontally. Note though that 'filling the frame with your subject' is not necessarily limited to your primary subject. Surroundings may be an important element of your image, but take care to include only what is essential.

RULE 4

Zoom in on colour

Colour is the element that first attracts the viewer's eye, and you must choose your subject deliberately for its colour. The drastic influence of water density and depth on colour is well known and we probably frequently pass exquisite subjects none the wiser. To reveal true colours, a photographer should always carry a small underwater light.

No designer is more courageous and masterful than Nature, and nowhere is colour more abundant than on reefs. Learn to see its potential as a background against which subjects may be coaxed. When you use a background colour that **contrasts** with that of your subject, e.g. yellow against purple or blue, both colours seem to come alive. Such visual impact is immediately arresting.

Soft colours on the other hand can be used for a more mystical and ethereal mood. There is incredible delicacy and often translucency in soft corals, some fish and hundreds of shrimps.

If your subject just cannot be coaxed against a suitable background, make use of an exposure trick. Create a black background (*see* page 74). While such a background removes part of the natural story, it is visually very dramatic and at least there are no disturbing elements to distract from the beauty of the subject.

RULE 5
Include some 'sky'
Include some 'sky' in your images. Isolated against a blue-water background, marine colours come alive. When you shoot upwards, you also attain a water backdrop that gradually lightens from dark royal blue at the bottom of the picture to sheer limpid blue at the top. This heightens the visual 'fluidity' of the water, adding a sense of depth and a lot of underwater drama to the scene.

A subject always looks sculpted rather than flat against blue water. Light falls on it and is reflected from it in all directions, producing many subtle shades and highlights that help 'round' it out into a three-dimensional 'body' with depth and substance.

RULE 6
Create both positive and negative space in your image
The positive space is allocated to your primary subject – its shape, colour or character. In wildlife portraits this means having the animal face you, with its eyes in sharp focus. In a scene of reef organisms, you could choose the strongest element as the centre of interest – again in shape, colour or character. This may be a single spectacular organism like a fan or sponge, or a group of organisms like soft corals.

Negative space is less finite, for it is everything that is not the subject. Negative space can make or

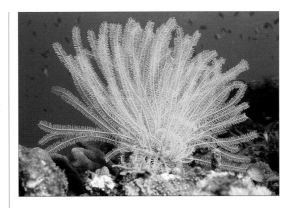

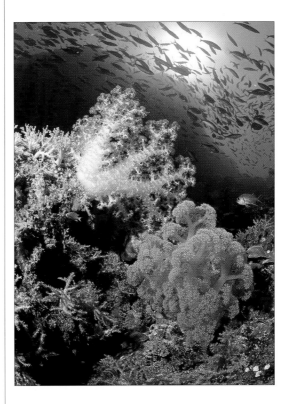

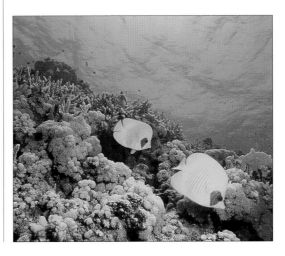

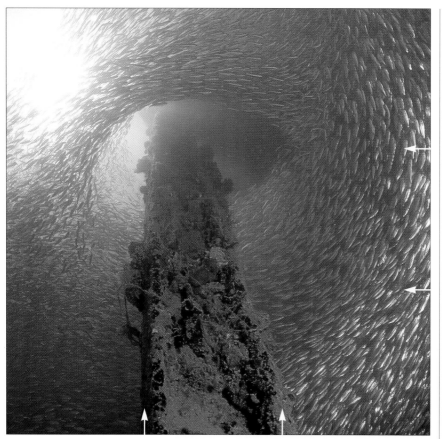

The Golden Mean grid

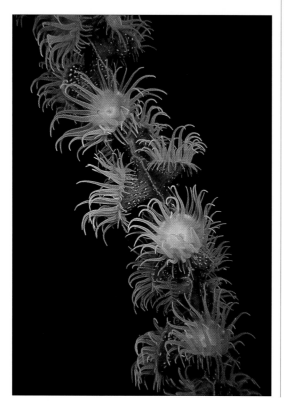

break an image and deserves as much careful consideration as the subject, for it links the primary subject to its environment and visually balances its weight. Negative is to positive space what shadow is to light – both well done will always create a winner.

A good rule is that negative space should usually form about one-third of the shot. This can be 'sky' – background water – or a wealth of soft corals for instance. It should convey a feeling of space, time and harmony and must allow sufficient breathing space for your subject, such as nose room in front of marine life faces. Create a basic foundation that helps your subject to 'sit' firmly in the image or use a natural frame around it.

RULE 7
Use the magic of the Golden Mean
The Golden Mean is so pivotal to good design that composition is seldom discussed without referring to it. Also known as the 'rule of thirds', it makes us divide our picture area into thirds both horizontally and vertically. The four points of intersection of the gridlines are considered to be visually strong positions ('sweet spots') at which to place a subject. When a second subject is introduced, it is placed on the diagonally opposite intersection, creating a harmonious balance with an inherent feeling of tension or activity. The vertical or horizontal gridlines are used for strong positioning too. The placement of the 'horizon' of your image, or another strong horizontal element, along one of the two horizontal gridlines, divides the picture into a one-third/two-thirds asymmetry, creating a much more dynamic composition. This functions equally well vertically.

When using the sweet spots, the main subject is automatically placed slightly off centre in the image. This subtle shift looks particularly harmonious in wide-angle photography or in three-quarter-profile fish portraits. It creates, and also balances negative space. Even in close-up or macro photography, where the rule usually is to fill the frame and centre the subject, the sweet spots can still be effectively used for important features, such as a subject's eyes.

RULE 8
Select lead-in lines
Lead-in lines have a profound influence on how the viewer's eye travels through an image. S-shaped curves, for example, help lead the eye through an

image slowly and tranquilly. These curves abound in all naturally growing things and usually come across as 'soft'. Diagonal lines, in contrast, create a sense of tension. This makes them particularly suitable for 'abstract' pattern close-ups. Wreck structures also have strong, recognizable lines that can be used to create depth, mystery or haunting sadness.

But diagonal lines can also be much more subtle, without losing any effect. When marine animals like dolphins, seals and sharks, for instance, are positioned diagonally within an image, a sense of active directional 'motion' is attained. When the same animals are posed with divers, the diagonal lines of eye-contact or a pointing arm not only create tension, but also cause the viewer's eye to continuously travel between the two subjects.

RULE 9
Create a sense of depth

Photography in its final format has only a two-dimensional plane. The missing dimension is true, palpable depth. Therefore a believable illusion of depth must be created by the skill and artistry of the photographer.

Diagonally converging lines can create a sense of depth that leads the eye deep into the picture. This happens when a coral-lined crevice or gully is photographed to appear wide at the front of the picture area, while its edges meet on the distant horizon.

Depth can also be induced by layering. Mainly used in panoramic scenes, this is achieved by deliberately placing the main subject close to the 'front' of the picture as we see it, with one or two more 'eye-catchers' positioned further 'back'. As long as the distant subjects are identifiable and have a known size, but appear progressively smaller, less colourful and more faint, our brains will automatically translate this into a sense of logical perspective.

Photographers usually make do with two and only seldom exceed three layers in underwater photographs. One reason is that subjects, especially living ones, are not easily controlled underwater.

The most common example in still photography is the typical wide-angle 'foreground-subject-and-distant-diver' shot. Three-layered images are more commonly used for video and are extremely successful at creating a sense of depth, because the natural movement of both camera and subjects avoids a contrived appearance.

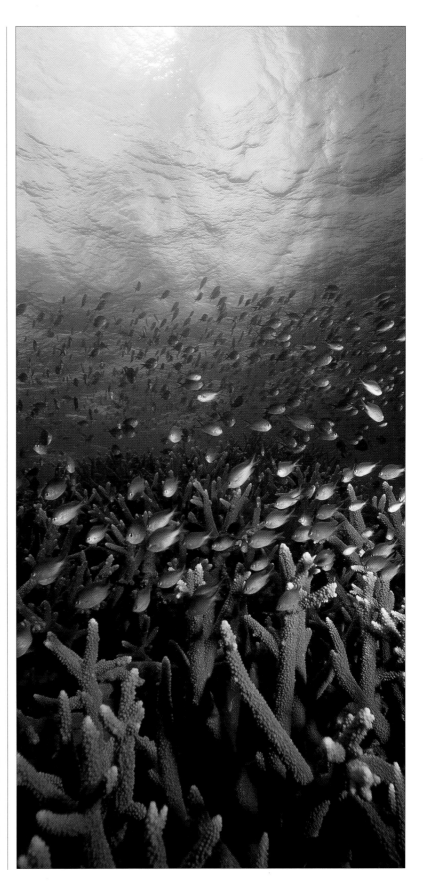

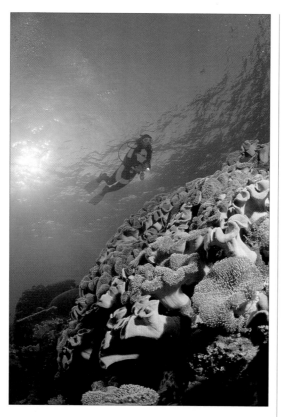

RULE 10
Change your viewpoint

There is a wonderful trick that is almost never used by underwater photographers, simply because they are divers. A diver usually moves around the reef in a horizontal position – but what about temporarily becoming a fish or a crab? Lower yourself to their viewpoint and discover vantage points you never even considered before. Look at a lettuce coral from way down below, then drift up ever so slowly, all the while studying pattern as you rise. This same method helps videographers to emulate the smooth tracking movement of movie booms! Reposition yourself, instead of the subject, whenever a situation allows.

RULE 11
Find mood and a visual catch phrase

You can portray drama and adventure, a single extraordinary underwater occasion or the breathtaking beauty of pure underwater wilderness. Each has a different mood. Be alert for distinct, naturally occurring moods. Sometimes composition and a change of camera angle alone can emphasise mood. Otherwise, employ features such as shape, pattern, colour, texture and behaviour.

With the right posture even a small, friendly shark can come across as impressively 'ominous' and awe-inspiring. The perpetual smile of dolphins evokes a feeling of kinship and fraternity. A gaping eel may look threatening, yet playfully draped across a diver, creates an almost puppyish atmosphere.

Animals usually have typical 'brand' characteristics that set them apart from all others – in cuttlefish, it is coy inquisitiveness; in blennies, those inimitable rolling eyes under their delicate eyebrow tufts; in hawkfish, the haughty pose; in clownfish, their endearing cheek. By naming these unique traits we are better able to convey their essence.

RULE 12
Vary picture format

All the elements of composition help to produce outstanding images, but now also consider format. It is tempting to take more horizontal than vertical format photos, because that is how still cameras are constructed and how we dive. But this is by no means always the most interesting format. So take insurance! If a subject is worthwhile, shoot both horizontally and vertically. Always use the vertical

format for 'tall' things: barrel sponges, huge sea fans, fish with 'high' fins. Never cut off these features because they do not fit into horizontal format.

RULE 13
Break the rules

Exceptions add the spice to our lives and present challenges that move us out of a rut. Once able to compose almost instinctively, experiment! If a subject is willing and worthwhile, shoot from different angles, analyzing and reinventing composition as you go. Stop to think of entirely new ways to present things – then realize your thoughts on film.

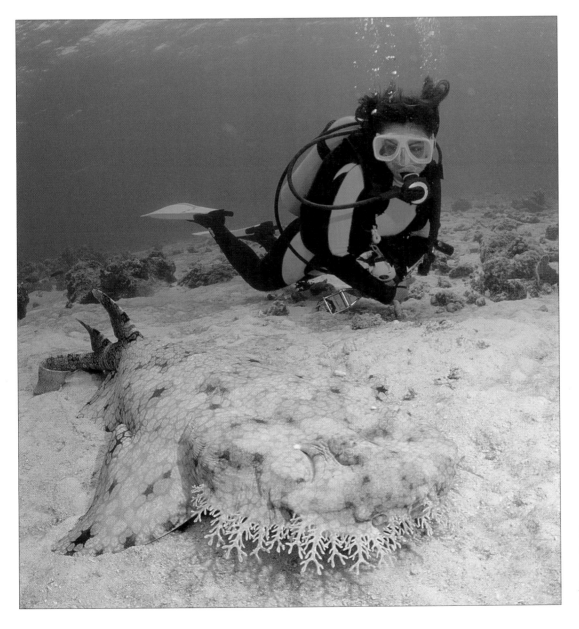

While this composition breaks a rule by 'cutting' the image in half, the subjects are compellingly posed on sweet spots of the Golden Mean.

PHOTOGRAPHING PEOPLE

Contrary to expectations, divers are notoriously difficult subjects to photograph well; they are often the sole reason that otherwise perfect images may be ruined. Yet divers in photographs are extremely popular because they lend a human aspect to this largely unknown domain. For publishers and advertisers the marketing supposition is that these images literally place the viewer in a wetsuit underwater.

Here is what you should watch out for when you photograph divers:

• Divers are only visitors underwater – they never appear entirely natural and when inactive look even more displaced in photographs. To be successfully portrayed, divers need to look interested in exploring this alien world. Therefore, it is much easier for divers to swim through the picture rather than holding a hovering pose.

• A professional trick is to have the model swim in a C-shaped curve towards a specific point in the picture – as it places the body in a pleasant shape.

• For 'surprise' effects, have the diver swim in one direction, then suddenly turn around. This works particularly well for video.

• Whatever the pose, the diver must be visually associated or linked with the environment and/or any primary marine subject, either by looking at it, reacting to it or exploring it.

• In diver and animal interaction it is the animal that cannot be controlled. The diving model therefore has a more exacting job. Eye contact between the two subjects can make or break the interest and immediacy of such pictures. A diagonal line of sight creates tension and avoids 'cutting' the picture in half.

• At close quarters, the eyes of the subjects are larger and clearer and must therefore be pin-point sharp. A viewer's natural reaction is to seek eye contact – and his glance will glide to and fro along this line of sight several times. This makes it essential that the model's mask is scrupulously clean and clear of water. Even a few drops or just a little fog can look disturbingly messy.

• A peculiar effect called 'the close-up squints' is unique to close-up diver photography. It usually occurs when the diver looks at too-near a subject or into the camera. As close posing is necessary for filling the frame, the 'squints' must be avoided by having the model peer slightly beyond the subject. The strobe should also light the diver's eye sockets and add catch lights to the eyes.

• For still photography divers should never look directly into the camera – for video however, divers can treat the camera like a buddy.

• Reflections in a model's mask can make great pictures. But unplanned reflections may spoil an otherwise perfect picture, so always double-check.

• Always meter for the diver's more reflective skin in extreme close-ups, and bracket half a stop either way for insurance.

• When you photograph divers partially, avoid 'cutting' them at natural body joints like the neck, elbows, groin and knees – opt for midway between joints. Except in extreme close-up facial shots, include both head and shoulders, lest the neck seems to 'grow' unnaturally from the bottom of the picture.

• When the subject is small in relation to the diver, think 'extreme close-up and diagonal'. By moving in, the diver's masked eyes with the tiny subject can make a very strong impact. But check your picture borders with special care.

UNDERWATER MODELLING

Buddies, wives, girlfriends, husbands and boyfriends are readily available and usually economical models. But a camera-bearing diver is a *hunter* and their idea of a 'fun' dive may be worlds apart from that of their dive-partner. As familiarity proverbially breeds contempt, a close dive-partner may not be the right choice of model for you. People photography is demanding and exacting – and add to this impatience and temperament – and small matters may mushroom into violent arguments or relationship

MODEL MOVEMENTS

Divers photographed upright or standing on the sand look ridiculous. Diving as a concept requires that the diver should move down, horizontally or diagonally, at the same time graciously and weightlessly suspended in the blue. This draws the viewer down, almost as if to participate in the underwater world.

Moving upwards should generally only be connected with subjects that naturally appear above the diver's head or body, e.g. boats and ladders or animals cruising or hovering slightly above the diver.

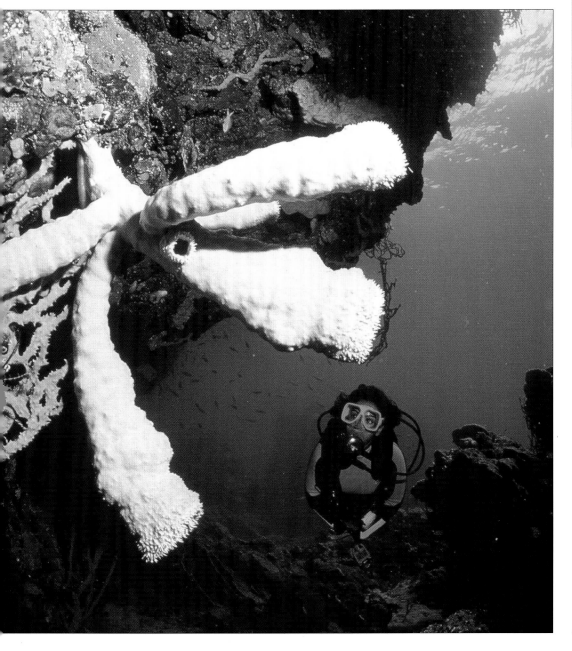

The model should look at the subject, not the photographer.

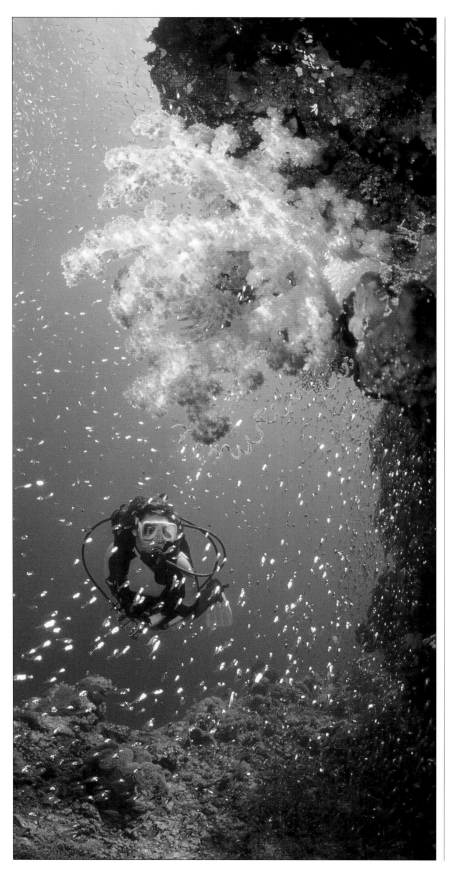

breakdown. Of course there are always exceptions; if your buddy is your perfect model, then consider yourself lucky.

But then there is the professional underwater model – a person who can depict a diver as an alien intruder, explorer, hunter, photographer, discoverer, or simply a true water-baby lacking only a pair of gills – and who does so with a calm routine that guarantees fast, efficient and, for the photographer, uncomplicated work.

A professional model offers dive experience, good looks, a happy personality, ease and elegance in the water and concentrated effort. Executing her tasks with grace, a professional model can use her body in ways that may be physically unnatural, but which in photography will appear light, slim and streamlined. A professional model has a way with marine creatures and can interact with them sympathetically.

This is an impressive package indeed. But to make the most of the relationship, the secret still lies in planning and predive preparation – on the part of the photographer and model.

Underwater modelling can be as demanding as photography – remember that praise will reinforce confidence and cultivate goodwill. Above all, never let photography spoil the fun that diving should be for both of you.

TEN GOLDEN MODELLING TIPS
1. **The model-photographer relationship** must be based on mutual respect, whether the model is being paid or not. Since a model poses voluntarily for the camera in either case, she/he has every right to expect fair treatment. In return, the model should follow instructions precisely.

2. **The photographer's requirements** must be discussed beforehand, on land, since most misunderstandings originate in a lack of communication. While the model should have an intuitive feeling for what appears 'right' through the lens, the photographer must spell out or demonstrate clearly what is required and how it will be signalled. Arrange scouting/practice sessions for important work.

3. **A personal photogenic style** and an understanding of the underwater environment and the photographer's subject are essential. The necessary traits are: perfect buoyancy control; an elegantly stretched, graceful body; and ideally, experience with or an understanding of photography.

Traits to avoid at all costs: inelegantly splayed or bent legs, downward pointing fins, and awkwardly flailing, oaring or sculling arms.

4. The model's **colour-coordinated attire** should harmonize, and not compete, with reef creatures; the main subject is the underwater domain. Figure-hugging Lycra skins or suits, preferably with space age insulating properties for warmth, are ideal.

Colours that best cut through underwater gloom are: red (not for video, though), yellow, orange, pink, acid-green, silver or white. Colours like black, blue and purple lose definition underwater and look lacklustre in photographs. Fin colours should match the suits, suit stripes or BC. A degree of transparency in fins looks especially great in back-lit shots.

5. **Streamlining** is crucial for elegance. Modern low-bulk BCs with integrated air hoses and weights eliminate both octopus hose and ungainly weight belt. If a weight belt is worn, ensure that weights are seated close to the body.

Modern miniature colour-coordinated regulators hide less of the face and do not reflect flashlight.

6. Modern low-volume **masks** with all-in-one lenses that extend across the bridge of the nose have replaced the popular 'old-fashioned' oval panorama masks. The new frames come in up-to-date colours, have translucent silicone skirts, are unisex, and preserve facial features perfectly.

Avoid colourless or black masks, black mask skirts and separated lenses – they are unflattering, shade eyes beyond recognition, and they lack photographic definition.

7. The model should **swim naturally** through the frame, rather than stopping and attempting to hold position (for wide-angle scenes in particular, a model must *be* active to *look* active).

When holding a torch, point it in the direction of the subject or the scene, and not into the photographer's eyes or lens.

8. While **bubbles** are acceptable because they orient the diver in the picture, photographers usually prefer a bubble-less shot. The photographer must anticipate bubble-free periods and the model must practise controlled breathing – avoid skip breathing.

9. When interacting with creatures, the model should **anticipate the 'peak' of the shot**. This requires a sharp eye, a natural instinct and much concentration. The breathing rhythm may possibly have to be paced differently.

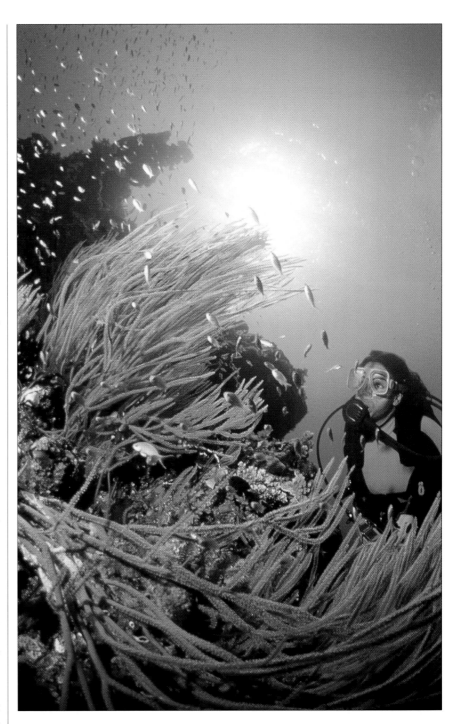

Always stay calm if you miss a shot – by maintaining rapport with the subject, you may quite possibly get a second chance.

10. **A knowledge of different camera lenses** helps the model anticipate poses, especially when the photographer switches cameras. A photographer never portrays divers unrealistically or compromises the safety of his model.

Above Represent divers truthfully, dressed in modern, functional equipment.

Opposite Elegance and good buoyancy are vital skills for an underwater model.

A velvet exposure lifts this thumbnail-sized lionfish from its distracting background and emphasizes its fragility.

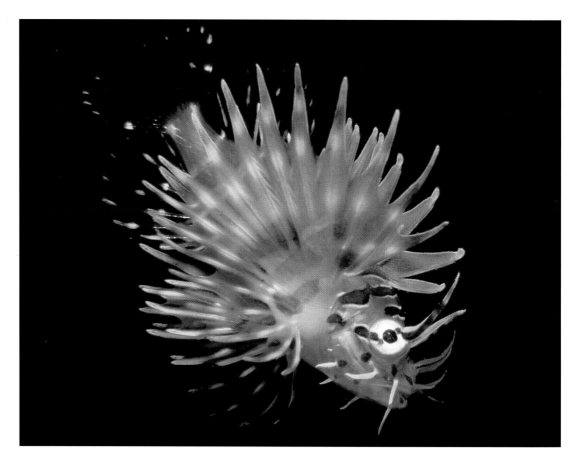

AWARD-WINNING PHOTOGRAPHS

Brilliant photographs – those award-winning shots – surprisingly always have the same things in common: simplicity, good composition, vivid colour and perfect lighting. But there is one extra intangible factor that sets them apart: the 'spirit' or 'essence' of the subject and the sea.

How to impart this 'essence' into photography cannot be taught. You have to develop a 'feel' and an understanding for the marine environment. Winning shots are never 'lucky' shots; they almost always demand a fair amount of time and concentrated effort.

On most dives we encounter fairly predictable, perhaps even ordinary, subjects. Yet, every so often we see those very same creatures jumping off the pages of a new photographic book. Consider the potential of a subject and award it the necessary time as there is a remarkable correlation between time spent on a subject and the excellence of subsequent images. Concentrate on a minimum of subjects during any one dive and photograph those well.

Focus on only a small section of the reef – this slows down your diving and helps you and the inhabitants to acclimatize to each other. In an amazingly short time this results in a wide selection of choice images.

An animal portrait must always be a conversation – intimate, face to face, eye to eye, and communicative. We automatically seek eye-contact – with our own kind, as well as with other living creatures – so, eyes are what we look at first in an image. Whether these belong to divers, fish or creatures, they must be alive, pin-sharp, and preferably show the sparkle of a catch light. Between interacting eyes there must be a feeling of active interest and anticipation.

Each reef species has its own character – a 'personal photo dimension' and photogenic angle at which it is best portrayed. To capture any creature's essence, this characteristic personality must literally ooze out of the shot. It is very helpful to distil what makes creatures so different from each other and to see their unique personality traits in terms of more familiar human mannerisms. One tends to compose and photograph each animal more characteristically with such defined visualization.

Mega-magnification helps emphasize the translucency of this tiny, cheeky character.

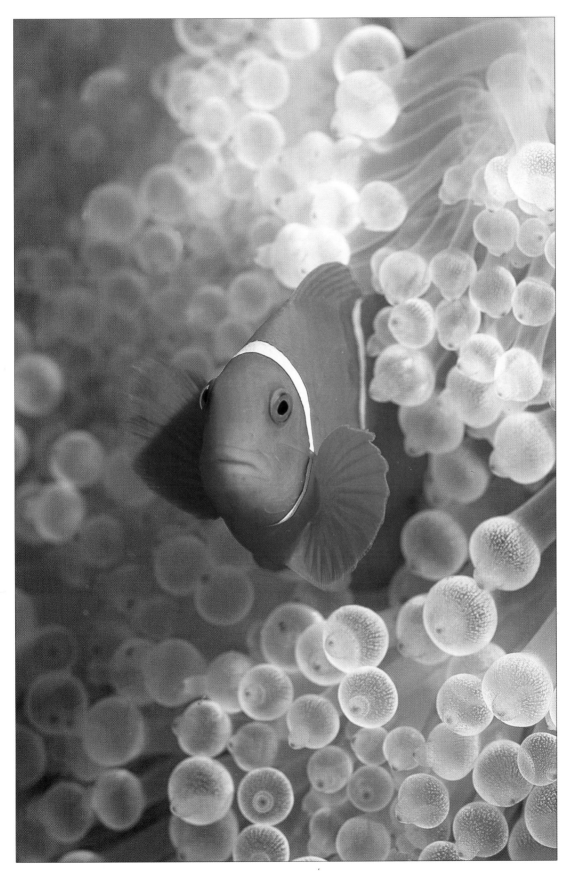

When taken at the 'peak' of the shot, a single image speaks a thousand words.

Finally, the most coveted ability a photographer can have is to know exactly when to release the shutter. The marine world is one of almost perpetual motion. Thus, there is almost always a definitive moment when all of the components in a picture will suddenly 'come together' and appear perfect.

This moment is termed the 'peak of the action'. It is governed by patience, knowledge and anticipation – and when attained, sets such a shot apart from every other. An obvious example is the instant of a predatory strike. But there are much more subtle peaks. It could be when a tiny nudibranch suddenly crawls clear of clutter, looks larger, and lifts its head.

Sometimes it means waiting for several components to 'gel' at one single time – the anemone tentacles to swing 'just so' and the clownfish to suddenly settle, peeping endearingly into the camera, sharply in focus, evenly lit, pectoral fins perkily displayed.

Lucky shots are always a gift from the sea. It is being in the right place at the right time as often as possible: capturing the instant a shark swims across a sunburst; or as eagle rays rise inches in front of you... shoot and hope you get lucky. If you are not, you will be better prepared next time.

Lush colour, intricate detail, a filled frame: components that make award-winning photographs.

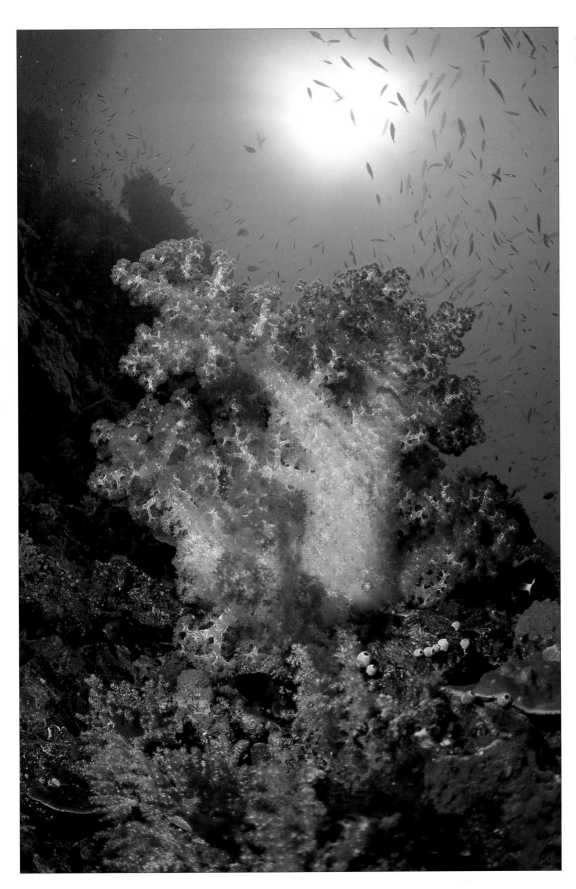

An image captures one perfect moment that evokes different moods and emotions, depending on the perspective of the viewer.

Opposite Patience and calm
breathing allows you
to capture natural fish
behaviour.

STALKING LIVE SUBJECTS

To reap the rich photographic rewards of reef wildlife, we must develop techniques that allow us to capture vivid colour and resolution, without inducing flight or unnatural behaviour. The most precious technique for this is **patience**; it is your own nature and your ability to control it that will most contribute to, or frustrate, success in this sphere.

But a camera inevitably creates a 'hunting' mode, and you'll find that moving subjects pose neither quite as willingly nor as prettily as they do when you are 'just diving'. Why this wariness? My conclusion is that our minds fill with such concerted effort to 'capture' our 'prey', that we unknowingly tense up and emit an aura of predatory aggression.

This threat is instantly read by all creatures, for their very survival depends on their finely honed senses. If the pursuit ceases, then so does all evasion. So, the answer is to drain all aggression from your mind, change your body language, and simply observe your subject in a non-intrusive way.

PREPARATION

Marine creatures, have unique traits and habits. They stake out preferred territorial habitats, hiding places, and invisible routes. A detailed understanding of each creature thus considerably eases the process of finding and stalking. Be aware of the marvellous strategies employed by nature to keep some of the smaller, more elusive creatures virtually invisible. It never fails to amaze me how often we discover never-found-or-seen-before creatures immediately after discussing them or looking at someone else's slides. It is as if this awareness helps open the mind's eye!

The 'lucky' shots that happen frequently to experienced photographers occur, in fact, simply because they are prepared as they cruise across a reef. By constantly adjusting camera settings and strobe angles, between deliberate shots, in anticipation of events that may happen on this dive, you are always prepared. When opportunity strikes, shoot! Luck is really a marriage between chance and readiness.

Top photographers teach us that a good subject is worth the investment of time, and they often devote entire dives and several rolls of film exclusively to one subject. Many scout dive sites several times, without ever carrying cameras, simply to make friends and study surrounds. These strategies and a calm disposition help to desensitize marine life to a human presence, and are worth duplicating, even within time constraints.

Accept that everything in the ocean, whether a large mammal or a minute crustacean, will see or sense you long before you notice them. Not only do

At night, it is easy to photo-
graph sleeping fish.

they recognize specific divers, but they remember how they behaved during previous encounters!

ATTITUDE

Your subject must at all times know that you mean it no harm. Communicate this with gentle, non-threatening body language. Since marine animals are intelligent, this takes surprisingly little time to achieve. Always be calm, patient and kind.

For their own safety all creatures have spheres of tolerance. They're different for different species, individual members of the same species, and at different times of the day. If you respect their borders, they will behave naturally. Cross the line too soon and their priorities will change, usually towards flight. On rare occasion, however, trapped marine animals may opt for violent defence.

Behaviour, whether feeding, mating or fooling around, is the best subject of all. This is what to look out for if you are a photojournalist:

Marine photography should show creatures where they really live, and how they really behave. Many subjects do not normally swim in open water so avoid shooting these tossed into the water for blue backgrounds. It presents behaviour that does not exist and may have them become food for fast, opportunistic feeders.

The best approach may be not to approach at all! Manta and eagle rays, sharks and dolphins all may interpret movement towards them as aggression. Rather find a good position, tuck in and remain low and calm. Curiosity will take care of the rest.

SKILLS

Good diving skills, perfect buoyancy and a blind knowledge of your camera equipment – in all kinds of conditions – is a must.

While scuba resolutely says no to skip breathing, occasional breath holding is a prerequisite for underwater photography. Provided that you move horizontally or downwards to avoid embolism, you are perfectly safe. Breathe normally beforehand, then take a last deep breath, move in and keep holding until you have the shot.

Look closely in soft corals for secretive, camouflaged species such as allied cowries.

TIPS FOR MACRO PHOTOGRAPHY

Macro subjects – especially the exciting ones – are often masterfully camouflaged. The trick is knowing where they live and training your eye to find them. Habitat usually plays a major role in determining how creatures camouflage themselves. Confine yourself to very small reef sections at a time and watch patiently for the dead give-away – minute movements. As you approach, they'll attempt to improve their situation and often 'overcorrect' instead of remaining still.

Every weed, coral, sponge, niche, crevice and obstruction abounds with life at night. Carefully search them all, looking very closely.

Soft coral decorator and spider crabs are so perfectly camouflaged that even minutes of staring could be fruitless. Watch for their claws – these are usually undecorated, and they often move.

Allied cowries live on specific soft and horny corals. If you know which corals they live on, they are less difficult to find. On soft corals they often occur in the more 'limp' specimens. On horny corals every slight thickening along individual veins may indicate a creature hiding. One trick is to cause extended coral polyps to retract, to show up the polyp-miming mantle of the shell. But this is telling only half of the story. The very charm lies in that masterful mimicry!

Tiny crustaceans suitable for macro photography abound at night. Most will venture out if they sense that you will not harm them. They are attracted to plankton accumulating in the beam of your light.

Nudibranchs occur on sponges, hydroids and soft corals and on the bottom. At night watch out for nudibranchs laying egg-ribbons, but refrain from disturbing them.

If you use framers around Christmas-tree and featherduster worms and they retract, wait for a second appearance. Position your frame quietly, keep your finger on the button and then stay utterly still. This may take some time. When the tentacles emerge, wait for the final flare, then quickly snap the shot. Twice frightened, these tentacles are unlikely to emerge again soon.

With skittish creatures you usually have only one chance. Learn to move in quickly, smoothly and precisely with framers, shooting as you reach the subject.

Often curious, and brilliantly coloured, coral trout are good subjects for beginners.

FISH PHOTOGRAPHY TIPS

As photographic subjects, fish constantly present a challenge. Intelligent and extremely wary, most photograph well only at close distances.

The magic words for having a subject accept you are 'low, slow and quiet.' Sneaking up on fish is difficult enough; chasing them is pointless and out-swimming them impossible. They win, and you lose. Approach them slowly, cautiously, and in proper control of your buoyancy. Breath control helps avoid spooking fish, but if you desire extremely close proximity, you better be able to hold your breath altogether!

Meter exposure early and prefocus at a distance you think you can attain, using a fixed stand-in subject. Also decide whether to shoot with mounted or hand-held strobe and adjust angles *before* you begin the approach. Fish are often momentarily less wary, offering a chance opportunity.

When you are ready, proceed cautiously. If the fish flees, relax. You have a 70% chance that it will return if you do not pursue it.

Fish, like people, have personalities – some are cooperative, some are belligerent, and some will simply not allow close approach. Fine-tune your empathy with the reef. In different circumstances the very same skittish individual may let you come surprisingly close.

Always look out for the legendary 'dumb fish' of every species – because its thought processes work much more slowly, it may remain still long enough, while contemplating how best to escape, for you to get your shot.

Study territory and routine: fish always swim along habitual paths and around preferred outcrops and consistently return to these. This allows you to anticipate the best position.

Schooling fish – by their very nature – present a massive, harmonious entity. Their most desirable posture is when they are all facing in the same direction and turn with perfect, balletic synchronization. When you are photographing schooling fish, always aim to keep the school intact.

Sleeping fish are easy close-up and macro subjects at night, allowing detail to be shot. Fins, tails and scales make wonderful abstracts.

Slow-moving lionfish usually offer many wonderful photographic opportunities.

TECHNIQUES

Try the **'stay-where-you-are'** method if you are a novice. With preset focus and exposure, hold absolutely still *until the fish approaches you*, not the other way round. Be ready to compose and take the picture when the fish swims into your range. Your buddy can assist to lure the subject into your framer.

Use the **'sky gliding'** method to video or photograph slow-moving fish, individually as well as in schools. The proviso is excellent buoyancy control. Again, preset your camera, note the direction in which the fish are moving, use a few gentle kicks to start your own motion and then simply glide along with the fish. Swimming towards the fish sets them to flight, resulting in images of tails and random confusion.

Gliding also works very well over fragile areas where it is impossible to kneel or stand. Practice will get you surprisingly close to your subject and it is quite easy to attain and hold a protracted motionless hover at the end of the glide. If you do have to kick to move away from fragile corals, lift yourself clear with *very* small and gentle butterfly kicks, and a simultaneous inhalation.

Approach hanging schools of fish very slowly, swimming *with* rather than *at* them. Stop and wait when they appear nervous. As they calm down, move in a little more. Even if they disperse, hang around; most will return to the same position.

Pretending to ignore fish invariably draws several insatiably curious fish almost to within touching distance; this is especially true for cuttlefish, lionfish, turtles and big groupers.

Feeding fish are often distracted and more relaxed. Plankton gobblers, pelagic fish and predators concentrate when and where currents strike most forcefully. This is the best place to photograph them, and your best chance of seeing a predator catching its prey. Be especially alert where reef sharks are common.

Cleaning stations – which are usually situated at prominent spots on the reef – provide excellent

photographic locations. All the best reef characters visit them and they are usually less nervous while being tended by cleaner fish or shrimps. You can also capture cleaners perching in mouths and gills.

How not to spook skittish fish, squid and octopus is the biggest problem. You will usually have much more success if you potter around close by, inching nearer as they relax. A plan that works becomes a future recipe; if not, you'll try something different next time. When using framers around subjects in mid-water, it usually helps to move the framer slightly away from the subject during strobe recycle times, so that they do not feel trapped or pinned down. Move the framer forward gently and calmly when you are ready for the next shot.

Rays and flat-on-the-floor fish like flounders, nurse sharks, tassel led sharks, gurnards, and scorpionfish require you to assume much the same position for photography. If not alarmed, most bottom-dwellers stay put. Start your approach further away for the more skittish: prepare your camera, then hover close to the reef floor, without settling directly on the bottom. On sand, pull yourself forward by your fingertips, remaining afloat to avoid stirring up sediment, and glide forward smoothly. As you get near, allow time for the fish to judge your intentions.

WHEN ALL ELSE FAILS, IMPROVISE

Of course it would be ridiculous to suggest that any of these techniques will work for subjects such as sharks, seals, manta rays, dolphins and whales. These shots must usually be thought out extremely quickly. If possible, try to anticipate the direction of movement. Learn to 'pan' with a moving animal: follow the movement of the subject with the camera and press the shutter release while the camera is still moving. The background will be blurred, but most of the time the subject will be sharp.

Finally, remember that Neptune's Underwater Law dictates that amazing animals will on occasion miraculously crowd you and pose obligingly, provided you have the wrong lens or have run out of film. Learn to live with it! This kind of remarkable event is designed solely to have you acknowledge that there is a magnificent world beyond the viewfinder.

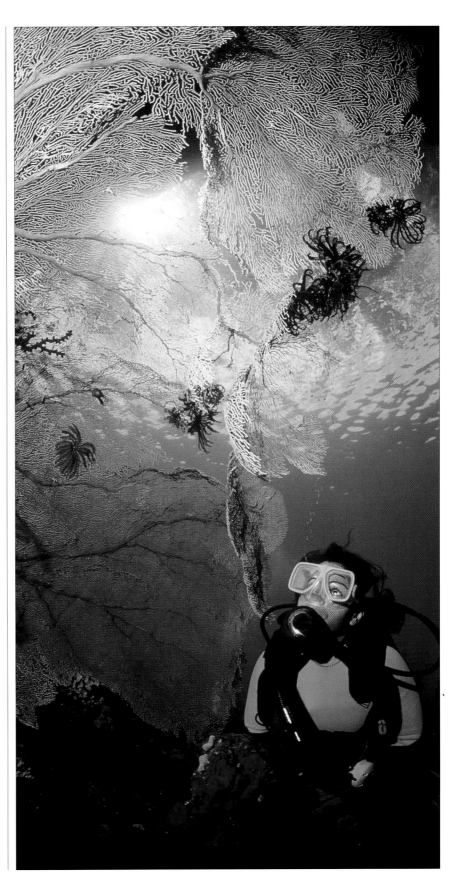

GLOSSARY

ambient light: this is natural light, provided by the sun penetrating the water.

angle of view: the field of view – that portion of a scene any lens is able to include.

aperture: the adjustable lens opening through which light rays pass to the film. The iris-type diaphragm mechanism controls, in calibrated degrees, the exact amount of light. Aperture is also used to influence depth of field.

backscatter: tiny particles suspended in water, that (when artificially lit) reflect to the lens and are registered as white spots on photographs.

bracketing: taking a series of otherwise identical photographs, but using different camera settings for each, to ensure that one exposure will be correct.

buffer zone: a small neutral zone around the edges of a Nikonos V close-up or macro framing device that ensures its exclusion from photographs.

close-up photography: usually refers to 1:1 life-size close-up images. This depicts colour and detail beautifully, without the extreme magnification of macro lenses.

colour correcting filter: an add-on filter used with video cameras to correct the blue cast of underwater light, thereby enhancing natural colours.

combination light: refers to combining the effects of both natural and artificial light in one photograph.

contrast: the difference between the darkest and lightest areas of a photographed scene. This can affect your choice of camera settings.

converters: add-on optical elements that convert lens angles of view. They are often used as an economical alternative to more expensive primary lenses, but do not always deliver the same optical excellence.

cropping: reducing the outside edges of a finished photograph in degrees that will improve its composition. As this may reduce the quality of the image, it is advisable to 'crop' mentally, while composing the picture.

depth of field: refers to the apparent sharpness within the picture field, from near to far, with a given lens. Macro lenses have small, and wide-angle lenses large, depths of field. Also, the smaller the aperture, the larger the area that will appear in focus. Large apertures cause

shallow depths of field and are often used to blur unappealing backgrounds.

diaphragm: a camera mechanism that controls the amount of light that will reach the film. (Refer to 'aperture'.)

diffuser: a translucent cover placed in front of a flash light, either to spread the light beam or – in conjunction with strobe settings – to temper, soften or control the effect and strength of the flash output.

directional continuity: capturing video images so that, once they have been edited, the action will flow logically across a television screen.

dome ports: curved ports used with wide-angle lenses to direct and focus all parts of a subject/scene correctly, even from the extreme outer edges, so that all elements of the picture appear sharp and accurately rendered.

DX coding: a code encrypted into film which allows modern cameras to 'read' and automatically set the relevant film speed.

exposure: usually refers to the process by which light is gathered, focused through a lens and registered on the film. An image which has already been taken (exposed) can also be called an 'exposure'.

extension tubes: hollow tubes that are added between camera and lens in order to determine an angle of view, in this case specifically for Nikonos V macro and close-up photography.

focal length: (of lenses) refers to that area of a picture a lens is capable of capturing – in comparison to others – at the same shooting distance. A wide-angle lens, for example, 'sees' a much wider view of the same scene than a medium range lens. Nevertheless, positioned at different shooting distances, any focal length is capable of rendering different image sizes, although this is still restricted to the limits of the lens and the limits of underwater photography.

framers: framing devices used in conjunction with extension tubes, to outline the picture area for Nikonos V macro or close-up photography. (Refer to 'buffer zone'.)

f-stops: a series of calibrated numbers that indicate aperture sizes. Small numbers depict large aperture openings and vice versa. Depending on the direction of f-stop changes, each consecutive number either halves or doubles the amount of light allowed onto the film by the previous aperture opening.

Golden Mean: also known as the 'rule of thirds', is a mental compositional tool that involves

dividing your intended image into thirds, both vertically and horizontally. The rule holds that harmonious balance is automatically attained by visually dividing an image into one-third/two-third proportions, while any subject placed on grid intersections ('sweet spots') will gain greater visual dominance.

hot spots: optically unpleasant 'spot light' effects that can occur when choosing or using strobe light incorrectly. This can be remedied by re-positioning the strobe, using two strobes or by using a diffuser.

housed system: refers to a normal land camera which has been placed in a watertight module or housing, to make it usable underwater.

ISO: the sensitivity of film to light, predetermined by the manufacturer and calibrated internationally by means of ISO numbers. Low ISO numbers refer to slow film speeds and fine grain, and require more light. Higher ISO numbers or faster film requires less light but renders more grainy images.

lens ports: these are coupled to housings to accommodate different camera lenses. Flat ports are used for macro, and dome ports for wide-angle photography.

macro photography: a method of larger-than-life-size photography that renders tremendous rates of magnification. It is usually used for very small subjects or for portraying intricate parts of larger subjects.

magic line: an imaginary line passing through the 'centre' of any recorded subject or scene that can present a peculiar video anomaly: should the camera stop recording while passing the line and then resume recording on the other side of it, the screen direction of the subject will be reversed. This illogical situation is difficult to remedy in editing.

medium range photography: the relatively close depiction of a subject, usually diver head-and-shoulder portraits, large fish portraits, or small fish schools. Underwater this is taken from closer distances than on land.

opening up: a photographic term used to describe setting a larger aperture.

o-ring: specially designed rings seated between all connecting parts of underwater camera equipment, that flatten as hyperbaric pressure increases, to provide a watertight barrier. Most camera floods are caused by incorrectly treated or seated O-rings.

parallax error: an anomaly caused in images captured with viewfinder cameras that use a

separate viewfinder, positioned higher than the camera lens. To avoid this, the camera position must be adjusted to correct the difference between what the viewfinder and the lens sees.

shutter speed: a mechanism that controls the length of time for which light is allowed to fall on the film. Shutter speed is usually selected according to the presence or lack of action in the subject.

SLR: refers to single lens reflex cameras. The viewfinders of these cameras are designed to show exactly what image you will get, a great advantage for accurate composition and precise focusing.

stopping down: the term used for decreasing aperture size.

strobes: a collective term used for underwater artificial lights. Other alternatives are flashlights, flash units or speedlights.

slave setting: refers to a specialized strobe-light setting. Once set the 'slave' strobe is triggered by the light of another, the 'master' strobe. Strobes with 'slave settings' can also be used independently. Dedicated slave units, however, are always subordinate to the primary strobe.

synchro-cords: the electronic cables connecting strobes to cameras, so they can work in unison.

TTL: refers to a through-the-lens 'sensing' feature, that allows the camera to read and automatically make all adjustments necessary for an artificial light exposure.

viewfinder: usually refers to the tiny built-in view port through which a photographer sees and composes an image. Underwater camera systems normally adjust and magnify these viewfinders for more comfortable underwater viewing – alternatively separate viewfinders may be needed. The separate, higher positioned viewfinders of viewfinder cameras may present parallax error, an anomaly that increases the closer the camera gets to the subject.

virtual image: refers to a curved optical image created by the curve of a dome port to allow light to be correctly focused in the lens.

white balance: is an important setting that provides video cameras with a norm for 'white', or white light, from which the camera calculates and renders all other colours. A correct setting results in colours that appear natural in the recorded image.

wide-angle photography: a varied and flexible style of photography, taken with special wide-angle lenses that combine wide angles of view with great depth of field, clarity of rendition and sharpness of detail, from infinity to the closest point of focus. Their most outstanding effect is the tremendous sense of space they create – both in panoramic vistas and even when positioned extremely close to a dominant subject.

PUBLISHERS' ACKNOWLEDGEMENTS
The publishers would like to thank Jack Jackson and Geoff Spiby for their invaluable advice on technical aspects of underwater photography.

ABOUT THE AUTHORS

Annemarie Köhler is an ardent diver and underwater videographer. A jewellery designer by profession, she has spent many years researching tropical reefs and marine life behavior. Her keen powers of observation and her knack for finding the most elusive of creatures continually strengthens her belief that nature is this planet's greatest schoolroom.

Danja Köhler, a qualified dive instructor for two international SCUBA diving associations, now devotes most of her time to photography, driven by the endless quest for the perfect image. Her considerable diving experience and her affinity with the creatures of the oceans have equipped her with both a sure technical and intuitive grasp of underwater photography.